SOVIETS

DRAWINGS AND TEXT Danzig Baldaev
PHOTOGRAPHS Sergei Vasiliev

CONCEPT, EDIT AND DESIGN Murray & Sorrell FUEL
TRANSLATION Polly Gannon and Ast A. Moore
CO-ORDINATOR Julia Goumen

SOVIETS

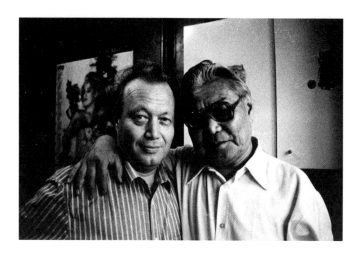

Danzig Baldaev (right)

Danzig Baldaev was born in 1925 in Ulan-Ude, Buryatiya, Russia. The son of an 'enemy of the people', he was subjected to repression in Communist Russia and sent to an orphanage for children of political prisoners. After serving in the army during the Second World War, he came to Leningrad in 1948 and was ordered by the NKVD to work as a warden in Kresty – an infamous prison – where he started drawing the tattoos of criminals. He was reported to the KGB, who unexpectedly supported him, realising the status of a criminal could be determined by deciphering the meaning of his tattoos. This work was published in the best-selling series *Russian Criminal Tattoo Encyclopaedia Volumes I–III* (2004, 2006, 2008), and has since been exhibited internationally as part of the Russian Criminal Tattoo Archive. His critically acclaimed book *Drawings from the Gulag* (2010) has been described as the most disturbingly graphic documentation of the Gulag ever produced. Baldaev died in 2005.

Sergei Vasiliev (left)

Sergei Vasiliev was born in 1936 in the Chuvash region of Russia. He was a staff photographer for the newspaper *Vecherny Chelyabinsk* for over thirty years. He has received many honours including International Master of Press Photography from the International Organisation of Photo Journalists (Prague, 1985), Honoured Worker of Arts of Russia, and the Golden Eye Prize. Alongside the drawings of Danzig Baldaev his hugely popular photographs of Russian criminals and their tattoos have been published in the best-selling books *Russian Criminal Tattoo Encyclopaedia Volumes I–III* (2004, 2006, 2008). His work has been exhibited internationally and is held in numerous museums' collections.

Contents

All footnotes have been researched and written by the editors. Quotes from various sources have been used where appropriate to expand or explain elements contained in the author's drawings and text (all sources are credited at the end of each quote).

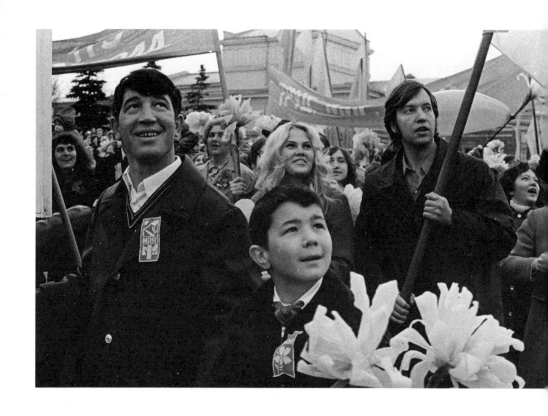

Above and right International Solidarity of the Working Class Day Parade, 1 May 1977, Chelyabinsk.

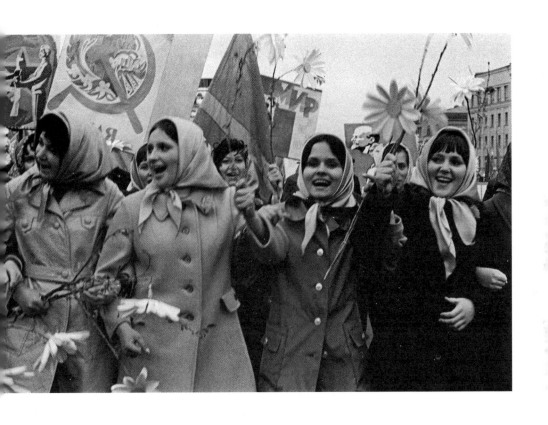

Foreword

Damon Murray, Stephen Sorrell

New information about the Soviet era is continually being unearthed. Despite this, as it crystallises into history, the everyday reality of life during this period becomes harder to imagine. Today, the machinations that created and maintained it appear extraordinarily foreign and opaque, belonging to a government using improbable methods to chase an impossible ideal. In the Soviet world a single situation might contain a plurality of diverse realities each as valid as the next, all intertwined in 'a bizarre confusion of the most contradictory logical systems, now and then erroneously called illogicality or alogicality by those who assume that there exists only one system of logic.'*

With revolution came a paranoid obsession of counter-revolution, prompting the killing and transportation of millions of Russian citizens. Even towards its demise, as its power dwindled, the Soviet system was still dangerous. Its cankerous influence had reached every part of the Russian mind, so that any primary thought was regulated by a counter-thought. In their attempts to maintain control, the authorities used every instititution, from nursery school to the KGB. Brainwashed by propaganda and paralysed by fear, citizens would betray members of their own families as 'spies' rather than show disloyalty to a State that insisted it had given them everything.

As the population tolerated increasing hardships in order to realise the 'Bright Future', their leaders (the *nomenklatura*) issued decrees – impermissible according to their own ideology – which favoured a new elite: themselves. Those in power knew the dreadful truths they had buried, but failed to reveal them, as doing so would threaten their own existence.

The officially sanctioned press photographs of Sergei Vasiliev (for the newspaper *Vercherny Chelyabinsk*) illustrate the ubiquitous State-endorsed fantasy: a parallel universe where Communism was continually undergoing construction, and targets were always being exceeded. These photographs provided the necessary veneer of propaganda, laid over the ghastly results of an enforced ideology. These images were Vasiliev's official work, but crucially he also documented the voiceless underclass, the criminals, of the country's prison zones.

By contrast Baldaev's drawings express the reality of a country exhausted by everyday absurdity, prejudice and corruption. But their dissident nature is complicated and compromised. Although Baldaev had been a victim of the system (his father had been arrested by the NKVD, and he and his sister had been raised in an orphanage for Family Members of Enemies of the People), he also served that system as a prison guard. Acutely aware of how dissidents were crushed, he nevertheless continued to draw. But he also cautiously ensured that his catalogue of fury and mockery against the system's failures remained an utterly private protest – a paradox that goes some way to summarising the Soviet condition.

* Ryszard Kapuściński, *Imperium*, 1992.

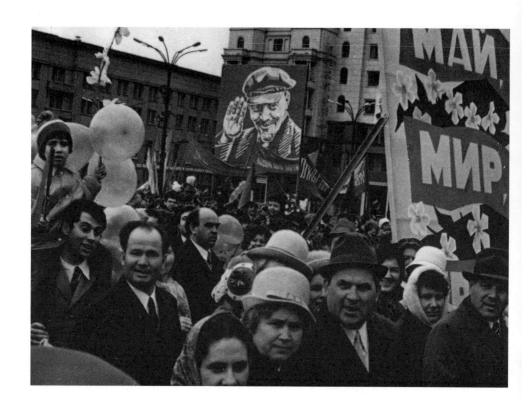

A parade passes through Revolution Square on the Day of International Solidarity of the Working Class, 1 May 1971, Chelyabinsk.

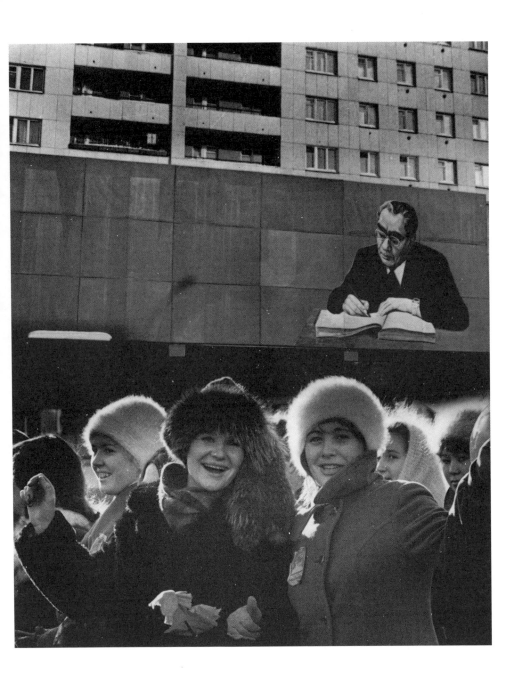

International Solidarity of the Working Class Day Parade, 1 May 1977, Chelyabinsk.

ASOCIAL DRAWINGS BY THE CRIMINALLY CONVICTED

Recorded and Systemised by D. Baldaev

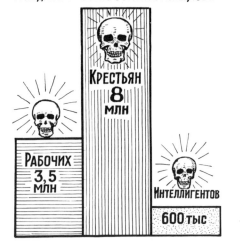

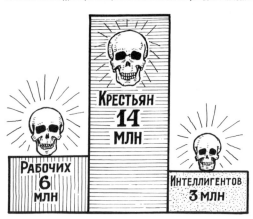

ПОГИБЛО ОТ ГОЛОДА, БОЛЕЗНЕЙ, РАН И УБИТО ПРИ СТАНОВЛЕНИИ СОВЕТСКОЙ ВЛАСТИ В ГРАЖДАНСКУЮ ВОЙНУ С 1917Г. ПО КОНЕЦ 1922Г.:

КРЕСТЬЯН 8 МЛН

РАБОЧИХ 3,5 МЛН

ИНТЕЛЛИГЕНТОВ 600 ТЫС

В ГОДЫ СТАЛИНСКОЙ КОЛЛЕКТИВИЗАЦИИ, РЕПРЕССИЙ С 1929Г. ПО 1940Г. ПОГИБЛО В ЛАГЕРЯХ, УМЕРЛО ОТ ГОЛОДА И РАССТРЕЛЯНО:

ЭТО СОСТАВЛЯЕТ ПО-ГОЛОВНОЕ ИСТРЕБЛЕНИ ВСЕГО НАСЕЛЕНИЯ, ТЕХ ВРЕМЕН, ТАКИХ СТРАН КАК БЕЛЬГИИ, ДАНИИ, ВЕНГРИИ, НОРВЕГИИ ВМЕСТЕ ВЗЯТЫЕ, Т.Е. 23 МЛН ЧЕЛОВЕК...

КРЕСТЬЯН 14 МЛН

РАБОЧИХ 6 МЛН

ИНТЕЛЛИГЕНТОВ 3 МЛН

С 1917Г. ВКЛЮЧИТЕЛЬНО ПО 1945Г. ПОГИБЛО В СССР СВЫШЕ 63 МЛН ЧЕЛОВЕК ИЗ КОТОРЫХ 70% ПРЕДСТАВИТЕЛЕЙ ВЕЛИКОГО РУССКОГО НАРОДА (БЕЗ УЧЁТА ПОТЕРЬ В РУССКО-ЯПОНСКУЮ 1905Г. И ПЕРВУЮ МИРОВУЮ 1914Г. ВОЙН) И ТЕМ САМЫМ ПРИОСТАНОВИЛСЯ ЕСТЕСТВЕННЫЙ ПРИРОСТ БОЛЬШОЙ НАЦИИ РУССКИХ, КОТОРЫХ МОГЛО БЫТЬ К 2000Г. СВЫШЕ 300 МЛН ЧЕЛОВЕК.

Text on top of the left-hand columns reads: **'The number of people who starved to death, died from diseases or wounds, or were killed in the Civil War during the establishment of the Soviet power from 1917 to the end of 1922'**; text inside the columns (left to right) reads: **'Workers – 3.5 million; Peasants – 8 million; Intelligentsia – 600,000'**. Text on top of the right-hand columns reads: **'The number of people who died in prison camps, starved to death, or executed during the years of Stalin's collectivisation and persecutions of 1929-1940'**; smaller text immediately underneath reads: **'This amounts to 23 million people – the complete eradication of the entire population (at the time) of Belgium, Denmark, Hungary, and Norway put together...'**; text inside the columns (left to right) reads: **'Workers – 6 million; Peasants – 14 million; Intelligentsia – 3 million'**.

Since 1917 and up to 1945, over 63 million people died in the USSR. Of them, 70% were of the great Russian people (not counting the losses during the Russo-Japanese War of 1905* and the First World War of 1914†). Thus, the natural population growth of the larger Russian nation, which could have otherwise numbered over 300 million people by 2000, was hindered.

*The Russo-Japanese War (8 February 1904 to 5 September 1905) between the Russian Empire and the Japanese Empire, was fought over the territories of Manchuria and Korea. The Russian Empire lost.
† Russia participated in World War I from 1914–1917, on the side of the Allied (Entente) Powers.

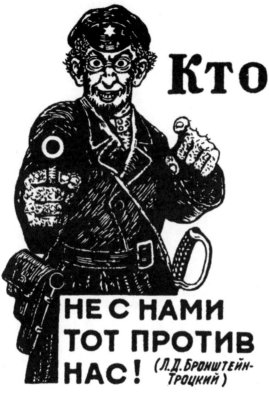

„ИЕРУСАЛИМСКИЙ КАЗАК" ВРЕМЕН ГРАЖДАНСКОЙ ВОЙНЫ...

КТО

НЕ С НАМИ ТОТ ПРОТИВ НАС! (Л.Д.БРОНШТЕЙН-ТРОЦКИЙ)

„И НИКТО НА СВЕТЕ НЕ УМЕЕТ ТАК СМЕЯТЬСЯ, РАДОСТНО УБИТЬ..."

Text at the top reads: **'A "Jerusalem Cossack*" of the Civil War.'**; text above his pointing finger reads: **'WHO[†]'**; large text at the bottom of the figure reads: **'THOSE WHO ARE NOT WITH US ARE AGAINST US! (L. D. Bronshtein-Trotsky[‡])'**.

'And nobody in the whole world can laugh and take pleasure in killing [as we can]...'

* The anti-semitic caricature wears the uniform of the VChK' *Vserossiyskaya Chrezvychaynaya Komissia* (the All-Russian Extraordinary Commission [for Combating Counter-Revolution and Sabotage]. The inference here is that the authorities were being controlled (and their policies enforced by), Jewish organisations.
[†] A play on the World War I poster depicting Lord Kitchener in a similar finger-pointing pose, appealing for recruits to the British army.
[‡] Reference to Leon Trotsky, Soviet politician, Marxist revolutionary and theorist (born Lev Davidovich Bronshtein).

ЕВРЕЙ СО „ЗНАКОМ КАЧЕСТВА"

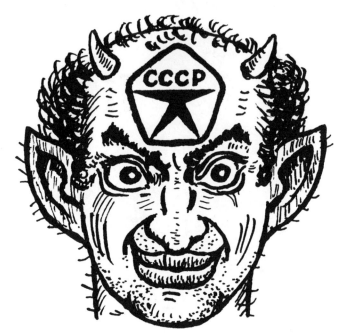

В ПАСПОРТЕ В ГРАФЕ НАЦИОНАЛЬНОСТЬ ВПИСАНО - РУССКИЙ И ДРУГИЕ НАЦИОНАЛЬНОСТИ

Text at the top reads: **'A Jew with a "high quality" mark*'.**

In the passport under Nationality it says "Russian" and other nationalities.[†]

* The State Quality Mark of the USSR was an official quality certification mark established in the USSR in 1967. It could be affixed to the packaging or the goods themselves, or both.

[†] One of the entries in Soviet passports (a form of internal identification) read 'Nationality'. However, a more appropriate translation would be 'Ethnicity'. Being mandatory, the entry simplified abuse and discrimination. Certain nationalities (e.g. Jews, Germans) experienced difficulty with employment, education, promotion, exit visas, etc. Since the mid-1990s, the entry is optional and only applies to birth and marriage certificates.

ПРИЗЫВ СИОНИСТСКОЙ ИДЕОЛОГИЧЕСКОЙ КРЫСЫ...

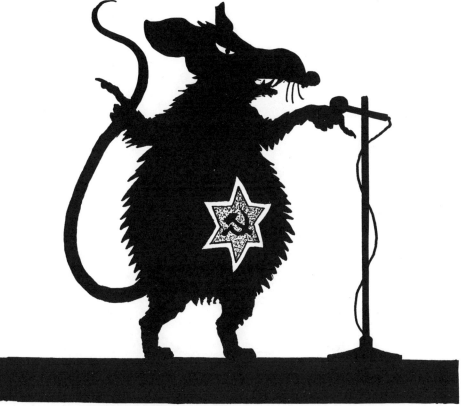

– ДЛЯ ЧЕГО РУССКИМ ПАМЯТЬ? НАША ЗАДАЧА ВЫБИТЬ ЕЁ ДАЖЕ ПУТЕМ РАСПРОСТРАНЕНИЯ НЕТЕРПИМОСТИ СРЕДИ НИХ. УСТРОИМ СВОЙ СОБСТВЕННЫЙ „КРАСНЫЙ ТЕРРОР" И ПОСТАВИМ ЕВРЕЕВ НА ВСЕ ВЫСОКИЕ ПОСТЫ В КРУПНЕЙШИХ ГОРОДАХ. ПУСТЬ ПОМНЯТ КТО ХОЗЯИН В ЭТОЙ СТРАНЕ!...

Text at the top reads: **'A call to action by a Zionist* ideologist rat...'**.

'What good is memory[†] to Russians? Our goal is to eradicate it, even if it means spreading intolerance among them. Let's launch our own 'Red Terror'[‡] campaign and appoint Jews to the highest posts in the largest cities. We'll make them remember who truly runs this country!'

* Zionism is a nationalist Jewish movement which worked for a separate Jewish nation state, opposing the assimilation of Jews into other societies. It now supports the state of Israel.
[†] Memory or *Pamyat* was a Russian nationalist movement dedicated to preserving the culture of the country. Formed in the late 1970s, it blamed Zionists as the source of the misfortunes of the Russian people, including the revolution of 1917 and Joseph Stalin's personality cult. The group always denied anti-Semitism, but it is widely acknowledged as a forerunner of modern Russian neo-fascist groups.
[‡] The 'Red Terror' refers to the period between September and October 1918, when mass arrests, executions and atrocities were ordered by the Bolshevik government in an attempt to crack down on anyone who they perceived to be a counter-revolutionary.

„МЫ САМЫЕ ЛУЧШИЕ ДРУЗЬЯ РУССКОГО НАРОДА..."

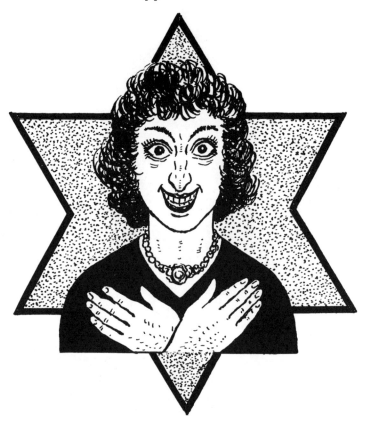

-ЕВРЕИ НЕ ЯВЛЯЮТСЯ ПИЩЕВЫМИ КОНКУРЕНТАМИ РУССКИХ. ВЫ ЛЮБИТЕ ОВОЩИ, КАРТОШКУ, ХЛЕБ, ЩИ, КАШУ, А МЫ СОКИ, ФРУКТЫ, КУРОЧКУ, БАЛЫЧЁК, ИКОРКУ И КАЖДЫЙ КУШАЕТ ТО, ЧТО ЛЮБИТ И ЕМУ ДОСТУПНО В МАГАЗИНАХ, НА СКЛАДАХ, БАЗАХ И ХРАНИЛИЩАХ...

Text at the top reads: '**We are the best friends of Russian people...** '.

Jews don't encroach on the trophic niche space of Russians. You like vegetables, potatoes, bread, cabbage soup, and porridge. We prefer juices, fruit, chicken, sturgeon fillet, and caviar. So everyone eats what he likes and can afford to obtain from stores or storage facilities.*

*A fruit and vegetable storage facility. See page 67.

„МЫ САМЫЕ ЛУЧШИЕ ДРУЗЬЯ РУССКОГО НАРОДА.".

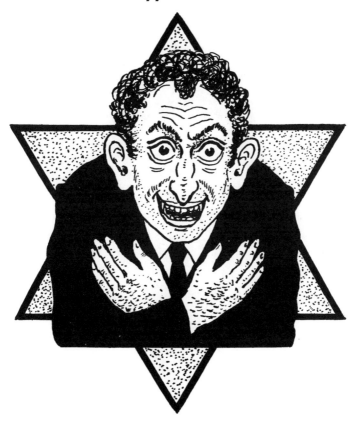

–ЗАЧЕМ ВАМ РУССКИМ ИНТЕЛЛЕКТ, ТАЛАНТЫ, ГЕНИИ? ДЛЯ ЭТОГО ЕСТЬ
МЫ ЕВРЕИ БОГОМ ИЗБРАННЫЙ НАРОД. МЫ ЗАБОТИМСЯ О ВАС КАК О
МАЛЫХ ДЕТЯХ: УЧИТЫВАЕМ ВСЮ ПРОДУКЦИЮ, УПРАВЛЯЯ ЭКОНОМИКОЙ,
ВЫВЕЛИ РОССИЮ ИЗ ДИКОСТИ В ПЕРЕДОВУЮ СТРАНУ МИРА...

Text at the top reads: **'We are the best friends of Russian people... '.**

Why do you Russians need the intellect, talents, and geniuses? For all that you have us Jews, the chosen people. We take care of you like small children: we account for all the produced goods and steer the economy. We brought Russia from barbarism and made it the most advanced nation in the world.

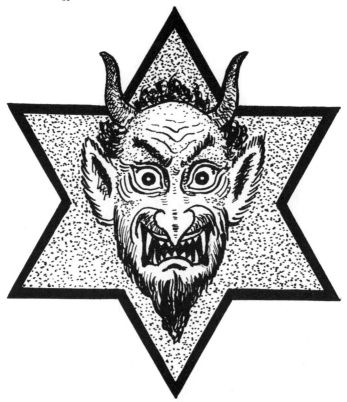

Text at the top reads: **'The Fifth Column in the USSR '**.

Our goal is to disband the most pernicious organisation, which stymies our every action – the KGB.

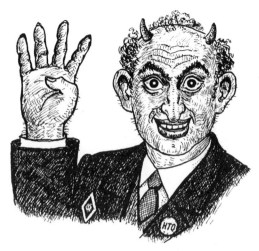

„МЫ СИОНИСТЫ В РОССИИ ОСУЩЕСТВЛЯЕМ СЛЕДУЮЩЕЕ ..."

В ПЕРИОД ЛЮБОГО БОЛЬШОГО ДЕЛА:
- ПЕРВОЕ - СОЗДАТЬ ШУМИХУ
- ВТОРОЕ - НЕРАЗБЕРИХУ
- ТРЕТЕЕ - НАКАЗАТЬ НЕВИНОВНЫХ
- ЧЕТВЁРТОЕ - ПРОИЗВЕСТИ НАГРАЖДЕНИЕ НЕПРИЧАСТНЫХ

Text at the top reads: **'We Zionists* carry out the following in Russia... '**.

During the time of any grand undertaking:

Number 1: Create hype/sensation

Number 2: Create confusion

Number 3: Punish the innocent

Number 4: Reward those who are not privy

* Zionist – see page 19.

† The badge on the character's left lapel denotes membership of the Society for Science and Technology (*Nauchno-tekhnicheskoye obshchestvo*), the one on the right is a university insignia, both are intended to show that the wearer has societal connections and associations.

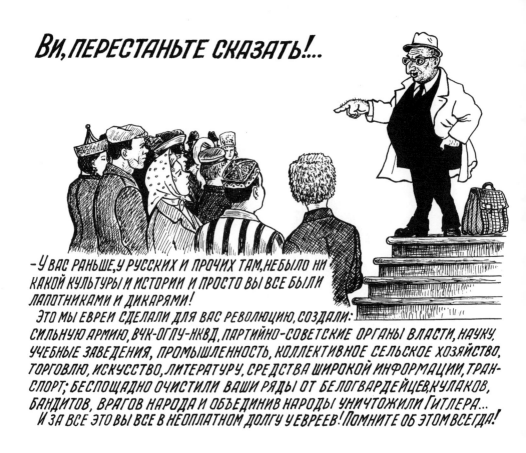

Ви, ПЕРЕСТАНЬТЕ СКАЗАТЬ!...

— У ВАС РАНЬШЕ, У РУССКИХ И ПРОЧИХ ТАМ, НЕ БЫЛО НИ КАКОЙ КУЛЬТУРЫ И ИСТОРИИ И ПРОСТО ВЫ ВСЕ БЫЛИ ЛАПОТНИКАМИ И ДИКАРЯМИ!

ЭТО МЫ ЕВРЕИ СДЕЛАЛИ ДЛЯ ВАС РЕВОЛЮЦИЮ, СОЗДАЛИ: СИЛЬНУЮ АРМИЮ, ВЧК-ОГПУ-НКВД, ПАРТИЙНО-СОВЕТСКИЕ ОРГАНЫ ВЛАСТИ, НАУКУ, УЧЕБНЫЕ ЗАВЕДЕНИЯ, ПРОМЫШЛЕННОСТЬ, КОЛЛЕКТИВНОЕ СЕЛЬСКОЕ ХОЗЯЙСТВО, ТОРГОВЛЮ, ИСКУССТВО, ЛИТЕРАТУРУ, СРЕДСТВА ШИРОКОЙ ИНФОРМАЦИИ, ТРАНСПОРТ; БЕСПОЩАДНО ОЧИСТИЛИ ВАШИ РЯДЫ ОТ БЕЛОГВАРДЕЙЦЕВ, КУЛАКОВ, БАНДИТОВ, ВРАГОВ НАРОДА И ОБЪЕДИНИВ НАРОДЫ УНИЧТОЖИЛИ ГИТЛЕРА...

И ЗА ВСЕ ЭТО ВЫ ВСЕ В НЕОПЛАТНОМ ДОЛГУ У ЕВРЕЕВ! ПОМНИТЕ ОБ ЭТОМ ВСЕГДА!

Text at the top reads: **'You, shut up!'**[*] **USLON**[†] **OGPU**[‡].

'You, Russians and the rest, didn't have culture or history. You all were peasants and savages! We Jews made the revolution for you and created a strong army, VChK-OGPU-NKVD[§], the Soviet party power, science, education, industry, collective agriculture, trade, arts, literature, mass media, and transportation. We ruthlessly cleansed your ranks from the White Guard, *kulaks*[II], bandits, and enemies of the people. We united the people to destroy Hitler. For all that you all should be greatly indebted to Jews. Don't you forget it!'

[*] Ungrammatical, parodying stereotypical Jewish speech.
[†] USLON – *Upravlenie Solovetskimi Lageryami Osobogo Naznacheniya* (the Directorate of Solovki Special Prison Camps).
[‡] OGPU – *Obyedenennoe Gosudarstvennoye Politicheskoye Upravlenie* (the United State Political Directorate).
[§] VChK – or simply ChK, *Chrezvychaynaya Komissiya* (Extraordinary Commission), OGPU – see above, NKVD – *Narodnyy Komissariat Vnutrennikh Del* (the People's Commissariat for Internal Affairs).
[II] *Kulaks* (*kulak* lit. 'fist') – relatively affluent peasants in the later Russian Empire, Soviet Russia, and early Soviet Union.

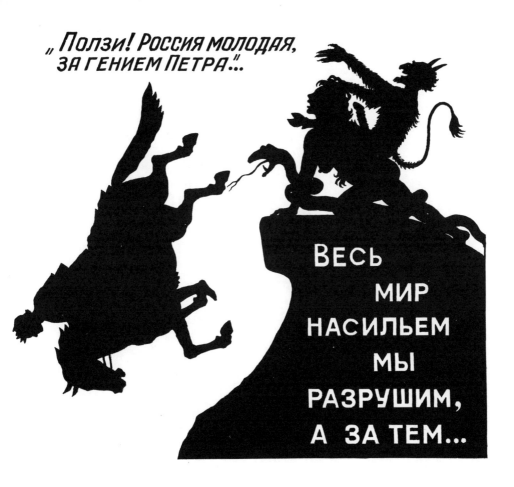

Text at the top reads: **'Crawl, young Russia, following the genius of Peter the Great...'***. Text on the stone plinth reads: **'We will destroy the entire world with violence, and then...'**[†].

The drawing depicts the devil with a stereotypically Jewish nose, toppling the statue of the Bronze Horseman[‡] from its pedestal. The serpent is part of the original sculpture, representing evil and treachery.

* A mock paraphrase of a line from *Poltava*, a narrative poem by Alexander Pushkin.
[†] A mock paraphrase of a line from a Russian translation of *The Internationale*. When translated into English the original Russian version reads: 'We will destroy this world of violence / Down to the foundations, and then / We will build our new world.' The paraphrase replaces the word *of* with the word *with*, so it reads: 'We will destroy this world *with* violence...'
[‡] The Bronze Horseman is the iconic statue of Peter the Great in central St Petersburg by Étienne Maurice Falconet, unveiled in 1782.

„*Разговор у портрета...*"

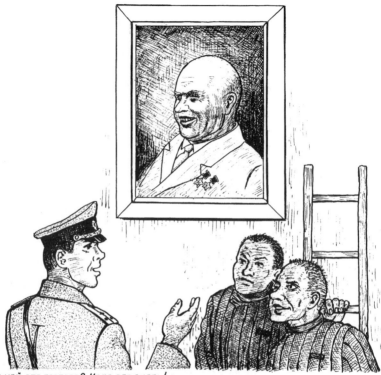

– ЗНАЕТЕ ЧЕЙ ЭТО ПОРТРЕТ?.. НАДО ЕГО СНЯТЬ!
– ДА, ГРАЖДАНИН-НАЧАЛЬНИК! ЭТО НИКИТА СЕРГЕЕВИЧ ХРУЩЕВ, ХОРОШИЙ МУЖИК ГОВОРЯТ БЫЛ, БОЛЬШУЮ
АМНИСТИЮ ЗЭКАМ СДЕЛАЛ... РАЗРЕШИЛ НА ПОРУКИ...
– НУ, А ДАЛЬШЕ ЧТО СКАЗАТЬ МОЖЕШЬ?
– ХОТЕЛ КРЕМЛЕВСКИМ ДРУЖКАМ ИХ ПАЙКУ СРЕЗАТЬ, ДА ОНИ ЕГО ЗА ЭТО ГОЛОВОЙ В ПАРАШУ ОКУНУЛИ...

A conversation by the portrait.

'Do you know whose portrait that is? Take it down!'
'We do, citizen boss*. That's Nikita Khrushchev†. They say he was a great man; he granted amnesty to a lot of convicts. Got them released on bail.'
'What else do you know?'
'Well, he wanted to cut the ration to his Kremlin buddies, but they dumped his head in the toilet‡ for that...'

* Convicts often use the term 'boss' as a form of address to any prison guard (or other authority), regardless of rank.
† Khrushchev was First Secretary of the Communist Party between 1953–1964. He denounced Stalin's brutal methods and ushered in a less repressive era, including reforms and amnesties.
‡ A common form of humiliating and suppressing those who resisted authority in prison (used figuratively here).

— РАЗРЕШИТЕ ОБРАТИТЬСЯ! МОЙ ДЕД БЫВШИЙ ЖАНДАРМСКИЙ ОФИЦЕР ГОВОРИЛ МОЕМУ ОТЦУ О ТОМ, ЧТО СТАЛИН-ДЖУГАШВИЛИ ИЗ КРЕЩЁННЫХ ОСЕТИНСКИХ ЕВРЕЕВ И ОБ ЭТОМ ЗНАЛО ЖАНДАРМСКОЕ УПРАВЛЕНИЕ ЦАРЯ, А ПОСЛЕ ЛЕНИНА ЕГО ВЫДВИНУЛА ЕВРЕЙСКАЯ МАФИЯ ГЕНСЕКОМ, ПОСЛЕ ОН ВЫШЕЛ ИЗ ИХ КОНТРОЛЯ И ЕЩЕ СКАЖУ, ЧТО НИ ОДНОГО ЧИСТОГО ГРУЗИНА ПО ИМЕНИ ДЖУГА НЕ БЫЛО НИКОГДА!...

'May I? My grandfather, a former gendarme officer*, told my father that Stalin-Djugashvili was a baptised Ossetian Jew, and that the Main Directorate of the czar's Gendarmerie knew that. Then, when Lenin died, the Jewish mafia promoted Stalin to be the General Secretary, but they lost any power and control over him. May I also say, that there's never been a pure Georgian by the name of Djuga?'

* The Special Corps of Gendarmes were the security police of the Russian Empire between 1826–1917, when they were disbanded by the Russian Provisional Government.

-*Начальник, какой революций? Брат Лэнина хотэл рэзить цара, цар рэзил брата Лэнина, Лэнин рэзил цара и сел на его скамейка! Какой революций? Это кровный мэсть! Я заключённый Мамедов так понимаю...*

'What revolution, boss? Lenin's brother wanted to kill the czar. The czar killed Lenin's brother, Lenin killed the czar and took his place. That's no revolution, that's a blood feud. That's how I, convict Mamedov,* understand it.'

*The convict's name (Mamedov), the style of the caption (ungrammatical), and the reference to the blood feud, suggest the convict is an Azerbajdzjani – or any other inhabitant of the southern USSR, whose first language is not Russian.

–НАЧАЛЬНИК, СКАЖИ ПОЖАЛУЙСТА КОМУ НУЖНА БЫЛА
ЭТА РЕВОЛЮЦИЯ? ПОГИБЛИ МИЛЛИОНЫ ЛЮДЕЙ, ЗЭКОВ
СТАЛО В 10 РАЗ БОЛЬШЕ, НАХЛЕБНИКОВ В 100 РАЗ!
ТОЛЬКО ВЫИГРАЛИ ОДНИ ЕВРЕИ И БЮРОКРАТЫ-КУ-
ХАРКИНЫ УБЛЮДКИ И ЖИВУТ ПРИПЕВАЮЧИ, ПРИДУ-
ШИВ, ПРИДАВИВ И ПОДМЯВ ВСЕХ! НЕ БЫЛО БЫ ЭТОЙ
РЕВОЛЮЦИИ Я НЕ СИДЕЛ ЗДЕСЬ ПО СТ. 92 И СТ.170 УК
РСФСР, Т.К. НИ ОДНОЙ КОПЕЙКИ СЕБЕ НЕ ВЗЯЛ И Я
КАК ДИРЕКТОР БЫЛ ПОСТАВЛЕН В ДУРАЦКОЕ ПО-
ЛОЖЕНИЕ ГЛАВКОМ И МИНИСТЕРСТВОМ...

'Boss, who needed that revolution anyway? Millions of people died, the number of convicts increased tenfold, spongers a hundredfold! Only Jews and bureaucrats have benefited from it, those damn bastards. They enjoy life after they strangulated and bulldozed over everyone! If it hadn't been for the revolution, I wouldn't have been doing time here under Articles 92 and 170 of the Criminal Code of the RSFSR*. I never stole a kopeck. I was a director, the Central Authority and the Ministry set me up.'

* Article 92 of the Criminal Code of the RSFSR: Embezzlement of national property; Article 170 of the Criminal Code of the RSFSR: Abuse of power.

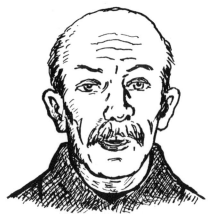

— ГРАЖДАНИН ПРЕПОДАВАТЕЛЬ! ОТВЕТЬТЕ НА ВОПРОС — ПО КАКОЙ ПРИЧИНЕ МЫ СОВЕТСКИЙ СОЮЗ ПРОДАЕМ ЗА ГРАНИЦУ СВОЙ ГАЗ, НЕФТЬ, МЕТАЛЛОМ, ЛЕС, ХЛОПОК, КОЖУ, ПУШНИНУ, КОНИНУ И МНОГОЕ ДРУГОЕ ИЛИ МЫ НАСТОЛЬКО ОТСТАЛАЯ СТРАНА, ЧТО ПРОДАЕМ ЗА БЕСЦЕНОК СЫРЬЕ? КТО ЖЕ РОССИЮ-МАТУШКУ ДОВЁЛ ДО ЭТОГО?... ВОТ УЖ 50 ЛЕТ ПОСТОЯННО ДЕЛАЮТСЯ БОЛЬШИЕ И СПЛОШНЫЕ ОШИБКИ, ПОРА ПОУМНЕТЬ!...

'Citizen Instructor,* answer this question please. How come the Soviet Union sells its gas, oil, scrap metal, timber, cotton, leather, furs, horse meat, and a lot more abroad? Are we so backward that we have to sell raw and natural resources for cheap? Who drove Mother Russia to this state? For fifty years straight we have been making big mistakes. It's high time we got smarter.'

* Prisoners were made to attend Political Information Classes, to re-educate them so that they would be able to serve a fully functioning role in Communist society.

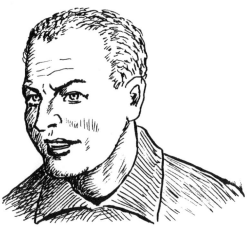

-ГРАЖДАНИН НАЧАЛЬНИК, ПОЧЕМУ ТАК ПРОИСХО-
ДИТ, ЧТО КУДА ПРИШЛИ К ВЛАСТИ КОММУНИСТЫ
СТАНОВЯТСЯ НИЩИМИ И ОТСТАЛЫМИ? НАПРИМЕР:
СССР, ПОЛЬША, РУМЫНИЯ, АЛБАНИЯ, БОЛГАРИЯ,
ВЕНГРИЯ, ЧЕХОСЛОВАКИЯ, ГДР, ЮГОСЛАВИЯ, КИ-
ТАЙ, КОРЕЯ, МНР, ВЬЕТНАМ, АФГАНИСТАН, КУБА-
НИ ПОЕСТЬ, НИ ОДЕТЬСЯ, НИ ОБУТЬСЯ ПРИЛИЧНО,
ВСЕГДА БОЛЬШИЕ ОЧЕРЕДИ, ТАЛОНЫ, КАРТОЧКИ...
 ИЗ НАШИХ ГАЗЕТ И РАДИО МОЖНО ПОНЯТЬ, ЧТО
ВО ВСЕМ ВИНОВАТ ПРЕЗИДЕНТ РЕЙГАН ВМЕ-
СТЕ С АМЕРИКАНСКИМ ИМПЕРИАЛИЗМОМ...

'Citizen Boss, how come wherever the communists take over, everyone becomes poor and backward? In these countries for instance: the USSR, Poland, Romania, Albania, Bulgaria, Hungary, Czechoslovakia, the GDR, Yugoslavia, China, Korea, Mongolia, Vietnam, Afghanistan, Cuba. You can't get good food, clothes, or shoes. There's always long lines and ration cards. Our newspapers and radio say that it's all the fault of President Reagan and American imperialism...'

„ТОЛКОВИЩА ЗЭКОВ" В ИТК.

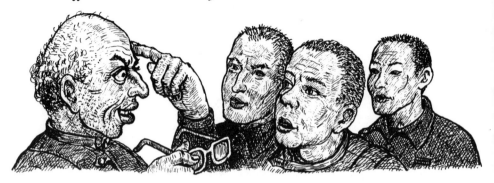

— АРОН ЛЬВОВИЧ, ПОЧЕМУ ЕВРЕИ НЕ РАБОТАЮТ У СТАНКОВ НА ЗАВОДАХ,
ФАБРИКАХ ИЛИ В КОЛХОЗАХ, НА ФЕРМЕ, В ПОЛЕ-ПАХАТЬ, СЕЯТЬ, УБИРАТЬ
— У НАС ЕВРЕЕВ ВЫСОКО ОРГАНИЗОВАННЫЙ МОЗГ И ТРАТИТЬ ЭНЕРГИЮ.
СИЛЫ НА ЭТО?! ПУСТЬ ЭТУ ЧЁРНУЮ РАБОТУ ДЕЛАЮТ ПОДОБНЫЕ ТЕБЕ
ИВАНУШКИ-ДУРАЧКИ И МАШКИ-ДАШКИ, ПОНЯЛ! У ТЕБЯ 206-Я, А Я ПО
93-Й ПРИМ! Я СКОРО ВЫЙДУ ПО КАССАЦИИ, А ТЕБЕ ТЯНУТЬ СРОК ДО ЗВОНКА...

A meeting of convicts in a labour camp.

'Aron Lvovich*, how's it that Jews don't work the machinery at plants, factories, in the *kolkhoz*, or farms? They don't plough, sow, or harvest.'

'We Jews have highly organised brains. Do you really expect us to waste our time and energy on all that? Let Ivan the Fools[†] like you and other Mashkas and Dashkas[‡] do all the dirty work. What have you got? The 206. I've got the 93 part 1[§]. I'm getting out soon after an appeal, and you're going to do full time here.'

* Stereotypically Jewish name and patronymic.
[†] Ivan the Fool is a character in many Russian folk tales.
[‡] Mashka (from Masha/Maria) and Dashka (from Dasha/Daria) are diminutive forms of Russian female names.
[§] Article 206 of the Criminal Code of the RSFSR (ca. 1960): hooliganism, misdemeanour; Article 93 part 1 (also known as Article 93-prime): embezzlement of national and public property of a high degree.

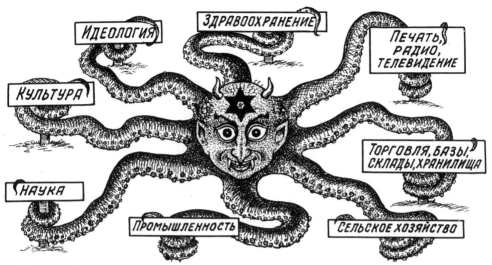

„ЕВРЕЙСКИЙ ПОЛЗУЧИЙ „РАКОВЫЙ" СПРУТ..."

ИДЕОЛОГИЯ

ЗДРАВООХРАНЕНИЕ

ПЕЧАТЬ, РАДИО, ТЕЛЕВИДЕНИЕ

КУЛЬТУРА

ТОРГОВЛЯ, БАЗЫ, СКЛАДЫ, ХРАНИЛИЩА

НАУКА

ПРОМЫШЛЕННОСТЬ

СЕЛЬСКОЕ ХОЗЯЙСТВО

„НА ПЕРВЫЙ ВЗГЛЯД ТИХИЕ, БЕЗОБИДНЫЕ, УЛЫБЧИВЫЕ СИОНИСТЫ, ПРОНИКНУВ В ЛЮБУЮ СТРАНУ, ПРЕЖДЕ ВСЕГО ЗАХВАТЫВАЮТ КЛЮЧЕВЫЕ ПОЗИЦИИ ЭКОНОМИКИ, СТРЕМЯТСЯ УБИТЬ КУЛЬТУРУ И МОЗГ НАЦИИ, НАРОДА - ИНТЕЛЛИГЕНЦИЮ И ЗАТЕМ ПРЕВРАТИТЬ ЭТИ НАЦИИ И НАРОДЫ В СВОИХ РАБОВ..." (ДОСТОЕВСКИЙ).

Text at the top reads: **'The Jewish Crawling "Cancerous" Octopus'**. Signs clockwise from top read: **'Health Care'**; **'Press, Radio, Television'**; **'Commerce, Warehouses, Storage Facilities'**; **'Agriculture'**; **'Industry'**; **'Science'**; **'Culture'**; **'Ideology'**.

'Having penetrated any country, seemingly timid, innocent, and smiling Zionists, first and foremost capture key economic posts and try to exterminate the nation's culture and brains – intelligentsia. Then they strive to turn those nations and people into their slaves...'
Dostoevsky*

* Dostoevsky's anti-Semitism is well documented (if controversial).

РУКОВОДЯЩАЯ РОЛЬ КОММУНИСТИЧЕСКОЙ ПАРТИИ НАРОДНЫМИ МАССАМИ-ЗАКОН ПРИРОДЫ!

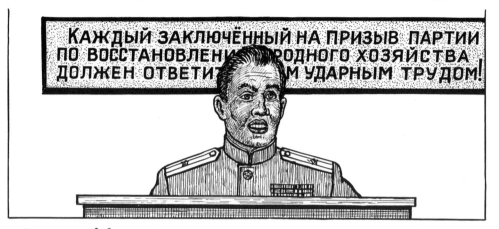

-ТОВАРИЩИ! САМА МАТЬ-ПРИРОДА СОЗДАЛА НАШУ СЛАВНУЮ КОММУНИ-
СТИЧЕСКУЮ ПАРТИЮ! КОММУНИСТИЧЕСКАЯ ПАРТИЯ ЭТО ИДЕЙНОЕ СОЛН-
ЦЕ МАРКСИЗМА, ДАЮЩЕЕ СВОИМИ СВЕТЛЫМИ И ТЕПЛЫМИ ЛУЧАМИ
ЖИЗНЬ ВСЕМУ ЖИВОМУ И ПРОГРЕССИВНОМУ НА ПЛАНЕТЕ ЗЕМЛЯ.
МЫ, КОММУНИСТЫ, ПРИЗВАНЫ САМОЙ ПРИРОДОЙ ЗАЩИЩАТЬ МАССЫ
ТРУДЯЩИХСЯ ОТ ВРАГОВ НАРОДА, ПАРАЗИТОВ-ЭКСПЛУАТАТОРОВ
И ВЕСТИ ЗА СОБОЙ МАССЫ В СВЕТЛОЕ БУДУЩЕЕ, В ЛУЧЕЗАРНУЮ
МЕЧТУ ЧЕЛОВЕЧЕСТВА- КОММУНИЗМ!...

„ЛГУННАЯ ПРАВДА." 1954 год.

Text at the top reads: **'The role of the Communist Party as the ruler over masses is the law of Nature!'** The sign reads: **'Each prisoner must answer the call of the Party to restore the economy by intensified labour!'**

'Comrades! Mother Nature herself has created our glorious Communist Party. The Communist Party is the ideological Sun of Marxism, which gives life to everything that is alive and progressive on planet Earth, with its bright and warm rays. We communists have been called up by Nature herself to protect the working class from the enemies of the people – parasites and exploiters – and to lead the masses into the bright future, into the radiant dream of humanity, which is communism!'
*Lgunnaya Pravda**, 1954.

* *Lgunnaya* (lying, deceiving) *Pravda* (truth); here Baldaev is making a comment on the Soviet propaganda newspaper *Pravda*.

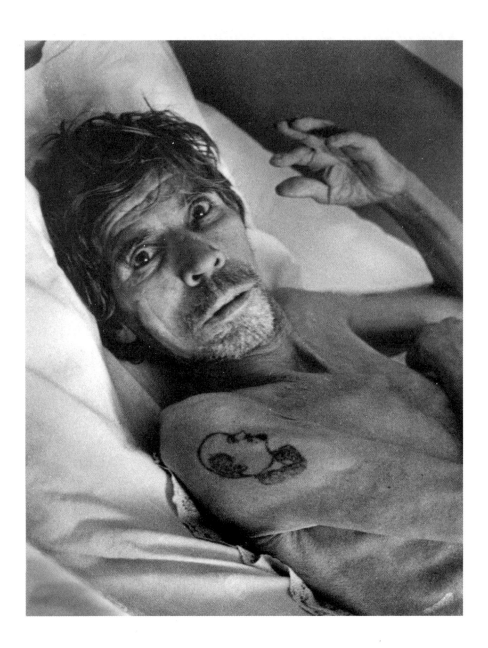

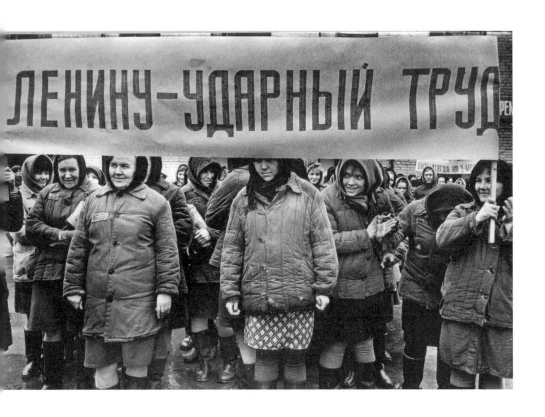

Above Women from a local prison volunteer to work on their day off. [There was an institution of *subbotniks* in the Soviet Union: quarterly 'black Saturdays' when people supposedly volunteered their day off to either put in extra hours in their regular workplace, or perform some community service, such as cleaning parks, etc. In reality, these Saturdays were mandatory]. The sign reads: 'Our record-breaking work – for Lenin!'. Chelyabinsk, 1981.

Left An inmate suffering from tuberculosis lies in a prison hospital bed. An image of Lenin is tattooed on his arm – a concealed acronym for the Russian word *VOR* (thief), the first letters of which make up the words 'Leader of the October Revolution'. Strict Regime Corrective Labour Colony No.6. Chelyabinsk Region, 1989.

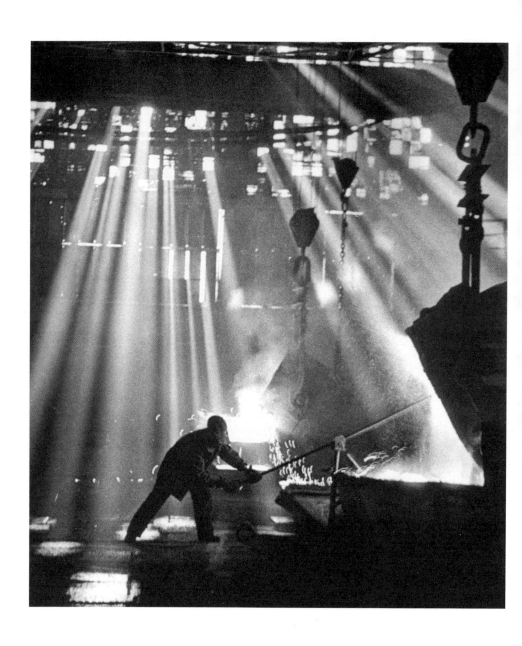

Outstanding labourers of heavy industry. Chelyabinsk, 1969.

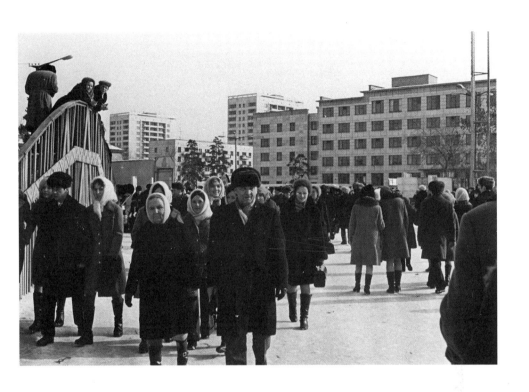

New buildings and main roads replace traditional single-storey wooden houses in the centre of Chelyabinsk, 1969.

RELIGION

Atheism As An Ideology

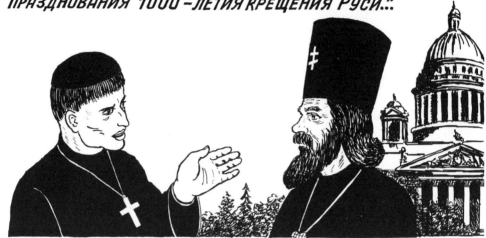

„Разговор католического священника из Ватикана (гостя) с православным русским священнослужителем во время празднования 1000 – летия крещения Руси..."

– Скажите пожалуйста, когда Ваша Христианская правоверная церковь возведёт в лик Святых растоптанных, истерзанных и расстрелянных коммунистами священнослужителей после Октябрьской революции 1917 года?
– Этих погибших великомученников за веру, по приказу Идеологичесого отдела ЦК КПСС, возведут в лик Святых при праздновании двухтысячелетия крещения Руси в 2988 году в июне месяце, 12-го числа в 12 часов дня. Если мы служители культа не подчинимся, то нас всех снова отправят на многолетние коммунистические курсы ГУЛАГа на учебу и перевоспитание.

A conversation between a Catholic priest from the Vatican with a Russian Orthodox Church priest during the festivities commemorating the 1000th anniversary of the Christianisation of the Kievan Rus.*.

'I would like to know when the Russian Orthodox Church is going to canonise the priests that were trampled, tortured, and executed by Communists after the 1917 October revolution.'
'Those perished martyrs will be canonised during the celebrations of the 2000th anniversary of the Christianisation of the Kievan Rus on 12 June 2988, at noon, by an order of the Ideology Department of the Communist Party of the USSR. If priests don't submit, they'll enrol us all again in a multi-year GULAG Communist course, so we study and reform our character.'

* Traditionally, the date is considered to be 988, so the 'conversation' depicted in the drawing is taking place in 1988.

ТАК НАЧАЛАСЬ НЕПРЕКРАЩАЮЩАЯСЯ БОРЬБА С РЕЛИГИЕЙ С 1918 ГОДА...

- Кончилась ваша власть - теперь наша! Власть мы не упустим! Мы переломаем, взорвём, снесём, закроем церкви - одну синагогу на тысячу ваших! Я помню эти еврейские погромы, слуга Исуса!...

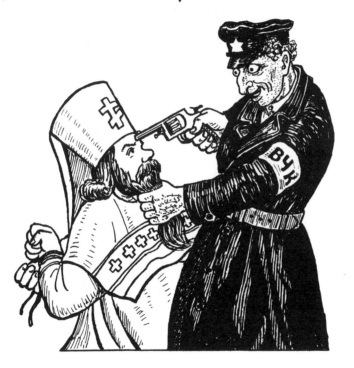

Text at the top reads: **'This is how the never-ending oppression of religion began in 1918*'**. Text on the sleeve: **'VChK'** *Vserossiyskaya Chrezvychaynaya Komissia* (the All-Russian Extraordinary Commission [for Combating Counter-Revolution and Sabotage]).

'Your time is over, now it's our time! We won't let the power slip from us. We'll demolish, blow up, destroy, and close down the churches. A thousand of your churches for one synagogue. I still remember your Jewish pogroms, you Jesus' servant!'

* The Soviet Union was the first state to promote atheism and outlaw religion on ideological grounds, following the Marxist idea of religion being 'the opium of the people' (Karl Marx, *Deutsch-Französische Jahrbücher*, 1844). Though never completely eradicated, throughout the Soviet period a series of campaigns led to many believers being exiled, tortured and killed; their places of worship looted and destroyed.

Исповедь... в Партийном бюро...

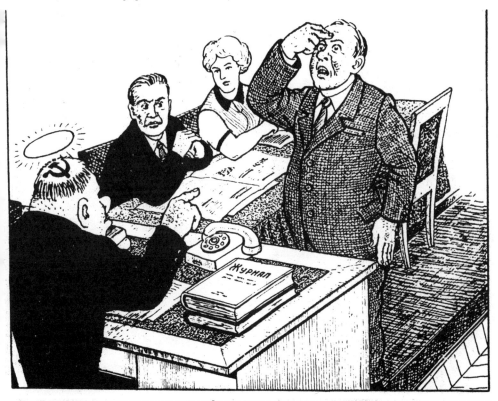

– Товарищ Иванов, к нам членам партийного бюро поступил сигнал, что вы, будучи членом КПСС, каждый раз при выходе из дома на работу креститесь. Вы, что верующий, может быть в церковь ходите?
– Товарищ парторг, это всё враки! Вот посмотрите, я, идя на работу, проверяю правильно ли одел шапку или шляпу, застёгнута ли ширинка у брюк, при мне ли у сердца партбилет и не позабыла-ли жена положить в правый внутренний карман рубль на обед...

Text at the top reads: **'A confession... in a Party office...'**. Cover of the book on the desk reads: **'Minutes'**.

'Comrade Ivanov, we members of the Party Bureau have been told that you, a member of the Communist Party, cross yourself every time you leave home for work. Are you a believer? Maybe you go to church, too?'
'Comrade Party Organiser, these are all insinuations and lies! Look here, I'll show you. On my way to work I make sure I have the hat put on right, then I check to see if my fly is zipped up, whether or not I have my Party membership card – right here next to my heart, and then I check whether my wife remembered to put money for lunch in my other inside pocket on the jacket...'

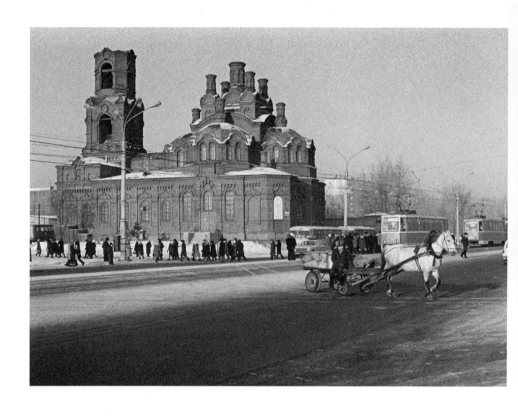

The ruined Holy Trinity Church, closed and without its cupolas. The Soviet authorities attempted to abolish religion (see footnote on page 43), viewing it as ideologically opposed to their regime. Places of worship were ransacked and destroyed. Chelyabinsk, 1970.

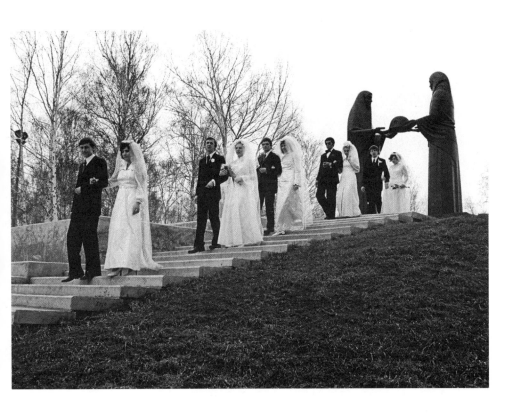

An atheist Soviet wedding ceremony. As part of the drive against religion civil marriages replaced religious, and divorce became easy to obtain: you could simply notify your spouse by postcard. Unwed mothers received special protection, and all children – legitimate or illegitimate – were given equal rights before the law. Women were granted sexual equality under matrimonial law, the inheritance of property was abolished, and abortion legalised.

According to legend, when Vladimir I was choosing a religion for Russia he rejected Islam, realising its prohibition laws would be too much of a burden for his subjects to bear. Instead, impressed by its glittering clothing, ceremonies, and buildings, he chose Eastern Orthodoxy. It was necessary for the Soviet authorities to find an equivalent architecture for their time, which reflected their ideals. 'There was even one area where architects were encouraged to indulge in romantic exuberance: social ritual. For the authorities, the fight against religion was a crucial aspect of the wider ideological struggle. Citizens had to be kept away from churches and other places of worship. The challenge, therefore, was to create secular spaces with their own dramaturgy, designed to offer appropriate settings for weddings and funerals, while avoiding any kind of religious presence. Collective gatherings were an essential part of the Soviet liturgy. The solid, reliable masses had always been the foundation of communism, hence the importance attributed to these "palaces of ceremony". Their architects were encouraged to come up with forms that were as original and situating as they were solemn. [...][The resulting] profusion of forms marks a return to expressionism.' Frédéric Chaubin, *Cosmic Communist Constructions Photographed*, 2011.

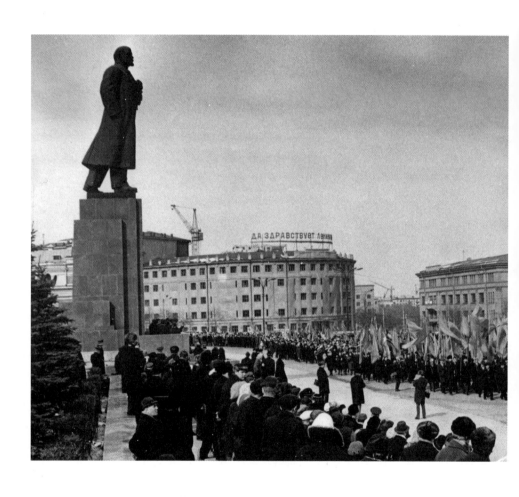

Above A statue of Lenin oversees the May Day Parade. Chelyabinsk, 1967.
Right Crowds at the May Day Parade. The figures on the poster are (left to right) Marx, Engels and Lenin. Chelyabinsk, 1969.

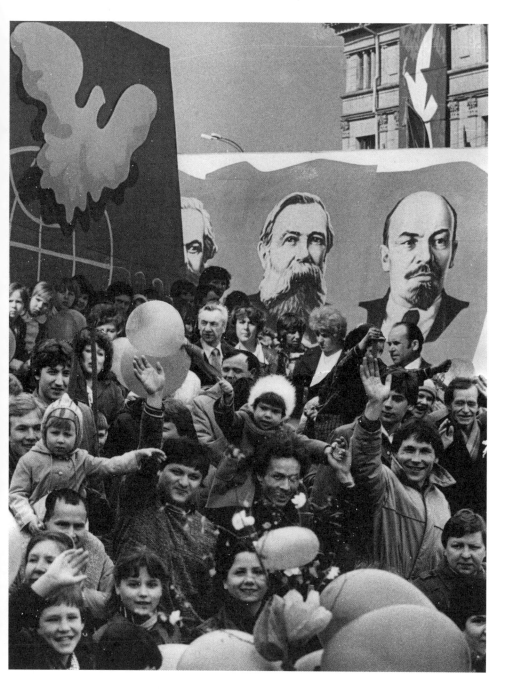

POLITICS AND THE CITIZEN

We Are Very Happy With Our Superiors

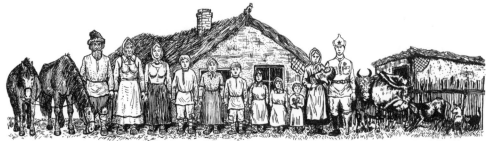

„РОССИЙСКАЯ СРЕДНЯЦКАЯ КРЕСТЬЯНСКАЯ СЕМЬЯ ПРЕД РАСКУЛАЧИВАНИЕМ..."

СТАЛИН И ЕГО ВЕРНЫЕ ЦЕПНЫЕ ПСЫ-БЮРОКРАТЫ С ПРИМЕНЕНИЕМ ЗВЕРСКИХ МЕТОДОВ НАСИЛЬСТВЕННОГО РАБСКОГО ТРУДА НА КОСТЯХ КРЕСТЬЯНСТВА БЫВШЕЙ РОССИЙСКОЙ ИМПЕРИИ ПОСТРОИЛИ: ДНЕПРОГЭС, МАГНИТКУ, БЕЛОМОРКАНАЛ, ТУРКСИБ, ИГАРКУ, КУЗ-БАСС, КОМСОМОЛЬСК-НА-АМУРЕ, КРАСМАШ, ВОРКУТУ, МАГАДАН И Т.Д. ОСОБЕННО ПОСТРАДАЛО РУССКОЕ КРЕСТЬЯНСТВО-МИЛЛИОНЫ ТРУПОВ БЫЛИ ЗАРЫТЫ В БЕСЧИСЛЕННЫХ БРАТСКИХ МОГИЛАХ... КТО О НИХ КОГДА-ЛИБО ВСПОМНИТ И НАПИШЕТ ?...

'An average Russian peasant family'

Using savage methods of forced slave labour, Stalin and his bureaucratic hounds built the Dnieper Hydroelectric Station, Magnitogorsk, the White Sea–Baltic Canal, Turkestan–Siberia Railroad, Igarka, Kuzbass, Komsomolsk-on-Amur, Krasmash, Vorkuta, Magadan*, and more, on the bones of the peasants[†] of the former Russian Empire. Millions[‡] of dead bodies of Russian peasants[§] were buried in countless common graves. Who will ever remember them and write about them?

* Projects and camps that utilised slave labour supplied by the Gulag system.

[†] On 29th December 1929 Stalin announced his policy of 'liquidating the *kulaks* as a class.' (A *kulak* – literally 'fist' in Russian – referred to any peasant who was wealthy enough to own a farm and hire labour.) According to Solzhenitsyn (see page 188) this Dekulakisation was a means of terrifying the rest of the population into submission. The *kulaks* tried to resist Stalin's collectivisation. Many were arrested, exiled, or killed. 'Working in consort with tens of thousands of Party activists, the punitive organs fanned out from the cities, with rifles, and bundles of orders and instructions. Not all Soviet villages contained *kulaks*, but all Soviet villages had to be terrorized, so *kulaks* had to be found in all Soviet villages. Stalin was, of course, using a quota system (as he would in the Great Terror). He seemed to have in mind just under 10%: about 12 million people.' Martin Amis, *Koba the Dread*, 2002.

[‡] According to official statistics (released in 1991 by Vladimir Kryuchkov then head of the KGB) between 1920 and 1953 there were 4.2 million purge victims; 2 million were killed or imprisoned in 1937 and 1938, when Stalin's reign of terror was at its peak. Many experts believe the true figures are much higher. They consider the KGB's evidence unreliable, arguing they falsified dates and causes of death.

[§] 'A woman [...] whose husband had been given five years in the camp, had managed to keep her family fed in various ways until April 1933. Then her four-year-old son died. Even then the brigades did not leave her alone, and suspected that the grave she had dug for the boy was really a grain pit. They dug it up again, found the body, and left her to rebury it.' Robert Conquest, *The Harvest of Sorrow: Soviet collectivisation and the Terror-Famine*, 1984.

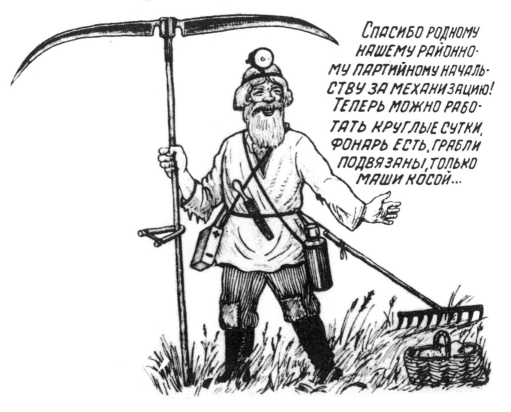

„РУССИШМЕХАНИЗЕЙШЕН"

СПАСИБО РОДНОМУ
НАШЕМУ РАЙОННО-
МУ ПАРТИЙНОМУ НАЧАЛЬ-
СТВУ ЗА МЕХАНИЗАЦИЮ!
ТЕПЕРЬ МОЖНО РАБО-
ТАТЬ КРУГЛЫЕ СУТКИ,
ФОНАРЬ ЕСТЬ, ГРАБЛИ
ПОДВЯЗАНЫ, ТОЛЬКО
МАШИ КОСОЙ...

'Russischmechanisation'

'I'm thankful to our beloved local party heads for the mechanisation*. Now I can work around the clock: I've got a headlamp, the rake is tied to my back. All I have to do is make hay with my scythe.'

* Mechanisation was intended to be the answer to the food shortages brought on by forced collectivisation. 'Collectivisation without mechanisation did not work. The agricultural difficulties of the early 1930s, and in particular the rapid decline in the number of horses, eloquently demonstrated that widespread mechanisation was essential even if the level of production reached in the 1920s was merely to be maintained. [...] For most of the 1930s the level of mechanisation was even inadequate to compensate for the loss of the draught power of work horses and oxen.' R. W. Davis, M. Harrision, S. G. Wheatcroft (editors), *The Economic Transformation of the Soviet Union, 1913–1945*, 1993.

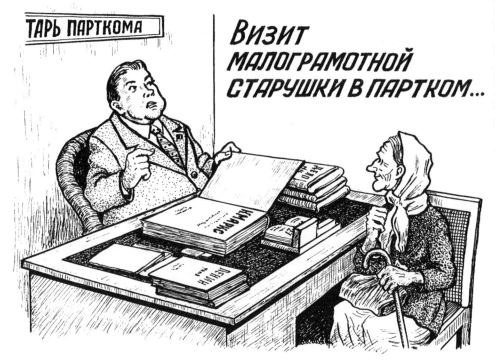

ТАРЬ ПАРТКОМА

ВИЗИТ МАЛОГРАМОТНОЙ СТАРУШКИ В ПАРТКОМ...

–СЫНОК, СКАЖИ ПОЖАЛУЙСТА КТО ПРИДУМАЛ СОЦИАЛИЗМ-КОММУНИЗМ УЧЁНЫЕ ИЛИ ВЫ ПАРТЕЙНЫЕ-КОММУНИСТЫ?
–ЭТО, БАБУШКА, ПРИДУМАЛ ПЕРВЫЙ КОММУНИСТ КАРЛ МАРКС, А МЫ ЕГО ДЕЛО ПРОДОЛЖАЕМ С БОЛЬШИМ УСПЕХОМ!
–Я ТАК И ДУМАЛА, ЧТО ЕНТО ПРИДУМАЛИ ВЫ КОММУНИСТЫ, А НЕ УЧЕНЫЕ, ОНИ БЫ УПЕРЁД НА СОБАКАХ ПРОВЕРИЛИ! ВЫ, КОММУНИСТЫ-ПАРТЕЙНЫЕ УСЁ ЕНТО СРАЗУ НА ЛЮДЕЙ, РАЗВЕ МОЖНО ТАК БЕСПРОВЕРКИ?!...

Text across the top reads: **'An illiterate old woman visits the local Communist Party Committee...'** Sign on the wall reads: **'Secretary of the Party Committee'**. The open book on the desk reads: **'Karl Marx'**. The book in the foreground reads: **'Lenin'**. The folder at the other end of the desk reads: **'Case No.'** (a standard file cover).

'Tell me, sonny, who invented this communism-socialism? Was it scientists or you Party Communists?'
'It was the first communist Karl Marx, granny. We move his idea forward with great success, by the way.'
'I see. That's what I thought. It was you Communists who invented it; not the scientists. See, scientists would have tested it on dogs* first. You, Party Communists, you do it on people right away. How could you do it without testing it first?'

* A reference to Ivan Pavlov (1894–1936), the famous Russian scientist best known for the concept of 'conditioned reflex'. He worked with dogs, feeding them at the same time as sounding a buzzer, and was eventually able to stimulate salvation using sound alone. Pavlov's work became popular in the West, underpinning the practice of comparitive psychology and having a great influence in popular culture.

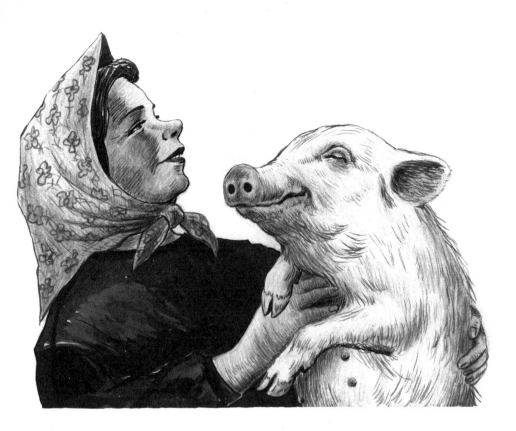

Свинарка: Мы очень довольны нашим начальством.

Поросёнок: В ответ за вашу заботу обязуюсь прибавить в весе за неделю на 14кг. Я очень доволен нашими руководи-телями!!!

Pig farmer: We are very happy with our superiors.
Pig: To pay back for your kindness, I hereby take it upon myself to increase my weight by 14 kilos in seven days. I am very happy with our supervisors!

During the process of collectivisation many peasants slaughtered their livestock rather than relinquish them to the authorities. 'Cattle raising never got over the blow that was the slaughter or starvation of more than one hundred million horses, cows, bulls, sheep, and pigs. It is beyond doubt that the ongoing agricultural crisis in the USSR has its roots in those distant years, in that "victory" that turned out to be a defeat. The land and the peasants retaliated in the only way they were able to against those who had conquered them. The earth stopped giving birth, and the peasants lost their love of working the land. It was a terrible, but just, revenge.' Sergei Maksudov (et al), *Hunger by Design: The Great Ukrainian Famine and its Soviet Context*, 2009.

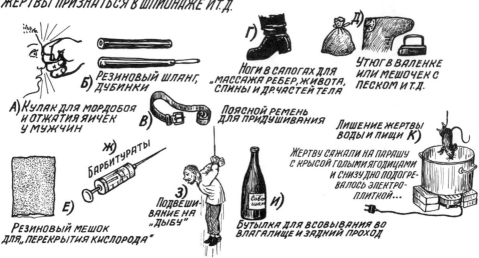

При махровом сионисте в годы культа Генеральном прокуроре Вышинском при допросах III-й степени применялись зверские способы чтобы заставить жертвы признаться в шпионаже и т.д.

Б) Резиновый шланг, дубинки

Г) Ноги в сапогах для "массажа ребер, живота, спины и др.частей тела

Д) Утюг в валенке или мешочек с песком и т.д.

А) Кулак для мордобоя и отжатия яичек у мужчин

В) Поясной ремень для придушивания

Лишение жертвы воды и пищи К)

Ж) Барбитураты

Жертву сажали на парашу с крысой голыми ягодицами и снизу дно подогревалось электро-плиткой...

Е) Резиновый мешок для "перекрытия кислорода"

З) Подвешивание на "дыбу"

И) Бутылка для всовывания во влагалище и задний проход

When the inveterate anti-Zionist Prosecutor General Vyshinsky* was in office during the years of the cult of personality†, sadistic methods of making the victims confess to espionage, etc. were used as part of third-degree interrogations.

a) A fist for hitting in the face and squeezing testicles

b) A length of rubber hose or a nightstick

c) A belt for suffocating the victim

d) Feet clad in heavy boots for 'massaging' the ribs, stomach, back, and other body parts

e) A solid iron in a felt boot, a bag of sand, etc.

f) A rubber bag for 'cutting off the oxygen'

g) Barbiturates

h) Hanging on the rack

i) A bottle for inserting into the vagina or the anus

j) Deprivation of food and water

k) A victim with his pants down was forced to sit on a waste bin with a rat in it. The bottom of the waste bin was then heated with a hot plate

* Andrey Vyshinsky (1883–1954) was Prosecutor General of the USSR. He was known as the legal mastermind behind Joseph Stalin's Great Purge.

† The Stalin era. 'Torture, among its other applications, was part of Stalin's war against the truth. He tortured, not to force you to reveal a fact, but to force you to collude in a fiction.' Martin Amis, *Koba the Dread*, 2002.

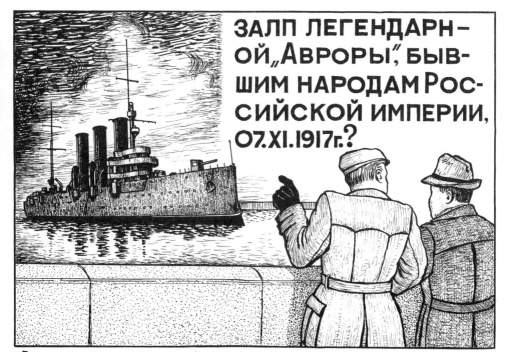

ЗАЛП ЛЕГЕНДАРН-
ОЙ „АВРОРЫ", БЫВ-
ШИМ НАРОДАМ РОС-
СИЙСКОЙ ИМПЕРИИ,
07.XI.1917г.?

ВОДОИЗМЕЩЕНИЕ КРЕЙСЕРА „АВРОРА"-6.800 ТОНН.
ПО САМЫМ СКРОМНЫМ ПОДСЧЁТАМ С 1917Г. ПО 1940Г. ПОГИБЛО
20.000.000 ЧЕЛОВЕК (В 1 ЧЕЛОВЕКЕ 5 ЛИТРОВ КРОВИ). КРОВЬЮ
ПОГИБШИХ МОЖНО БЫЛО НАПОЛНИТЬ БАССЕЙН ДЛИНОЙ 200М,
ШИРИНОЙ 50М, ГЛУБИНОЙ 10М, ОБЪЁМОМ 100.000 КУБОМЕТ-
РОВ В КОТОРОМ СВОБОДНО МОГЛА ПЛАВАТЬ „АВРОРА" В 6.800Т.

The volley of the legendary *Aurora* to salute the former people of the Russian Empire, 7 November 1917*

The water displacement of the cruiser *Aurora* is 6,800 tons. According to the most conservative estimates, twenty million people perished in the period from 1917–1940[†]. There are about five litres of blood in the human body. That's enough blood to fill a swimming pool 200 metres long, 50 metres wide, and 10 metres deep. The total volume of such a swimming pool would be 100,000 cubic metres, which could easily accommodate the *Aurora* with its 6,800 tons of displacement.

* A reference to the blank shot volley that allegedly signalled the beginning of the assault of the Winter Palace in St Petersburg, which was the last episode of the October Revolution. The event took place on 25 October 1917 Old Style Julian Calendar (7 November 1917 New Style Gregorian Calendar); hence the name October Revolution.
[†] These dates refer to the purges that began in 1917 (the October Revolution) and continued through 1937–1940 (Stalin's purges).

„ПРОТЕСТ ПРОТИВ ДВУХПАРТИЙНОЙ СИСТЕМЫ"

ТОВАРИЩИ! Я КАК РЯДОВОЙ РАБОЧИЙ СО ВСЕЙ ОТВЕТСТВЕННОСТЬЮ ЗАЯВЛЯЮ: ДВЕ ПАРТИИ НАМ РАБСИЛЕ НЕ НУЖНЫ. НАМ ИХ НЕ ПРОКОРМИТЬ !!!...

At a rally against the bipartisan system

'Comrades, as an ordinary worker, I hereby claim with due responsibility, that we workers don't need two parties. We couldn't feed them all!'*

* A comment on the exasperation with the single party system, and its self-destructing policies. Analysts had been predicting the fall of communism almost since the revolution itself, but as the USSR continued to stagnate under Brezhnev, the problems with the regime were more widely recognised. The writer Robert Conquest saw 'the USSR as a country where the political system is radically and dangerously inappropriate to its social and economic dynamics. This is a formula for change – change which may be sudden and catastrophic.' Zbigniew Brzezinski (editor), *Dilemmas of Change in Soviet Politics*, 1972.

„ГНЕВНОЕ ОСУЖДЕНИЕ ТРУДЯЩИМИСЯ ПРОИСКОВ МИРОВОГО ИМПЕРИАЛИЗМА"

–Я НЕ ЗНАЮ КТО ТАКАЯ ЧИЛИ, Я НЕ ЗНАЮ КТО ТАКАЯ ХУНТА, ГДЕ ОНИ ЖИВУТ И РАБОТАЮТ, НО ЕСЛИ ОНИ НЕ ОТПУСТЯТ ЛЮИСА ИЗ КАРНОВАЛА, ТО ЗАВТРА ДОИТЬ КОРОВ НА ФЕРМУ НЕ ПОЙДУ!

An angry condemnation of the intrigues of global imperialism by the working class

'I don't know who Chile or Junta are, where they live or work at, but if they don't release Luis from Carnival*, I'm not going to milk cows tomorrow!'

* The politically illiterate dairymaid is referring to Luis Corvalán, a Chilean politician who was arrested in 1973 by Augusto Pinochet after a military coup. Instead of the word *coup*, Soviet media had used the word *junta*, which, along with the word *Chile* have been interpreted as female names by the dairymaid. (Her mistake is understandable when viewed in this context: 'After the revolution [in some areas of the USSR] they started giving girls names that celebrate the modern inventions now making their way to the countryside. So there are girls with the names Tractor, Chauffeur. One father apparently counting on tax reductions, called his daughter Finotdiel, which is an abbreviation of the name of the Office of Finance – *Finansovyj Otidel*).' Ryszard Kapuściński, *Imperium*, 1992.

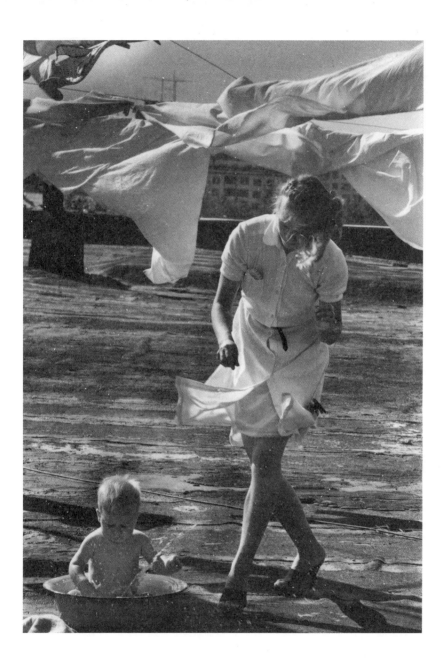

A woman washes her son on the roof of her apartment. She works as a nurse. Chelyabinsk, 1977.

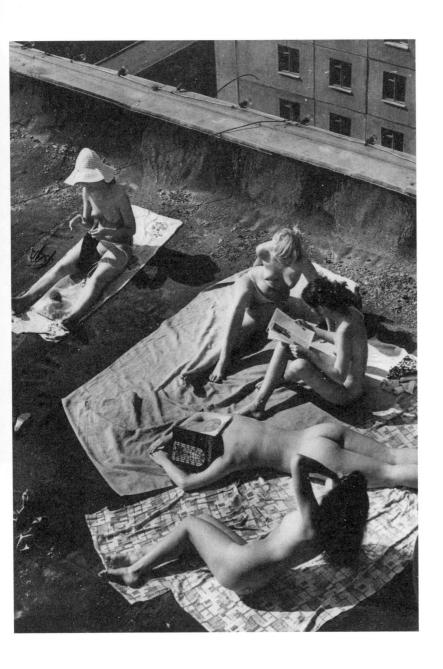

Rooftops double as beaches. Chelyabinsk, 1976.

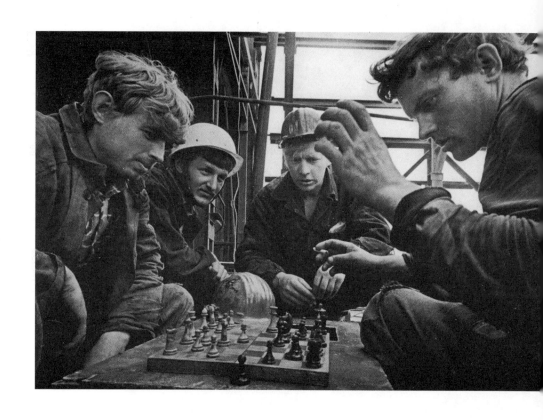

Workers on a construction site play chess during their lunch break. Chelyabinsk, 1969.

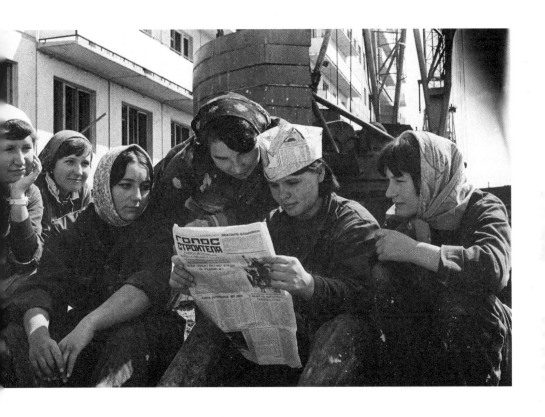

Young plasterers take a break from the construction of new apartment blocks in the north of the city. They are reading their own newspaper called *Builders' Voice*. Chelyabinsk, 1969.

WORK

Complete the Five-Year Plan in Four Years!

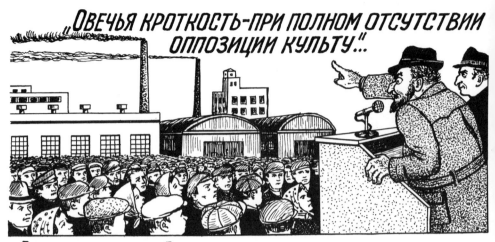

„ОВЕЧЬЯ КРОТКОСТЬ-ПРИ ПОЛНОМ ОТСУТСТВИИ
ОППОЗИЦИИ КУЛЬТУ...".

–ПО УКАЗАНИЮ СВЫШЕ ПАРТКОМОМ ВЫНЕСЕНО РЕШЕНИЕ –
ЗА СРЫВЫ ПЛАНА, ВЫПУСК БРАКА ЗАВТРА РАБОТНИКАМИ
АППАРАТА НКВД, В ЦЕЛЯХ БОРЬБЫ С ВРАГАМИ НАРОДА, БУДЕТ
ПОВЕШАН КАЖДЫЙ ДЕСЯТЫЙ! ЭТО ВАМ НЕ В США ИЛИ В КАКОЙ-
ТО ТАМ АНГЛИИ, ГДЕ МОЖНО ТВОРИТЬ ВСЁ ЧТО УГОДНО! ВОПРОСЫ ЕСТЬ?!
–РАЗРЕШИТЕ ЗАДАТЬ ВОПРОС, ВЕРЕВКУ ИЗ ДОМА ПРИНЕСТИ ИЛИ КАК...?
–НА ВЫДЕЛЕННЫЕ ПРОФСОЮЗОМ ДЕНЬГИ КУПЛЕНО 1000 М ВЕРЕВКИ,
КОТОРАЯ ЗАВТРА БУДЕТ. РОЗДАНА ВСЕМ ПАРТЯЧЕЙКАМ ЦЕХОВ ЗАВОДА...

Sheeplike meekness and the complete lack of opposition toward the cult* [of personality].

'Following orders from above, your local Party Committee has issued a command to hang every tenth person for not meeting the quota and producing low-quality goods. Tomorrow, NKVD officers will execute the order as part of the effort to eliminate enemies of the people. What do you think this is, the USA or England, where people can do whatever they want? Any questions?'

'Excuse me, should we bring our own rope?'

'With the funds allotted by the Labour Union, we have purchased 1,000 metres of rope, which will be distributed among all the party cells† of the plant tomorrow.'

* During his time as Soviet leader Joseph Stalin (1878–1953) created a cult of personality around himself. He rewrote Soviet history books, enlarging his role in the 1917 October Revolution. Cities, towns and villages were named after him, and he received fantastical accolades such as, 'Brilliant Genius of Humanity', 'Gardener of Human Happiness', 'the Mountain Eagle' and 'Best Friend of All Children'. This idealised figure of Stalin was developed and nurtured through propaganda, according him a charisma that went beyond his political role, mesmerising Soviet citizens who were fortunate enough to meet him. 'He [Stalin] helped create on the foundation of Marxism something akin to religion, but with a God, and the almighty, all-knowing, and dangerous God of the new religion was proclaimed to be Stalin himself.' Roy Medvedev, *Let History Judge: The Origins and Consequences of Stalinism*, 1988. Only with Nikita Khrushchev's 'secret speech' of 1956 was the spell effectively ended when he stated that it was contrary to the spirit of Marxism-Leninism to elevate a single person 'into a superhuman possessing supernatural characteristics akin to those of a god.'

† This was the lowest level of the organisational hierarchy of the Communist Party in the USSR, created in any organisation where there were at least three communists.

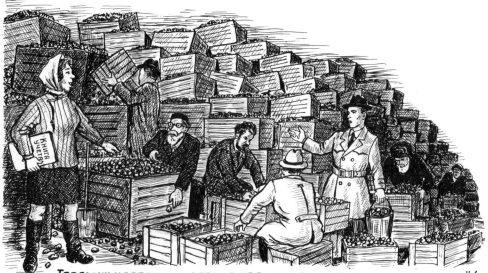

"Академия Наук на овощной базе, как в былые времена проклятой историей царской России..."

– Товарищ кладовщик, здесь в больших ящиках почти одно гнильё!
– Вот потому вас из Академии Наук и пригнали сюда на недельку. Все вы эту картошку любите жрать так что шевелитесь, да побыстре и делайте норму! А ты, дед в шапочке, что смотришь как баран? Тебе бы на печке лежать, спину греть, а не переться на овощебазу!...

The Academy of Sciences at a vegetable storage facility*, as during the long-gone days of the cursed history of czarist Russia.

'Comrade storekeeper, it's mostly rotten goods in these large crates.'
'That's why they sent you over here for a week from the Academy of Sciences. You all love eating potatoes, so move it, and on the double. You've got a quota to meet. You, old man in a hat! Quit staring at it like a sheep! You should have stayed home, warming your bones on the stove, instead of coming down here to the facility!'

* Fruit and vegetable storage facilities were specialised long-term storage houses built close to large cities. During the period of planned economy, these storage facilities were a part of the government-run supply programme. In the autumn, when harvesting began, storage facilities required plenty of extra hands. Socialism addressed this problem of workforce shortages by ordering urban workers, as well as employees of educational and scientific institutions, to labour at such storage facilities.

„Догнать и перегнать Америку по молоку, маслу и мясу"

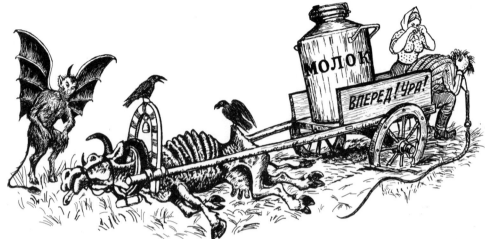

Рисунок Нихухрымухрыниксы

Text at the top reads: **'To catch up and overtake America in the production of milk, butter, and meat*'**. Text on the churn reads: **'Milk'**. Text on the cart reads: **'Forward! Hoorah!'**. Text underneath reads: **'Drawing by the Nikhukhrymukhryniksy[†]'**.

* 'To catch up and overtake America' was a promise made by Nikita Khrushchev, taken from his famous speech of 22 May 1957. This declaration meant the USSR had to triple the amount of meat produced within a three-year period. Following disappointing results during the first year, Khrushchev issued a circular to regional party committees urging 'decisive action' to remedy the situation. A few regions managed to meet these demands, but only at considerable cost: the slaughter of complete bovine herds, as well as dairy stock; confiscating privately owned cattle; channeling agriculture funds to buy in cattle from other areas. The enforcement of such methods enabled a small number of regions to increase production. The region of Ryazan for example, announced a total meat production of 150,000 tons for the year 1959. However, due to the drastic measures undertaken, in 1960 this collapsed to 30,000 – the level of production was simply unsustainable. This agricultural failure was a contributing factor in Khrushchev's eventual removal from power in 1964.

[†] A portmanteau of *ne khukhry-mukhry* ('not to be sniffed at'), and the Kukryniksy – three satirical cartoonists who signed their work collectively under this name. Their political drawings in the magazine *Krokodil* became famous across the USSR during the 1930s.

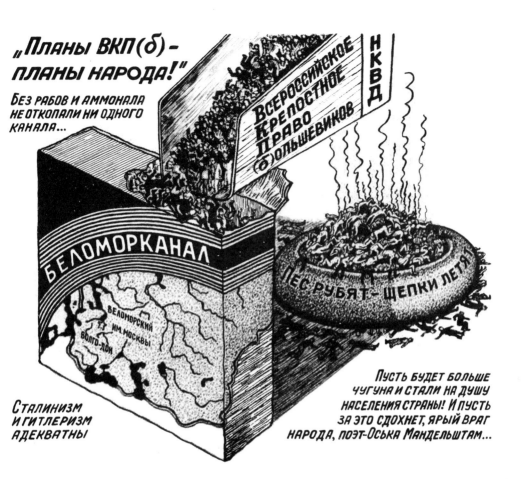

Text top left reads: **'The plans of the VKPb are the people's plans!'**. Text below reads: **'Without slaves and ammonal* they couldn't dig a single canal…'**. Text on the chute reads: **'The All-Russia Serfdom Right of Bolsheviks[†]**'. Text on the cigarette packet reads: **'Belomorkanal[‡]'**. Text on the ashtray reads: **'You can't make an omelette without breaking eggs'**. Text under the cigarette packet reads: **'Stalinism and Hitlerism are equivalent'**. Text under the ashtray reads: **'Let there be more cast iron and steel per capita! And may the vehement enemy of the people, poet Osip Mandelstam[§] die for it!'**.

* A type of explosive.

[†] A play on 'VKPb', which originally stands for the 'All-Union Communist Party (of) Bolsheviks', an early name of the Communist Party.

[‡] Belomorkanal cigarettes were released to celebrate the White Sea–Baltic Canal in 1932 (the canal opened in 1933). The cigarettes are a traditional Russian design known as a *papriosa*: one third tobacco and the rest hollow cardboard tube.

[§] Osip Mandelstam (1891–1938) was a Russian poet, one of the leading lights of the Acmeist movement. His collection *Stone* (1912) was regarded as their greatest work. He did little to hide his anti-establishment views, and following a reading of the critical poem *Stalin Epigram* (1933), he was arrested and sentenced to exile. Despite his writing of a number of poems that seemed to glorify Stalin, in 1937 he was accused of possessing anti-Soviet views. In 1938 he was arrested and sentenced to five years for counter-revolutionary activities. He was sent to a camp in Russia's Far East, where his cause of death was recorded as 'unspecified illness'. It wasn't until 1987, under the Gorbachev administration, that he was fully exonerated from all charges and completely rehabilitated.

A capitalist and exploiter – the enemy of the working class – teaches us how to work...*

'And the price has to be reduced (this is very important) because of the manufacturing economies that have come about and not because the falling demand by the public indicates that it is not satisfied with the price. The public should always be wondering how it is possible to give so much for the money.'

'It is not good management to take profits out of the workers or the buyers; make management produce the profits. Don't cheapen the product; don't cheapen the wage; don't overcharge the public. Put brains into the method, and more brains, and still more brains...†'

Henry Ford, *My Life and Work*

* In 1930 unemployment was officially abolished in the USSR following the closure of the last labour exchange. The state undertook the task of providing work for every citizen. During the final year of the Soviet Union the saying 'They pretend to pay us, we pretend to work' cynically demonstrated how the system had failed: workers had little incentive, they were paid low wages and their access to privileges was determined by their position in the official hierarchy. Petty theft was acknowledged and often ignored by the authorities as a method of supplementing wages. All products carried production dates and consumers would favour those produced earlier in the month rather than later, when workers scrambled to meet their quota and quality deteriorated.

† In the Soviet planned economy all production, farming and manufacture was owned and regulated by the state. A series of five-year plans was established (the first was drawn up by GOSPLAN – the state planning organisation – in 1928) to turn the country into an industrial powerhouse which would rival its capitalist competitors. Mechanisms were put in place to allow comment from the management as well as the ordinary worker in the formation of the Plans, but the reality of the political situation meant that almost all comment was positive. As a result the Plans were often based on faulty information. This in turn led to reported levels of production being falsified, resulting in both over and under production. To compensate a barter system developed between some factories, materials and parts were exchanged without the knowledge of the authorities and without appearing on the Plan. 'The second economy engulfed a significant fraction of the GDP. Not only individuals but state enterprises as well engaged in these practices, often out of necessity, when extra-legal influence or illegal operations appeared to be the only way to fulfil the demands of the plan. Claims of plan fulfilment that were passed up the hierarchy became as impossible to believe as the targets in the next plan.' Robert V. Daniels, *The End of Communist Revolution*, 1993.

Враг трудящихся-капиталист и эксплуататор учит как работать...

„Нужно помнить и принять за правило, что цена изделия должна уменьшаться в связи с уменьшением издержек производства, а не из-за того, что публика перестала покупать, находя цену дорогой. С другой стороны, нужно добиваться, чтобы покупатель постоянно удивлялся, как можно за такую низкую цену давать столь высокое качество."

„Когда прибыль выжимается из рабочих или покупателей, это свидетельствует о дурном ведении дела. Её должно дать более искусное руководство. Берегитесь ухудшать продукт, берегитесь понижать заработную плату и обирать публику. Побольше мозга в вашем рабочем методе — мозга и еще раз мозга!"

Генри Форд-
„Моя жизнь, мои достижения."

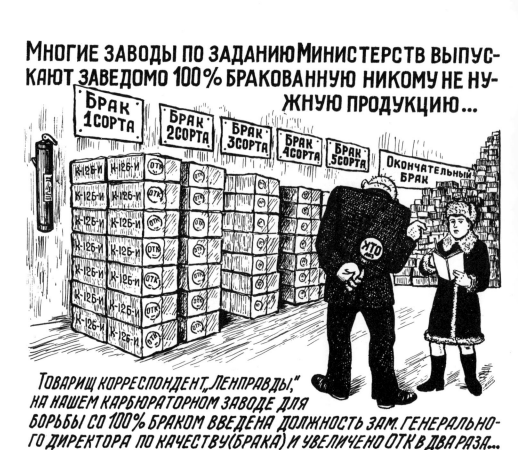

Text across the top reads: **'Following direct orders from the Ministries, many plants manufacture products that nobody needs and are known to be 100% defective...'** Text across the stacked boxes reads (left to right): **'Class 1 defective products'**, **'Class 2 defective products'**, **'Class 3 defective products'**, **'Class 4 defective products'**, **'Class 5 defective products'**, **'Completely defective products'**. The label on the boxes reads: **'K-126-I*'**, the stamp on the boxes reads: **'QC Passed†'**. The stamp in the man's hand reads: **'QC Passed'**, underneath in smaller letters: **'LKZ'** [abbreviation for *Leningradsky Karburatorny Zavod*: Leningrad Carburetor Plant].

'Comrade reporter for *Lenpravda‡*, in order to eliminate the 100% output of defective goods, our carburetor plant has introduced the position of Vice Director on the Quality of Defective Goods. In addition, the Quality Control Department is now twice the size it used to be...'

* The K-126-I was a make of a carburetor produced in the Soviet Union.
† OTK stands for *Otdel Tekhnicheskogo Kontrolya* (Quality Control Department). The round stamp with the letters 'OTK' was equivalent to the QC Passed sticker used by some western manufacturers.
‡ *Leningradskaya pravda* or *Lenpravda* for short, was the Leningrad edition of *Pravda* newspaper, the official voice of Soviet Communism.

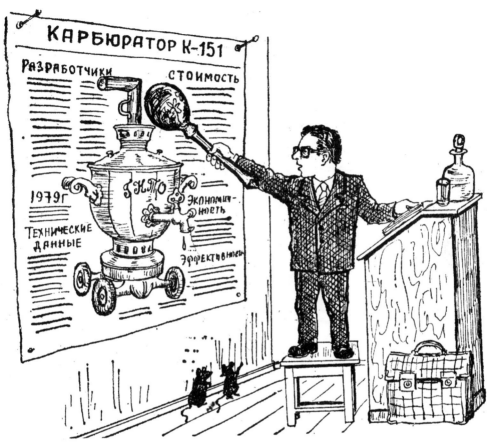

ЭТОТ НЕПРЕВЗОЙДЕННЫЙ КАРБЮРАТОР НЕ ИМЕЕТ АНАЛОГОВ В МИРОВОЙ ПРАКТИКЕ ПО СВОЕЙ ВЫСОКОЙ СТОИМОСТИ И ДЛИТЕЛЬНОСТИ СОЗДАНИЯ, ТОВАРИЩИ !...

Text on the poster reads: **'K-151 Carburetor. Designers, 1979, Cost, Specifications, Feasibility, Efficiency'.**

'This unsurpassed carburetor has no match in global practice in terms of its high cost of manufacture and the long time it took to design, comrades!'

In a handwritten note underneath this drawing Baldaev states that: 'After retirement, I worked at LenKarZ [Leningrad Carburetor Plant] as Head of the Bureau for the Preservation of Social Property. In just a year and a half, due to the evidence I collected and submitted, twenty-three criminal cases were opened and eight people were jailed. In 1987, following Gorbachev's amnesty, fourteen higher executives of LenKarZ "slipped out" avoiding imprisonment, including General Director F. Timofeev. Together with members of the Komsomol [the youth division of the Communist Party] I dug up 5.5-million-roubles worth of embezzlement cases, along with the theft of 39,000 carburetors for Volga, Moskvich, and Zaporozhets automobiles. The thieves used to call me Batu Khan [a 13th-century Mongol ruler who invaded ancient Rus – Baldaev was a Buryat, a major northern subgroup of the Mongols], and they were very happy when I left. They used to say: "Batu Khan is introducing proper order in Rus again."'

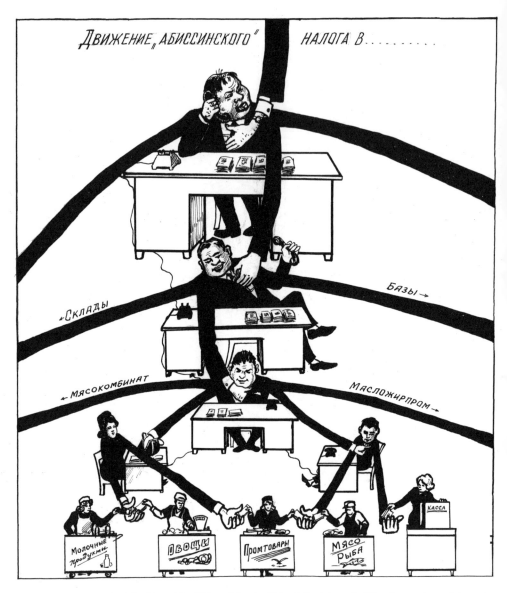

The text at the top reads: **'The flow of the "Abyssinian tax"* in...'**. Top left reads: **'Warehouses'**; top right reads: **'Storage facilities'**; middle left reads: **'Meat processing and packing'**; middle right reads: **'Butter and oil industry'**; text on the counters at the bottom read (left to right): **'Dairy products'**; **'Vegetables'**; **'Wares'**; **'Meat/Fish'**; **'Cash Register'**.

* Euphemism (commonly used in prison slang) for grafting.

The text at the top reads: **'The "Lavatory" Cooperative'**. Sign across the top left reads: **'Long Live the Multi-Party System and Democ**[racy]'; sign below this reads: **'Money does not smell! – Julius Cesar*'**; sign below this reads: **'Sanitary service fee: 15 kopecks'**; sign below this reads: **'WC supervisor L. Mokhnatkina†'**; the box sitting on the desk reads: **'Cash'**; the sign above the urinating man reads: **'Citizens, cleanliness is the guarantee of health!'**

'Are you comfortable with the fact that this is a men's restroom? Who cleans it? What kind of money do you make?'

'Oh, I'm perfectly alright with it. I have two cleaning ladies and a plumber working for me on demand. In terms of turnover, this place is no comparison to restrooms at a train station or the airport, where they make much more money. I make 40–50 roubles a day. I pay taxes, including the "Abyssinian Tax", that is protection racket money, 200 roubles a month to the boss.'

* A reference to the saying 'money does not stick', attributed to the Roman emperor Vespasian, who imposed a tax on the distribution of urine from public urinals (used in tanning and as a cleaning agent).

† A play on words: *Mokhnatka* is a reference to female pubic hair (from *mokhnaty* 'furry, hairy').

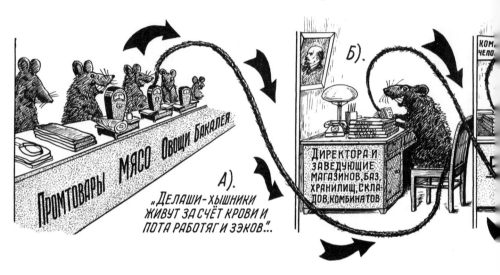

Text at the top reads: 'The collection and flow of the "Abyssinian tax*" at cushy jobs...'. Text across the counter reads: 'Wares, Meat, Vegetables, Groceries'; 'A) Go-getters live off of the sweat and blood of plodders and convicts'; 'B) Directors and managers of stores, storage facilities, warehouses, plants, and service centres'; 'C) Raion Marketing'[†]; text on the poster reads: 'Communism [is the Bright Future] of all Mankind!'; 'D) Municipal Marketing'; text on the poster reads: 'Complete the five-year plan[‡] in four years! The Party plan is the people's plan.'; 'E) Oblast Marketing, Kray Marketing, Republican Marketing'[§]; 'F) Chief Directorate for Marketing, State Agricultural Complex'.

...ГА" В ТЁПЛЫХ ДОХОДНЫХ МЕСТАХ...

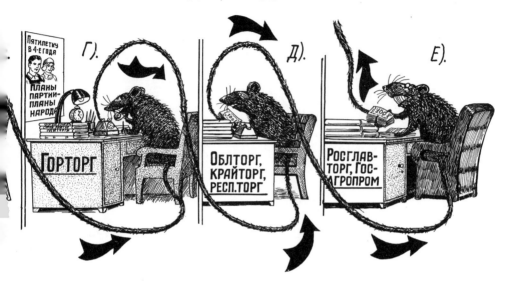

Г). Д). Е).

ПЯТИЛЕТКУ
В 4-Е ГОДА

ПЛАНЫ
ПАРТИИ-
ПЛАНЫ
НАРОДА

ГОРТОРГ

ОБЛТОРГ,
КРАЙТОРГ,
РЕСП.ТОРГ

РОСГЛАВ-
ТОРГ, ГОС-
АГРОПРОМ

* Euphemism (commonly used in prison slang) for grafting. 'A popular stagnation-era gag sums up what historians dub the Brezhnevian social contract. Six paradoxes of Mature Socialism: 1) There's no unemployment, but no one works; 2) no one works, but productivity goes up; 3) productivity goes up, but stores are empty; 4) stores are empty, but fridges are full; 5) fridges are full, but no one is satisfied; 6) no one is satisfied, but everyone votes yes.' Anya von Bremzen, *Mastering the Art of Soviet Cooking*, 2013.
† *Raion* – administrative division in the USSR and Russia.
‡ Nationwide centralised economic plans in the USSR; part of the planned economy of the Soviet Union. The 'five-year plan' was the catchphrase typically associated with bureaucracy. The first plan was initiated in 1928; the last – thirteenth – plan began in 1991 and lasted less than a year, when the Soviet Union was dissolved.
§ *Oblast*, *kray*, republic – administrative divisions in the USSR and Russia.

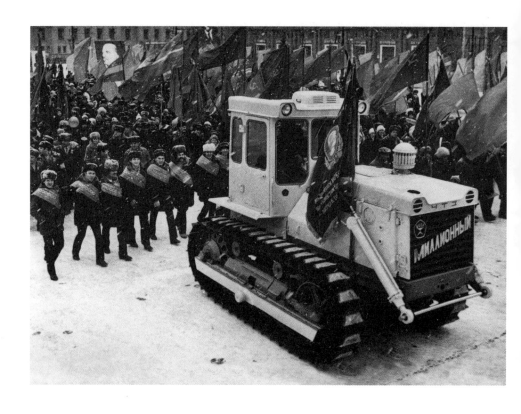

A parade at the Chelyabinsk Tractor Plant to celebrate the production of the millionth tractor. Chelyabinsk, 1984. The Tractor Plant could easily be adapted to build tanks (see footnote page 94).

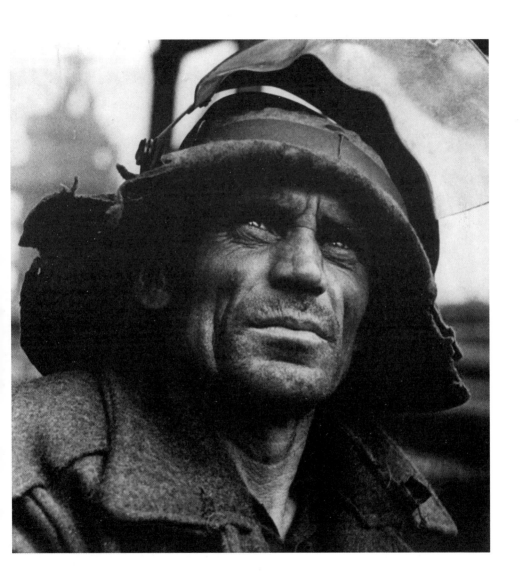

Above A blast furnace operator. Chelyabinsk, 1968.
Overleaf The daily queue to visit Lenin's Mausoleum. Moscow, 1963.

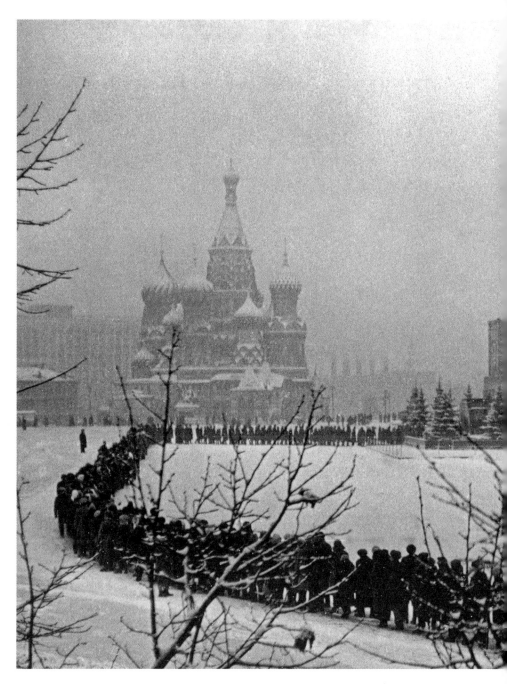

THE REALITY OF COMMUNISM IN PRACTICE

The Economy Must Be Economical!

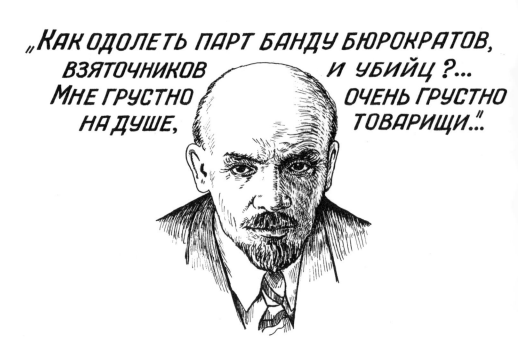

„*Как одолеть парт банду бюрократов, взяточников и убийц?... Мне грустно на душе, очень грустно товарищи...*"

„*Верх позора и безобразия: партия у власти защищает своих „мерзавцев." 18 марта 1922г. Из полного сборника собраний сочинений, том 45, стр. 53.*

Text at the top reads: '**The acme of shame and disgrace: the governing party protects its "villains".* March 18, 1922. From the Complete Works** [of Vladimir Lenin], **vol. 45, page 53**'. Text around Lenin reads: '**How do we deal with the Party gang of bureaucrats, grafters, and murderers? I am saddened, very saddened indeed, comrades...**'.

* Lenin was concerned that the Party was 'showing *indulgence* to Communist criminals' within its ranks. In this letter to the Politburo, he stated that the courts are 'obliged to punish Communists *more severely* than non-Communists.' (Source: Marxists Internet Archive.)

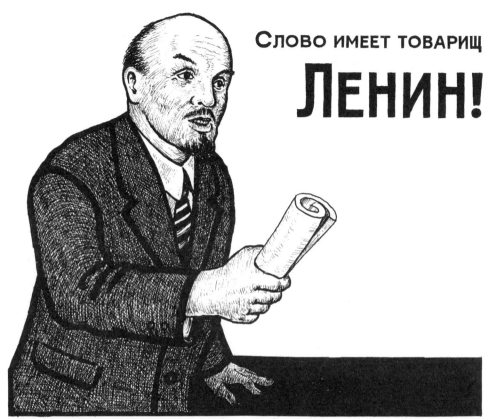

СЛОВО ИМЕЕТ ТОВАРИЩ

ЛЕНИН!

—ТОВАРИЩИ КОММУНИСТЫ, ОБРАЩАЮСЬ К ВАШЕЙ СОВЕСТИ! ВЫ ЗА 60 ЛЕТ ПОЛНОСТЬЮ ОБЮРОКРАТИЛИСЬ, УНИЧТОЖИЛИ ДЕСЯТКИ МИЛЛИОНОВ ЛУЧШИХ ГРАЖДАН, ДАЛЕКО ОТСТАЛИ ОТ КАПСТРАН В ПРОГРЕССЕ, НЕ СОЗДАЛИ БЛАГОПРИЯТНЫХ УСЛОВИЙ ЖИЗНИ ТРУДЯЩИМСЯ СТРАНЫ И НЕ РЕШИЛИ НАЦИОНАЛЬНЫЙ ВОПРОС! ЧТО ВЫ МОЖЕТЕ СКАЗАТЬ В СВОЁ ОПРАВДАНИЕ ПЕРЕД ВСЕМ МИРОМ?...

Comrade Lenin* has the floor!

'Comrade communists, I am appealing to your conscience! In just sixty years† you have become completely bureaucratised, destroyed tens of millions of the best people, lagged well behind capitalist countries in terms of industrial progress, have failed to create even passable living standards for the working class, and have not addressed the national question! How do you plead now, when the whole world is watching you?'

* 'The train is speeding to a luminous future. Lenin is at the controls. Suddenly – stop, the tracks come to an end. Lenin calls on people for additional Saturday work, tracks are laid down, and the train moves on. Now Stalin is driving it. Again the tracks end. Stalin orders half the conductors and passengers shot, and the rest he forces to lay down new tracks. The train starts again. Khrushchev replaces Stalin, and when the tracks come to an end, he orders that the ones over which the train has already passed be dismantled and laid down before the locomotive. Brezhnev takes Khrushchev's place. When the tracks end again, Brezhnev decides to pull down the blinds and rock the cars in such a way that the passengers will think the train is still moving forward.' Yuri Borev, *The Staliniad*, 1990.
† Here Baldaev has drawn a fictional scenario imagining Lenin addressing the traitors to the Communist cause: the current Soviet government (the drawing was made during Brezhnev's time in power).

Модель

	Полит
Министр	Президиум ВС
Зам. министра	
Нач. главка	**ВЛАСТЬ**
Ген. директор	
Директор	ОТВЕ
Гл. инженер	ЗАТРАТА
Начальник цеха	И ФИЗИЧ
Мастер	Риск потери 3.
Бригадир	
Рабочий	

Text across the top of the table reads: **'A model of socialism'**. Top of pyramid text reads: **'Political Bureau of the Central Committee of the Communist Party of the Soviet Union'**. Text on the left side reads (top to bottom): **'Minister'**, **'Deputy Minister'**, **'Head of Central Authority Division'**, **'General Director'**, **'Director'**, **'Senior Engineer'**, **'Shop Superintendent'**, **'Foreman'**, **'Crew Chief'**, **'Worker'**. Text centre left reads: **'Presidium of the Supreme Council'**, underneath in bold: **'Power'**. Text in the centre reads (top to bottom): **'Personal responsibility. Expenditure of psychological and physical energy. Risk of losing health and life.'**

ЛИЗМА

КПСС	
СОВМИН	**МИНИСТР ВС**
	ЗАМ. МИНИСТРА
МАТЕРИАЛЬНЫЕ	**КОМ. ОКРУГА**
И СОЦИАЛЬНЫЕ	**КОМ. СОЕДИНЕНИЯ**
СТЬ. **БЛАГА.**	**КОМ. ПОЛКА**
СКОЙ **ЗАРПЛАТА.**	**КОМ. БАТАЛЬОНА**
ЕРГИИ. **ОТДЫХ**	**КОМ. РОТЫ**
И.Т.Д.	**КОМ. ВЗВОДА**
И ЖИЗНИ	**КОМ. ОТДЕЛЕНИЯ**
	СОЛДАТ

Text on the right side reads (top to bottom): **'Minister of the Armed Forces'**, **'Deputy Minister'**, **'Commander of Military District'**, **'Commander of Formation'**, **'Commander of Regiment'**, **'Commander of Battalion'**, **'Commander of Company'**, **'Commander of Platoon'**, **'Commander of Squad'**, **'Soldier'**.

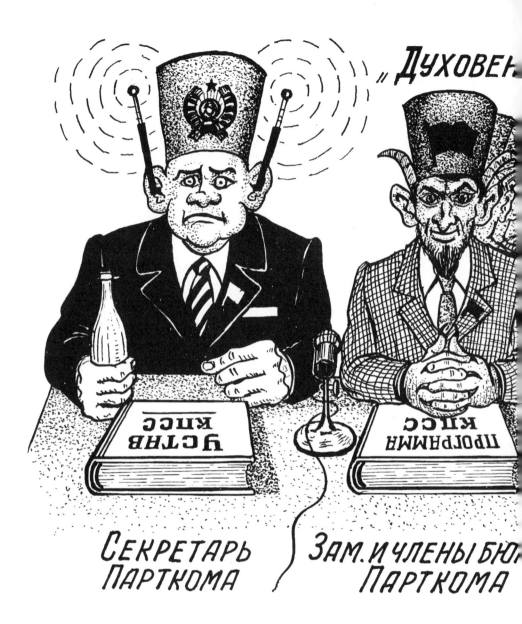

Text at the top reads: **'Clergy at work, and the common congregation*'**. The books on the desk, left to right: *The Charter of the Communist Party*, *The Programme of the Communist Party*, *Congregation Bookkeeping*, *The Food Supply Programme*. Titles underneath each character, left to right: **'Chairman of the Party Committee'**, **'Vice Chairman and members of the Party Committee Bureau'**, **'Party Group Organisers'**, **'Common congregation – lay brethren and sisters'**.

А МЕСТАХ И РЯДОВЫЕ ВЕРУЮЩИЕ "

ПАРТ-УППОРГИ

РЯДОВЫЕ ЧЛЕНЫ-ВЕРУЮЩИЕ-ПОСЛУШНИКИ

* Here Baldaev is highlighting the similarities between the hierarchical organisation of the Communist Party and that of the Russian Orthodox Church. He is also suggesting that most of the people in the pulpit are in collusion with – or are paid by – the KGB.

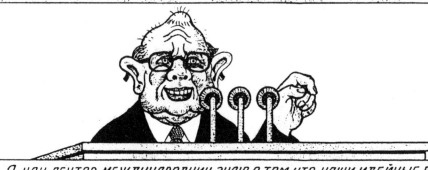

ЧЕМ ЯВЛЯЮТСЯ ДЛЯ СССР „КАБАЛЬНЫЕ" КРЕДИТЫ КАПИТАЛИСТИЧЕСКИХ СТРАН?...

Да Здравствует развитой социализм - преддверие коммунизма для Советского народа!

— Я, КАК ЛЕКТОР-МЕЖДУНАРОДНИК ЗНАЮ О ТОМ, ЧТО НАШИ ИДЕЙНЫЕ ВРАГИ НАЗЫВАЮТ НАШ ОБЩЕСТВЕННЫЙ СТРОЙ НАЦИОНАЛ-БОЛЬШЕВИЗМОМ И, ЯКОБЫ, МЫ ЯВИЛИСЬ ПРИМЕРОМ ДЛЯ НАЦИОНАЛ-СОЦИАЛИСТОВ ГИТЛЕРОВСКОЙ ГЕРМАНИИ В УНИЧТОЖЕНИИ СВОЕГО НАРОДА. ЭТО КЛЕВЕТА! НЕКОТОРЫЕ ТОВАРИЩИ ВЫСКАЗЫВАЮТ СВОЁ НЕДОУМЕНИЕ И ДАЖЕ НЕДОВОЛЬСТВО НАШИМИ КРУПНЫМИ ЗАЙМАМИ У ЗАПАДНЫХ КАПИТАЛИСТИЧЕСКИХ СТРАН, СОВЕРШЕННО НЕПОНИМАЯ ТО, ЧТО ЭТИ ЗАЙМЫ ТА ЖЕ ВЕРЁВКА, КОТОРОЙ МЫ ЗАДУШИМ ЗАГНИВАЮЩИЙ КАПИТАЛИЗМ, МОДЕРНИЗИРОВАВ ПРОМЫШЛЕННОСТЬ, ПОДНЯВ СЕЛЬСКОЕ ХОЗЯЙСТВО, ПЕРЕВООРУЖИВ И УКРЕПИВ ВООРУЖЕННЫЕ СИЛЫ!...

Text at the top reads: **'What are "cabal*" credits from capitalist countries for the Soviet Union?'** Text inside the box reads: **'Long live developed socialism, the forerunner of communism for Soviet people!'**

'As a public speaker specialising in covering international affairs I know that our ideological enemies call our socialist system "national Bolshevism". They allege that we set an example for national socialists in Nazi Germany in how we exterminated our people. Well, that is blatant slander! Some express puzzlement, even resentment, over the large-scale loans we take from Western capitalist countries. They fail to understand, however, that these loans are what we are going to use to strangulate rotting capitalism, by modernising our industry, improving our agriculture, and reequipping and strengthening our armed forces.'

* 'The Communist regimes [of the USSR] saw Western capital as a means of buying off public opinion at home and of delaying the introduction of much needed changes. They used the foreign credits not on new investment in technology or diversifying their industrial base, but on food and consumer goods, which they could pass on to their own people at unrealistically subsidised prices... In East Germany in the 1980s, 60% of income went towards loan repayment – a level that was impossible to maintain... Naturally they never let on to their people how heavily in hock they were to those they were describing each day in the state-owned media as the hyenas of capitalism.' Victor Sebestyen, *Revolution 1989: The Fall of the Soviet Empire*, 2009.

«ВЫСТУПЛЕНИЕ СВОЕГО ЧЕЛОВЕКА – ШТАТНОГО ПОДХАЛИМА...»

ПОМНИ ТОВАРИЩ! КАЖДЫЙ ВБИТЫЙ ГВОЗДЬ, КАЖДЫЙ УДАР МОЛОТКОМ – УДАР ПО ИМПЕРИАЛИЗМУ!

Я БЕРУ НА СЕБЯ СМЕЛОСТЬ ЗАЯВИТЬ О ТОМ, ЧТО ПОИСТИНЕ РЕДКОЕ СЧАСТЬЕ ВЫПАЛО НА НАШ КОЛЛЕКТИВ, РУКОВОДИТ КОТОРЫМ ТАКОЙ ГЕНИАЛЬНЫЙ, ТАЛАНТЛИВЫЙ, ВЫСОКО КУЛЬТУРНЫЙ ЧЕЛОВЕК, БОЛЬШОЙ ПЛАМЕННОЙ ДУШИ, ГОРЯЧЕГО СЕРДЦА, НАПРАВИВШИЙ ВСЮ СВОЮ КИПУЧУЮ ЭНЕРГИЮ НА НЕПРИМЕРИМУЮ, БЕСКОМПРОМИСНУЮ БОРЬБУ С ПРОКЛЯТЫМ ВРАГОМ ЧЕЛОВЕЧЕСТВА И МИРА ИМПЕРИАЛИЗМОМ И ОНИ В СВОИ ВОСЕМЬДЕСЯТ ЛЕТ ПОЛНЫ ТВОРЧЕСКИХ ИДЕЙ, КРЕПКИ ФИЗИЧЕСКИ, С ОГРОМНЫМ ЭНТУЗИАЗМОМ ВЕДУТ НАС ВСЕХ – К ОБЩЕЙ ЦЕЛИ НАШЕГО ОБЩЕСТВА...

РИСУНОК НИХУХРЫМУХРЫНИКСЫ.

Основными причинами возбуждающими ПОЯВЛЕНИЕ АСОЦИАЛЬНЫХ КАРИКАТУР, У УМЕЮЩИХ РИСОВАТЬ (ХУДОЖНИКОВ), ЯВЛЯЮТСЯ: НЕДОВОЛЬСТВО ВЛАСТЯМИ ОТОШЕДШИМИ ОТ ЛЕНИНИЗМА, ВОЗРОСШЕЙ БЮРОКРАТИЕЙ, РЕЖИМОМ СОДЕРЖАНИЯ, СУРОВОСТЬЮ НАКАЗАНИЯ, НЕУСТРОЕННОСТЬЮ ПОСЛЕ ОСВОБОЖДЕНИЯ ИЗ МЕСТ ЛИШЕНИЯ СВОБОДЫ, УСТАНОВКОЙ НА ЦЕННОСТНУЮ ОРИЕНТАЦИЮ, НРАВСТВЕННЫЕ НОРМЫ, ВЗГЛЯДЫ, САМОУТВЕРЖДЕНИЕ МАТЕРИАЛЬНОЙ БАЗЫ И Т. Д.

Text across the top reads: **'Our man – the staff bootlicker – takes the stage…'** Text in the sign underneath reads: **'Remember, comrade! Each nail driven in, each blow of the hammer, is a blow delivered to imperialism!**

'I am taking the liberty to claim that it is a rare joy for our collective to be under the supervision of such an ingenious, talented, and highly cultured man! He is a man of a large, fiery soul and the kindest of hearts, who has channeled all of his unceasing energy toward an uncompromising struggle against the cursed enemy of the entire world – imperialism. In his eighty years of age, he is full of creative ideas, in great physical health, and has enough enthusiasm to lead us all toward the common goal of our society…' Drawing by the Nikhukhrymukhryniksy.* The main reasons for the emergence of asocial caricatures by people with some artistic inclinations (artists) are: disillusionment with the powers that be who have strayed from the principles of Leninism, increased bureaucracy, prison conditions, harsh sentences, disorientation after release from prison, and their own inability to adapt to a system of values, moral perspectives, and views, and to provide themselves with material sustenance, etc.

* See footnote on page 68.

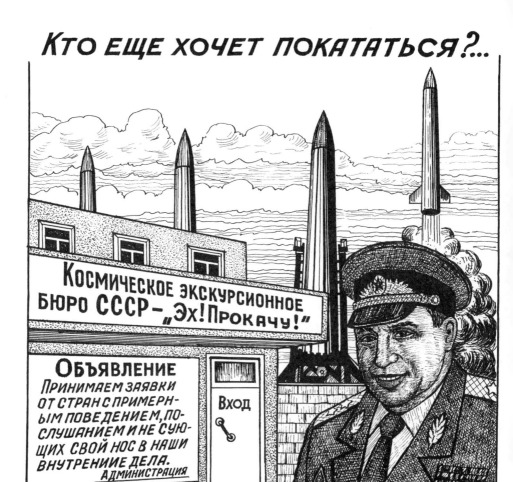

Text at the top reads: **'Who else wants to take a ride?'** The sign above the door reads: **'The C'mon, Take a Ride! USSR Space Travel Agency'**. The sign to the left of the door reads: **'Notice: We accept requests from countries that have demonstrated exemplary behaviour, obedience, and who do not stick their noses in our internal affairs. Signed: The Administration'**. The text on the door reads: **'Entrance'**.

'We have already taken a Bulgarian, Cuban, Mongolian, Syrian, French, and others for a ride around the planet. A single trip costs us around 10–12 million roubles, which isn't such a big deal.

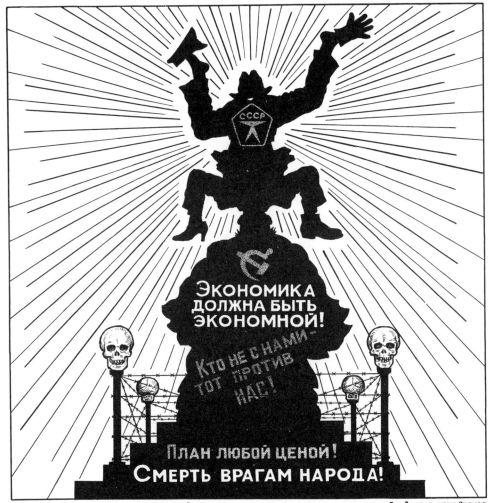

Рукотворный памятник „Всё с ног на голову"-в честь идола тупости, глупости и бюрократии Его Сиятельства Абсурд

At the top of the silhouette is the State Quality Mark of the USSR*. The texts on the monument read (from top to bottom): '**The economy must be economical!**[†]', '**Those who are not with us are against us!**', '**Complete the Plan at any cost!**[‡]', '**Death to the enemies of the people!?**'.

'Topsy-Turvy', a man-made monument to the idol of idiocy, stupidity, and bureaucracy of His Highness the Absurd.

* The State Quality Mark of the USSR was an official quality certification mark established in the USSR in 1967.
[†] Brezhnev used the phrase 'the economy must be economical' in his speech at the 26th Congress of the Communist Party of the Soviet Union in 1981. It has become a popular way of mocking the Soviet regime.
[‡] Nationwide centralised economic plans in the USSR; part of the planned economy of the Soviet Union. The 'five-year plan' catchphrase was typically associated with bureaucracy. The first plan was initiated in 1928 and the last in 1991, the year the Soviet Union was dissolved.

Text at the top reads: **'Ilich's 70th Anniversary...*'**. Left of portrait, top: **'The economy must be economical!†** **– Leonid Brezhnev'**; left of portrait, bottom: **'*The Scent of Ilich* family set of perfume and eau de cologne'**; sign top right of portrait reads: **'Food by the gramme!‡'**; sign under this reads: **'Our Ilich's favourite flowers'**; sign across the bookshelf reads: **'Ilich's capital works'**; text on the headboard reads: **'Sleep more and you will live longer!'**; text on the footboard reads: **'*The Ilich with Us* triple bed§'**.

'Here, comrades, take a look! To commemorate the biggest day ever for the country – the 70th anniversary of General Secretary of the Central Committee of the Communist Party of the Soviet Union, comrade Leonid Ilich Brezhnev – our industry has manufactured a broad range of mass-market products. They've all been approved with the honourable High Quality Mark∥.'

* It is customary in Russia to use patronymics as a form of endearment. Both Brezhnev and Lenin had the same patronymic – Ilich – which could sometimes lead to confusion, a fact that was often used in jokes and puns. This drawing plays on this.

† The phrase 'the economy must be economical' was used by Brezhnev in the speech he delivered at the 26th Congress of the Communist Party of the Soviet Union in 1981. The phrase has since become a popular way of mocking the Soviet regime.

‡ The 1982 Food Programme (*Prodovolstvennaya programma*) was colloquially referred to as *prodovolstvie po grammu* ('[distribute] food one gramme [at a time]').

§ Throughout the Soviet period consumer goods were always in short supply. During the 1970s and 1980s factories making industrial products (such as tractors, cars or electrical items), were required to have a military application too, so that they could be quickly switched to weapons production. This obligation completely distorted Soviet industry. 'The Soviet model was rigid. It was directed for political rather than economic ends, according to a centrally calculated Plan that bore no relation to the market. Prices and wages quickly turned out to be unrealistic, but no matter. They couldn't be changed because they were in the Plan, approved by the bureaucrats in the Party. It led to absurdities big and small. For example, there were no hairpins made in [Soviet] Poland throughout most of the 1970s. The Plan of course had been produced by men and no mention in it anywhere was made of hairpins, so there were none produced.' Victor Sebestyen, *Revolution 1989: The Fall of the Soviet Empire*, 2009.

∥ The official USSR state quality certification mark, established in 1967. It could be displayed on the packaging, the goods, or both.

В ЧЕСТЬ 70-ЛЕТИЯ ИЛЬИЧА...

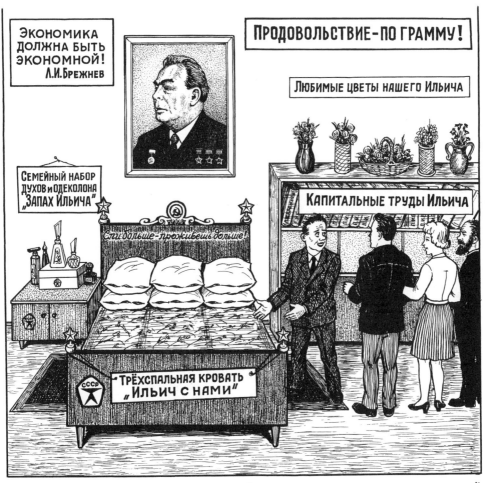

-*Прошу, товарищи, посмотреть! Вот ко дню знаменательной даты для всей нашей великой страны — 70-летию рождения Генерального секретаря Центрального Комитета КПСС лично товарища Леонида Ильича Брежнева промышленность выпустила большую серию товаров широкого потребления и все они удостоены высокого признания — „Знаком Качества..."*

ВРЕМЕНА ПРАВЛЕНИЯ Л.И. БРЕЖНЕВА БЫЛИ ГОДАМИ КАЗНОКРАДСТВА И СЛОВОБЛУДИЯ...

ВО ДВОРЕ ЗЛАЯ СОБАКА!

– ХОРОШО БЫЛО ПРИ ЛЕОНИДЕ ИЛЬИЧЕ, ВОТ УСПЕЛ ДАЧКУ СЕБЕ ПОСТРОИТЬ! БЫЛ СЕКРЕТАРЁМ ПАРТКОМА, ПОСЛЕ ДИРЕКТОРОМ И МНОГО-ЛИ НА ЭТОЙ ДОЛЖНОСТИ ВОЗМЕШЬ? ЕСЛИ БЫ В ТО ВРЕМЯ РАБОТАТЬ В ГЛАВКЕ ИЛИ В МИНИСТЕРСТВЕ, ТАМ УЖ ХАПАЛИ СКОЛЬКО ДУША ПОЖЕЛАЕТ, НА ИХ ВНУКОВ И ПРА-ПРА ВНУКОВ ХВАТИТ С ЛИХВОЙ! СЕЙЧАС Я НА ПЕНСИИ, БЫЛИ ВСЯКИЕ АМНИСТИИ, ОДНИМ СЛОВОМ ПРОНЕСЛО... ПОНЯТНО ?... ТЫ-ТО, БРАТ, УСПЕЛ ЗА ЭТО ВРЕМЯ ЧТО-НИБУДЬ УРВАТЬ ДЛЯ СЕБЯ ?...

Text at the top reads: **'Leonid Brezhnev's time in power was the time of embezzlement of national property and mere verbiage...'** The sign on the fence reads: **'Beware of the dog!'**

'Wasn't it great during Leonid Ilich*? I managed to build me a dacha right here. I was a Party Committee secretary then a director, but you couldn't grab so much as a director. If only I'd worked at a central authority of the Ministry... That's where they stole as much as they could! Enough for their grandchildren and great-grandchildren. Now I'm retired. I managed to fall under all sorts of amnesties and suchlike. Got lucky, in other words, see? How about you? Did you manage to grab a piece of the pie in those times?'

* The man refers to Brezhnev's time in power (1964–1982). During this period unbridled corruption prevailed, even at the highest levels. No enterprise was too far-fetched if it helped to oil the Party wheels. 'When Communist Party chiefs in Russia went fishing, scuba divers plunged underwater and put fish on the hooks. When they went hunting, specially bred elk, stag, and deer were made to saunter across the field in point-blank range. Everyone had a wonderful time. When the king of Afghanistan visited the Tajik resort of Tiger Gorge, he blew away the last Turan tiger in the country.' David Remnick, *Lenin's Tomb: Last Days of the Soviet Empire*, 1994.

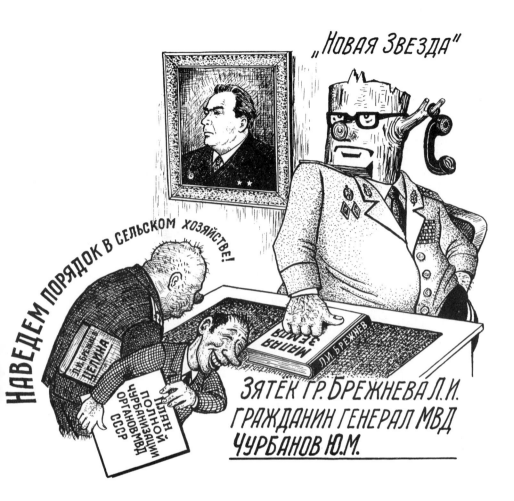

Text at the top reads: **'A New Star'**. The book on the desk is: *Minor Land* by **L.I. Brezhnev***. Text over the bowing figure on the left reads: **'We will make things right in agriculture and farming!'** The book under his arm is *Virgin Lands** by **L.I. Brezhnev**. The file held by the bowing figure on the right reads: **'The General Plan for the Complete Dumbification of the Agencies of the Ministry of Internal Affairs of the USSR'**.

Yuri Churbanov‡, Comrade General of the Ministry of Internal Affairs. Brezhnev's son-in-law.

* The Small (or Minor) Land was the name of a Soviet outpost during WWII, which was recaptured by the Soviet army after a 225-day-long battle. In the 1970s, Leonid Brezhnev, who had fought in that region, published a memoir consisting of three books: *The Minor Land*, *Rebirth*, *Virgin Lands*.

† This is a play on words: Churbanov (Brezhnev's son-in-law's last name), comes from the word *churban*, meaning both 'block of wood' and 'blockhead'.

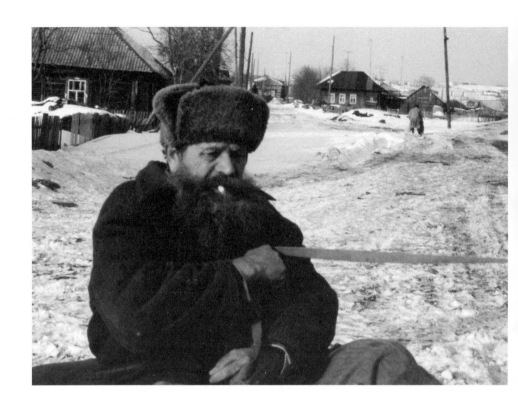

Above A man drives his cart across the main road of a village. Chelyabinsk region, 1978.
Right One of the first buildings in a new housing development on the outskirts of Chelyabinsk, 1979.

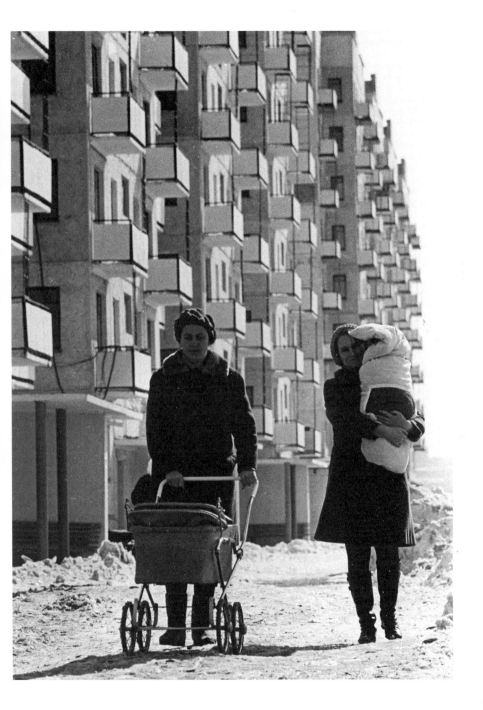

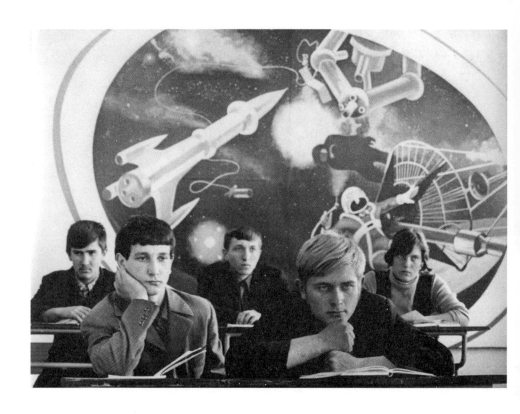

The first graduating class of the Cosmonaut Training School. Chelyabinsk, 1967.

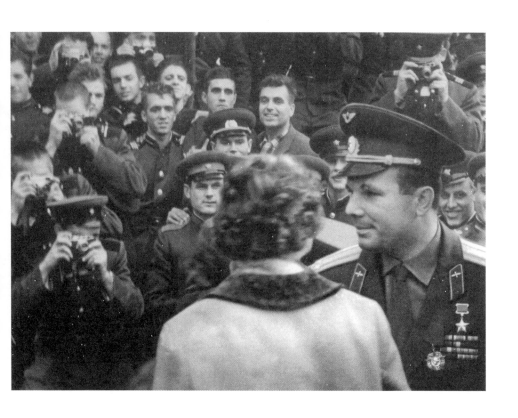

Soldiers from a Soviet military base welcome Yuri Gagarin, the first man in space. East Germany, 1963.

THE SITUATION WITH MINORITIES IN THE USSR

Citizens of the Soviet Empire

В СССР ВПЕРВЫЕ ЗА ВСЮ ИСТОРИЮ ВСЕГО ЧЕЛОВЕЧЕСТВА БЫЛИ ПРОВЕДЕНЫ В КРУПНЕЙШИХ МАСШТАБАХ ЖЕСТОЧАЙШИЕ, САМЫЕ БЕСЧЕЛОВЕЧНЫЕ, ЛИШЕННЫЕ ЭЛЕМЕНТАРНОГО ЗДРАВОГО СМЫСЛА АПАРТЕИД И ГЕНОЦИД С 1935 Г. ПО 1947 Г. КОГДА ЦЕЛИКОМ НАРОДЫ ИЛИ ЕГО ЧАСТЬ ОТ ГРУДНЫХ ДЕТЕЙ ДО ГЛУБОКИХ СТАРЦЕВ ОБВИНЯЛИСЬ В ПРЕДАТЕЛЬСТВЕ, ШПИОНАЖЕ И ВО ВСЕХ ТЯЖКИХ ЗЕМНЫХ И НЕБЕСНЫХ ГРЕХАХ. НАЧАЛУ АПАРТЕИДА И ГЕНОЦИДА В СССР ДАЛ ЯРЫЙ СИОНИСТ КАГАНОВИЧ. НАПРИМЕР БЫЛИ ВЫСЕЛЕНЫ СО СВОИХ РОДНЫХ ИСКОННЫХ ЗЕМЕЛЬ:

1. КОРЕЙЦЫ – 1935-36 Г.Г. В СРЕДНЮЮ АЗИЮ.	10. ЭСТОНЦЫ	
2. КИТАЙЦЫ – 1937 Г. ЧАСТЬ ИСТРЕБЛЕНА	11. ЛАТЫШИ	ТОЛЬКО
3. ЧЕЧЕНЫ	12. ЛИТОВЦЫ	ЧАСТЬ
4. ИНГУШИ	13. ФИНЫ	НАСЕЛЕНИЯ
5. БАЛКАРЦЫ	14. ПОЛЯКИ	ВО ВРЕМЯ
6. КАЛМЫКИ 1944 Г.	15. ГУЦУЛЫ	ЗАХВАТА
7. НЕМЦЫ ПОВОЛЖЬЯ	16. ВЕНГРЫ	ТЕРРИТОРИЙ
8. ГРЕКИ – ЭЛЛИНЫ	17. РУМЫНЫ	В 1939 Г. И
9. ТАТАРЫ-КРЫМСКИЕ	18. БОЛГАРЫ	1946 Г.

НАРОДЫ РЕАБИЛИТИРОВАННЫЕ Т. М. С. ХРУЩЕВЫМ ВЕРНУЛИСЬ В 50% СОСТАВЕ НА СВОИ ЗЕМЛИ ИЗ-ЗА ГИБЕЛИ ОТ КАТОРЖНЫХ УСЛОВИЙ В МЕСТАХ НАСИЛЬСТВЕННОГО ПОСЕЛЕНИЯ. КРЫМСКИЕ ТАТАРЫ И НЕМЦЫ ПОВОЛЖЬЯ РЕАБИЛИТИРОВАНЫ, НО ИХ НАКАЗАНИЕ ПРОДОЛЖАЕТСЯ...

In 1935–1947 in the **USSR**, for the first time in the history of humanity, the most cruel, inhumane, and lacking the basic common sense, apartheid and genocide took place. Peoples as a whole or in part, from newborns to the old, were accused of treason, espionage, and any other imaginable sins in heavens or on earth. This apartheid and genocide in the **USSR** was begun by the devout Zionist Kaganovich*. For example, the following people were forced out of their native lands:

1. Koreans in 1935–1936 into Middle Asia
2. Chinese, partially eradicated in 1937
3. Chechens
4. Ingush
5. Balkarians
6. Kalmucks
7. Volga Germans
8. Greeks, Hellenes
9. Crimean Tartars
10. Estonians
11. Latvians
12. Lithuanians
13. Finns
14. Poles
15. Guzuls[†]
16. Hungarians
17. Romanians
18. Bulgarians

10–18 [grouping caption]: Only part of the population during the capture of the territories in 1939 and 1946.

Only 50% of the peoples that were rehabilitated by Nikita Khrushchev returned to their lands, due to deaths resulted from hard labor in place of forced relocation[‡]. Crimean Tartars and Volga Germans have been rehabilitated, but their punishment still lingers on...

* Lazar Kaganovich, a Soviet politician and administrator, one of Stalin's main associates.

[†] An ethnic group of Western Ukrainians

[‡] In 1924, the Volga German Autonomous Soviet Social Republic was formed for the ethnic Germans living along the River Volga. After Hitler invaded the Soviet Union, Stalin, fearing that the Volga Germans might collaborate with the Hitler forces, dissolved the Volga German Republic and ordered an immediate relocation of ethnic Germans eastward to Soviet Central Asia and other remote areas.

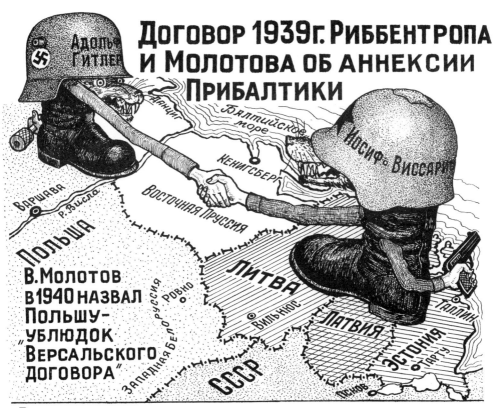

Text at the top reads: **'The 1939 Molotov-Ribbentrop Pact of the Annexation of the Baltic Countries'**. Text on the left helmet reads: **'Adolf Hitler'**, text on the right helmet reads: **'Josef Vissario** [novich Stalin]'. Text on the map reads: **'Baltic Sea'**; **'Danzig'**; **'Königsberg'**; **'East Prussia'**; **'Poland'**; **'Warsaw'**; **'River Wisła'**; **'Lithuania'**; **'Vilnius'**; **'Latvia'**; **'Estonia'**; **'Tallinn'**; **'Tartu'**; **'West Byelorussia'**; **'Rovno'**; **'USSR'**; **'Pskov'**. Text bottom left reads: **'In 1940 V. Molotov called Poland "the bastard of the Treaty of Versailles".'***

This is how deep care toward Estonians, Latvians, and Lithuanians was demonstrated, how they were admitted to the Soviet Heaven, and sent on NKVD-sponsored trips to Siberia...[†]

* The actual date of this quote is 31 September 1939. It's taken from Vyacheslav Molotov's speech to the Supreme Council about the Nazi-Soviet invasion of Poland: 'It became apparent that all that was needed was an initial attack of the German Army and, after that, the attack of the Soviet [army]; in order to leave nothing of [Poland,] this monstrous bastard of the Treaty of Versailles.'
[†] Meaning large numbers of these populations were sent to the Gulag camps of far-east Russia, where they were used as slave labour.

„Хищник и террорист" Рабинович

– Подсудимый, гражданин Рабинович, кроме хищений с группой лиц на овощной базе, где вы до ареста работали директором, вы убили лопатой три дойные козы и четырёх ягнят, принадлежавших вашим соседям по даче и чем вы можете объяснить суду причину столь дерзкого хулиганского поступка?
– Эта „ПРОДОВОЛЬСТВЕННАЯ ПРОГРАММА" НЕ ДАЁТ ПРАВО НА ПОДОЗРЕНИЯ И ОСКОРБЛЕНИЯ! Эти твари день и ночь бегали вокруг моей дачи, которую я построил на полученное наследство от моей бедной покойной бабушки, и кричали:
– „Бэ-Хэ-эС-эС, Ка-Гэ-Бе! Бэ-Хэ-эС-эС, Ка-Гэ-Бе!" Я не выдержал и убил их всех!
– Суду известно о том, что ваша дача оценивается в 140-145 тысяч рублей, а ваша дочь не вернулась из-за рубежа после служебной командировки от НИИ и проживает в данное время в Израиле...

'Predator and Terrorist' Mr. Rabinovich*

'Accused citizen Rabinovich, aside from the embezzlement that you have committed with a group of accomplices at the vegetable storage facility†, where you worked as director before your arrest, you used a shovel to kill three dairy goats and four lambs belonging to your neighbour at your country house. Explain to the court the reason behind such an insolent act of hooliganism?'

'The Consumer Goods Supply Programme‡ does not grant you the right to suspect and insult me! Day and night those bastards kept running around my house, which I built using the inheritance money from my poor deceased grandmother, shouting "BKhSS§, KGB! BKhSS, KGB!" I couldn't take it any longer, so I killed them all!'

'The court has become aware of the fact that your country house is estimated to be worth 140,000–145,000 roubles‖, and that your daughter has not come back from a business trip abroad, where she was sent by the research institute where she is employed. She currently resides in Israel.'

* A stereotypical Jewish surname.

† See footnote on page 67.

‡ The Consumer Goods Supply Programme of the USSR was an initiative proposed at the 1982 Plenary Meeting of the Central Committee of the Communist Party. The goal of the programme was to combat the shortage of basic consumer goods (including food products).

§ BKhSS (usually OBKhSS, *Otdel po Borbe s Khishcheniyami Sotsialisticheskoy Sobstvennosti* – Department Against Misappropriation of Socialist Property): the Soviet financial police. Charged with combating speculation, they were also responsible for the regulation of economic laws aiming to prevent corruption (usually in the form of theft of Soviet property from within the state system itself).

‖ This was an enormous sum of money back in the 1980s, when the average monthly wage was around 100 roubles.

„ПАРТИЙНО-ХОЗЯЙСТВЕННАЯ МАФИЯ УЗБЕКИСТАНА ОБИЖАЕТСЯ НА СВОИХ МОСКОВСКИХ ПОКРОВИТЕЛЕЙ-ВЗЯТОЧНИКОВ, УШЕДШИХ ОТ ОТВЕТСТВЕННОСТИ"...

– САЛЯМ АЛЕЙКУМ, ПАРТИЙНЫЕ ЯЛДАШИ ЗА ЧТО ПОВЯЗАНЫ?...
– АЛЕЙКУМ САЛЯМ, ГЕНЕРАЛЬНАЯ ПРОКУРАТУРА СССР ОБВИНИЛА НАС В ХИЩЕНИИ НА 4-Е МИЛЛИАРДА РУБЛЕЙ ПРИ БРЕЖНЕВЕ, НО МЫ ЩЕДРО ДЕЛИЛИСЬ С НАШИМИ МОСКОВСКИМИ ТОВАРИЩАМИ ПО ПАРТИИ, А ПРИВЛЕКЛИ К СУДУ ТОЛЬКО НАС УЗБЕКОВ! ГДЕ ЖЕ СПРАВЕДЛИВОСТЬ?...
– МЕНЯ ТОЖЕ ШАЙТАН ПОПУТАЛ, БЕЗ КАЛЫМА НЕВЕСТУ УКРАЛ В АУЛЕ...

The Party economy mafia of Uzbekistan is offended at its corrupt Moscow politician patrons who have escaped responsibility ...

'Salam alaikum*, Party yaldashes.† What did they book you for?'

'Alaikum salam. The Prosecutor General of the USSR accused us of embezzlement to the tune of 4 billion roubles under Brezhnev. We shared our spoils fairly with our Moscow Party comrades, and yet they only took us Uzbeks to court. Where is justice in that?'

'Ah, the devil lead me astray, too. I stole the bride in the aul‡ without paying the bride price...'

* A standard greeting in many Islamic countries meaning 'Peace be with you.' The standard response is the same phrase in reverse order: Alaikum salam.

† Meaning 'Comrade' in several Turkic languages.

‡ Meaning 'village'. A type of fortified village commonly found in Central Asia.

БЫЛИ НУЖНЫ КОГДА ГРОЗИЛА СМЕРТЕЛЬНАЯ ОПАСНОСТЬ И ПОРАБОЩЕНИЕ...

– Ну, что вы все нерусские прётесь к нам в Россию как мухи на сахар, в Ленинград, Москву, нам и так здесь жидовские морды надоели! Вы своими косоглазыми образинами испоганили наши улицы, магазины, хватаете наши продукты и дифициты!

– Гражданки, я защищал Ленинград, мой брат Москву в составе Панфиловской дивизии как и тысячи других нерусских и награждены медалями, орденами и на фронт мы прибыли из Казахстана в 1941 году добровольцами и никто в то время из вас русских не обзывал нас косоглазыми образинами, а радовались помощи... Приехали мы с внуками туристическим поездом посмотреть памятные Ленинские места, исторические памятники и музеи.

– Выметайтесь поскорее, без вас воздух чище будет, чао!

– Так нельзя говорить, это антиленински! Если вас русских начнут выгонять как из Афганистана с нерусских земель, как вы нас сейчас, из Украины, Молдавии, Белоруссии, Прибалтики, Урала, Поволжья, Западной и Восточной Сибири, Алтая, Тувы, Дальнего Востока, Средней Азии, Кавказа, Карелии, а также земли Коми, то вам русским в небольшой России будет очень тесно и нечего будет кушать, поняли меня?...

They were needed when people were in mortal danger and on the brink of enslavement...

'Why do you non-Russians keep coming here to Russia like flies to a piece of sugar? You come to Leningrad and Moscow where we're already sick and tired of kikes! Your damn slit-eyed faces have contaminated our streets and stores! You gobble up our food!'

'Ladies! I defended Leningrad. My brother fought for Moscow in the Panfilov Division, just like thousands of other non-Russians. We received medals and honours. We came as volunteers from Kazakhstan in 1941, and none of you Russians called us "slit-eyed" back then. You were happy that we were helping you. Now we're here with our grandchildren as tourists to see Lenin-related sites, historical monuments, and museums.'

'The sooner you get out of here, the sooner the air clears up! Adios.'

'You can't say that! This is anti-Leninist talk! Imagine if they started kicking you Russians out of non-Russian lands – like from Afghanistan – just the way you try to drive us out. If they kicked you out of Ukraine, Moldavia, Byelorussia, the Baltics, Urals, the Volga Region, West and East Siberia, Altai, Tuva, Far East, Middle Asia, the Caucuses, Karelia, and Komi, then you Russians will find yourselves crammed into your tiny Russia, and you'll have nothing to eat. Do you understand me?'

„*СТОЛИЧНЫЙ БЮРОКРАТ-ШОВИНИСТ РАЗБУШЕВАЛСЯ...*"

— *В Узбекистане, Таджикии и Туркмении очень большая дет-*
ская смертность! Срочно нужны средства на строительство
больниц, роддомов и на медицинское оборудование...
— *Эти области наши сырьевые придатки! Пусть сами себя*
обеспечивают! Эти азиатки слишком плодливы...
— *Так рассуждать нельзя, гибнут тысячи детей!*
— *Молчать! Вон отсюда!... Благодетели, слюнтяи...*

Text at the top reads: **'A Capital chauvinistic bureaucrat is furious...'**. Cover of the folder sitting on the desk
reads: **'Operating Budget'**.

'The rates of child mortality in Uzbekistan, Tajikistan, and Turkmenistan are extremely high! It is imperative
that we increase funding for the construction of both general and maternity hospitals, and medical equipment.'
'Those regions are our economic appendages! Let them take care of themselves! Those Asian women are too
fecund...'
'You can't think in this manner! Thousands of people are dying!'
'Shut up! Get out of my sight, you milksops!'

„Положение национальных меньшинств в СССР..."

- ВОТ УЖЕ 40 ЛЕТ УСИЛЕННО ИДЕТ РУССИФИКАЦИЯ ПРИБАЛТИКИ, В ЧАСНОСТИ ЭС-ТОНИИ И ДР. КОЛОНИАЛЬНЫХ ЗЕМЕЛЬ РОССИИ. РУССКИЕ ВЕЗДЕ ПРОПАГАНДИРУЮТ СВОЮ ИСКЛЮЧИТЕЛЬНУЮ ДОБРОТУ, ВЕЛИКОДУШИЕ, ГЕРОИЗМ, ЗАБЫВ НАЦИОНАЛЬ-НЫЕ ЧЕРТЫ: ПЬЯНСТВО, ХУЛИГАНСТВО, ВОРОВСТВО, ЖЕСТОКОСТЬ, ЛЕННОСТЬ В РАБОТЕ И ИЗУИТСТВО В ПОПРАНИИ ПРАВ МАЛЫХ НАРОДОВ. ЕСЛИБЫ В РОС-СИЮ ПОСЕЛИТЬ 300 МЛН КИТАЙЦЕВ И ОНИ ПРОВОДЯ ВЕЛИКОХАНЬСКИЙ ШОВИНИЗМ ПОВЕЛИБЫ МОЩНОЕ НАСТУПЛЕНИЕ НА РУССКУЮ КУЛЬТУРУ, ЯЗЫК И ИСТОРИЮ, ОТКРЫВ ТОЛЬКО РУССКИЕ ШКОЛЫ-ИНТЕРНАТЫ ПО ОДНОЙ НА 500 ТЫС, ТО РУССКИЕ УЗНАЛИБЫ НА ДЕЛЕ, ЧТО ТАКОЕ ПОЛОЖЕНИЕ И ЧУВСТВО БЫТЬ НАЦИОНАЛЬНЫМ МЕНЬШИНСТВОМ ПОД КОНТРОЛЕМ АНТИ-НАРОДНОЙ ПАРТИИ И ПОСТОЯННЫМ НАДЗОРОМ КГБ И КИТАЙСКОЙ АРМИИ...

The situation with minorities in the USSR

For forty years the Russification of the Baltic states – especially Estonia – and other colonies of Russia has been going on with a vengeance. Everywhere they can, Russians boast about their exceptional kindness, generosity, and heroism, while neglecting to mention their other ethnic traits: alcoholism, hooliganism, theft, cruelty, laziness, and insidiousness in trampling all over the rights of minorities. If 300 million Chinese were resettled in Russia and they were to use their Great Han chauvinism, trampling over Russian culture, language, and history; and if they opened only specialised Russian schools – one per every 500,000 people; then Russians would learn what it is to be and feel like an ethnic minority under the control of an anti-people's party, with the KGB and the Chinese Red Army breathing on your neck all the time...

НИКАКИЕ ВОПРОСЫ О ТЕРРИТОРИАЛЬНЫХ ПРИТЕНЗИЯХ НАРОДОВ СССР РАЗБИРАТЬСЯ НЕ БУДУТ НИКОГДА !!!

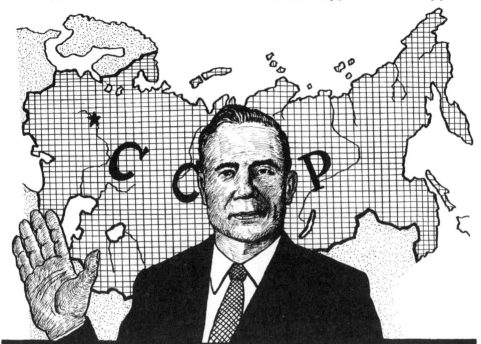

–Если армянам отдать Нагорный Карабах, то тогда и другие не русские народы потребуют вернуть им отторгнутые земли. Например: кабардинцы, балкарцы, чечены и ингуши Краснодарский и Ставропольские края, удмурты и коми Пермскую область, татары и башкиры Нижнее и Среднее Поволжье, Южный Урал и всю Западную Сибирь, алтайцы Абакан, Ново-Кузнецк, бурят-монголы весь Байкал и по половине Иркутской и Читинской областей вместе с национальными округами отобранными в 1937 г., якуты Магаданскую область и часть Хабаровского края, нивхи Сахалин, нанайцы, ульчи и гольды автономию захотят. Все остаётся как есть!...

Text at the top reads: **'No territorial claims by the peoples of the Soviet Union will ever be examined!'** Text on the map (partially covered by the man's head) reads: **'USSR'**.

'If we give Nagorno-Karabakh to Armenians, then other non-Russian ethnicities will demand that we give them back their land. For example, the Kabardins, Balkars, Chechens, and Ingush will demand the Krasnodar and Stavropol regions; the Udmurts and Komi will want the Perm Region back; the Tartars and Bashkirs the Low and Middle Povolzhie, Southern Urals, and the whole of Western Siberia; the Altais will want Abakan and Novo-Kuznetsk, the Buryat-Mongols the entire area around Lake Baikal and half of the Irkuts and Chita regions, along with their national *okrugs** that were siezed in 1937; the Yakuts will demand the Magadan Region and part of the Khabarovsk Kray, Nivkhis Sakhalin, and the Nanais, Ulchi, and Golds will also want autonomy. No, everything stays the way it is!'

* A unit of administrative division.

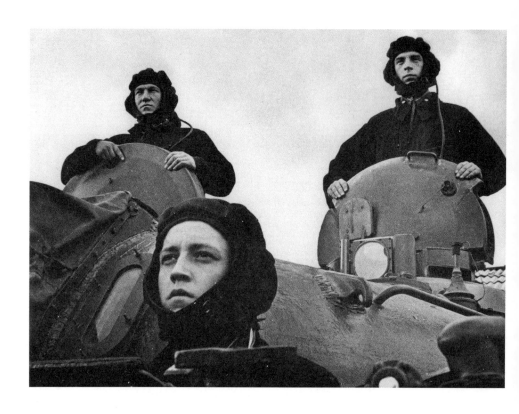

Above A vigilant tank crew are ready for action after the crushing of the anti-Soviet movement in Czechoslovakia. Prague, 1968.
Right Monument to Ivan Koncharenko (from Chelyabinsk) who was awarded the title Hero of the Soviet Union as first to break through the enemy lines on 9 May 1945. Prague, 1969.

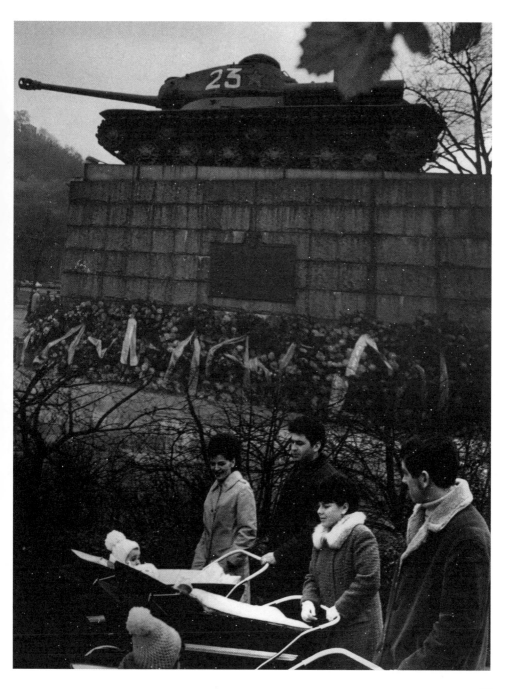

Sun bathing in March snow. Chelyabinsk, 1968.

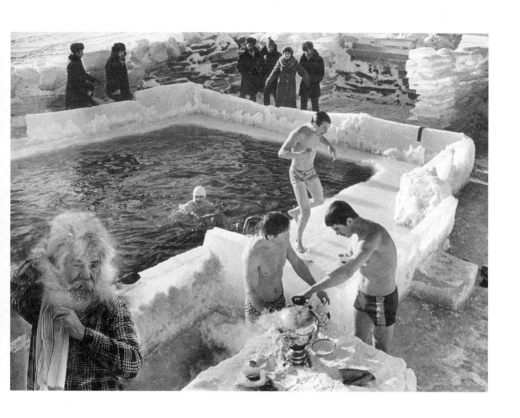

Ice-divers drink tea from a samovar after their open-air swim. Chelyabinsk, 1971.

ALCOHOLICS AND SHIRKERS

Drink to Our Soviet Government!

В отсутствии
хозяйки „свинатория."

Text on the bottle reads: **'Stenolaz C2H50H*'**.

While the head of the 'swinatorium' is not looking...[†]

* Literally 'wall climber'. This term is used to refer to various cocktails of dubious quality, or sometimes to pure undiluted alcohol (C2H50H is the formula for ethanol – pure alcohol). This bottle's shape and its label means that it's not been produced for human consumption. The illegal production of home-made *samagon* (alcohol made from beetroot, potato and fruit, or sugar and grains) increased fivefold during Gorbachev's anti-alcohol campaign, it became an important part of the underground economy and a substantial source of income for the Russian mafia.
[†] Baldaev suggests that when no one is watching the drinkers in the bar fill their glasses with pure alcohol.

Sign across the top reads: **'Comrade! Keep your workers'* honour!'**. Sign hanging over the bottle's window reads: **'For alcoholics† and shirkers'**. Sign underneath the bottle's window reads: **'Moskovskaya Special Vodka'**.

'Swim over here, buddy! There's no line to our paymaster's window.‡ It's all peaceful and quiet...'

* Factory managers were not allowed to pay their workers extra money for overtime or weekend work (which was often necessary to meet quotas): the solution was a payment made in pure alcohol (spirit). 'Pure alcohol is not sold in stores, with the possible exception of stores in the northern region of the USSR. Many factories keep stocks of pure alcohol for industrial purposes. A number of glasses of pure alcohol (a 'glass' is a unit of measurement) given to the workers in a semi-legal manner serves as a kind of payment for their work.' Aron J. Katsenelinboigen, *The Soviet Union: empire, nation, and system*, 1991.

† In May 1985 General Secretary Gorbachev introduced an anti-alcohol campaign entitled *Measures to Overcome Drunkenness and Alcoholism*. In this wide-ranging campaign prices of alcoholic drinks were raised and sales were restricted; propaganda posters informed citizens of their duty not to drink and temperance societies were established. Public reaction was negative and the black market production of alcohol flourished. Despite the success of the campaign (665,000 fewer alcohol-related deaths over the duration of the campaign), lost alcohol revenues meant that it was unsustainable – in 1988 it was discontinued.

‡ In the Soviet workplace alcoholics and shirkers fell into the same category, the former immediately spending their money on booze. Baldaev's drawing represents the alcoholic's dream of a paymaster's window being a vodka bottle. The alcoholics see their payment as booze, rather than money: they don't 'stand in the same line' as everybody else.

In the cell for intoxicated* detainees at Police Department No.36[†].

* 'The village was a sea of mud, a few heaps of garbage, an empty store, a couple of wooden houses tilting into the mud, the sort of poured-concrete barracks you'd see on the outskirts of almost any Soviet city. We saw a young woman – a beautiful woman, with a round Eskimo face – stumble drunkenly through a puddle. She sort of squinted at us and dropped to one knee. Further on, we saw a few more people, some leaning against a wall, a couple more passing a bottle back and forth and saying nothing. Half the town was smashed before breakfast. It was always this way in the morning, and by sundown hardly anyone was awake, my friend told me. They drank vodka, bathtub gin, hair tonic, eau de cologne, even bug spray. It had been that way for years.' David Remnick, *Lenin's Tomb: Last Days of the Soviet Empire,* 1994.
[†] In Leningrad.

"Золотая молодёжь" из под воротни. Васильевский Остров. Л-д.

The 'golden youth' from the alley. Vasilievsky Island. Leningrad.

The Soviet government profited greatly from the sale of alcohol: 'If consumption in 1940 was taken at 100, in 1950 it was 75 (attributable to post-war conditions), in 1960 it was 200, in 1965, 293 and then in 1970, 439... Little was published about the Soviet vodka industry and its costs, but such information that was available suggested that the state in fact received no less than 92% of the purchase price of every bottle of vodka. The income that the state received from the sale of vodka, and of other drinks, in turn accounted for about 12% of total budgetary revenue. In the 1960s and 1970s, according to another calculation, a highly regressive alcohol tax provided more than a third of all government revenues, and about a ninth of the entire state budget; taxes on alcohol matched the declared defence budget and even exceeded it in the early 1970s.' Stephen White, *Russia Goes Dry: Alcohol, State and Society*, 1996.

Пьяный, проснувшись на улице:
- Три часа ночи- и никто не подобрал. Как не внимательно работает милиция!
Я буду жаловаться

A drunk man wakes up on the street

'It's three in the morning and nobody's picked me up yet. The police should do a better job. I'm going to write a letter of complaint!'

Drunks often fell victim to extreme cold. In his book *Imperium* (1992) Ryszard Kapuściński reveals how a young Siberian girl identifies the signs of this. 'One can recognise great cold, she explains to me, by the bright shining mist that hangs in the air. When a person walks, a corridor forms in this mist. The corridor has the shape of that person's silhouette. The person passes, but the corridor remains, immobile in the mist... Sometimes one sees a corridor that is very crooked and then abruptly stops. It means that some drunk was walking, tripped and fell. In a great cold, drunks frequently freeze to death. Then such a corridor looks like a dead-end street.'

А Ванька слушает, да пьет...

-Товарищ бригадир, ваше указание выполнено! Фаустпатроны бормоты доставлены точно в срок!
-Ну, молодцы ребята! Гульнём после перерыва на обед в нашем греческом зале-подвале!
Мастера позовём...

And Vanka listened and kept drinking...*

'Comrade crew chief! Your orders have been carried out. The *Faustpatrone*† booze bottles have been delivered right on time.'
'Good job, boys! We're partying after the lunch break in the basement. We'll call the foreman, too...'‡

* A paraphrase of a line from the fable *The Cat and the Cook* by Ivan Krylov (1769–1844). The cook leaves the cat in charge of protecting food from mice. He returns to discover the cat eating the food, but instead of intervening, he yells at the cat as it finishes off all the food. The cat in the fable was named Vaska (a common name for a cat, the diminutive form of the name Vasily). Vanka above is from Ivan, another common Russian name. One of the lines in Krylov's fable runs: 'And Vaska listened and kept eating...' In addition to the name, here the verb eat has been replaced with drink (meaning 'consuming alcohol').

† A play on the similarity of the shape of the *Faustpatrone* (a German anti-tank weapon of WWII) to an upturned bottle.

‡ 'Between 75 and 90% of absences from work were attributed to alcohol. It was suggested that loss of productivity associated with alcohol was the main reason for the failure to achieve the five-year plan of the early 1980s.' Martin McKee, *Alcohol in Russia*, 1999.

Перестраховщик ...

Overcautious...*

* '"Drinking" in Russia does not mean "having a drink" or "getting pleasantly tipsy" or "passing the time of day with a glass in one's hand." It means "getting drunk": blotto, slammed, *atkluchony* ("disconnected", "totalled"). Secondly, *pokhmelye*, the Russian hangover, is not an unpleasant after-effect of drinking, but an accepted and important part of the drinking process – a half or third way stage, a significant marker.

On reaching *pokhmelye*, the dedicated drinker does not stop drinking: he merely pauses. Allowing the alcohol to settle in his bloodstream. Steadying that part of his being which is known in this country as the soul. Then he presses on. The verb *pokhmelitsa* ("to have a hangover") does not mean to resort to the Alkaseltzer. It means – and we should be quite clear about this – to reach for another drink.

If the above has already deterred the casual tippler, so much the better. Getting drunk in Russia is not for the faint of heart. It is hard work. But *staying* drunk is harder; a proper state of drunkenness has to be properly looked after, monitored, stoked and fed. All this requires dedication, perseverance, talent, professionalism.' John Nicolson, *The Other St Petersburg*, 1994.

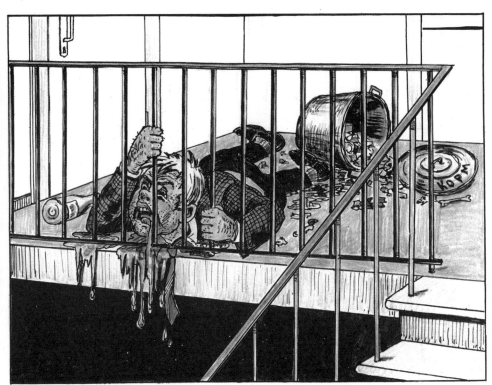

Опять посадили !!! За что?!! Прокурораа!!!...

Text on the dustbin lid reads: **'Fodder'***.

'Behind bars? Again? What for?! I demand a public prosecutor!'

* 'The whole point of vodka lies in the fact that a small jigger is swallowed quickly in one gulp (it's poured from a bottle kept in the freezer), as if one were ingesting fire, and at the same instant one takes a bite of something very hot or spicy – mushrooms, pickles, marinated pepper, salted fish, scalding borscht, hot sausages in tomato sauce, it doesn't matter what. Virtuosos don't eat but rather sniff black bread (only black!) or the sleeve of an old jacket – but it's hard to recommend the latter in a country with a well-developed system of dry cleaners: it won't have the same effect.' Tatyana Tolstaya, *Pushkin's Children: Writings on Russia and Russians*, 2003.

At the 'Soviet Bums*' restaurant

'Go ahead, ladies, drink to our Soviet government. We can't get jobs, we have nowhere to live, but they made us promise to leave town. Soon we'll end up behind bars again...†'

* 'Bums' is capitalised in the Russian text because it is an acronym: *Bez Opredelennogo Mesta Zhitelstva* (without a specific/determined/ permanent place of residence – see footnote below). A more rarely used acronym was BOMZhiZ – *Bez Opredelennogo Mesta Zhitelstva i Zanyatiy* (without a specific/determined/permanent place of residence and employment/occupation).

† This is a reference to the penal system of the USSR. Two articles of an older edition of the Criminal Code of the Russian Soviet Federative Social Republic were particularly applicable in the situation depicted in the drawing: Article 198, Breach of Internal Passport Regulations and Article 209, Loafing or Leading a Parasitic Lifestyle. All citizens were required to have a permanent or temporary registration in their area of (permanent or temporary) residence. If a citizen moved to another area, he/she had to register with a specialised registration bureau within a certain time. Failure to comply guaranteed a written warning from the police: a document requiring the citizen to leave the area within three days. Two warnings a year were permitted. A third warning resulted in imprisonment (under Article 198) for up to twelve months.

Similarly, Soviet law stated that every citizen had the right, *and was required*, to have a job. If a citizen didn't work (officially) for three months, he received a written warning from the police. Failure to find a job within thirty days after the warning was punishable by up to twelve months of imprisonment under Article 209.

Moscow and Leningrad had stricter registration rules. On release any ex-convict could reapply for the registration at the place of his former domicile, except for those imprisoned for treason (Article 64) and, paradoxically, loafing (Article 209). Even if he or she had relatives who agreed to register their 'rehabilitated' loved ones at their apartments, such requests were denied by the authorities.

Essentially, these citizens became homeless, 'bums'. They got a warning for failure to register. Then another one. Then they went to prison under Article 198. Their chances of returning to society dwindled to non-existent. In addition 'bums' were considered to be one of the lowest castes in prison, so no favours were shown to them by their 'fellow criminals' either.

В РЕСТОРАНЕ „СОВЕТСКИЙ БОМЖ..."

— ПЕЙТЕ, БАБОНЬКИ, ЗА НАШУ СОВЕТСКУЮ ВЛАСТЬ!
НА РАБОТУ НАС НЕ БЕРУТ, ЖИЛЬЯ НЕТ, НО ЗАТО ЕСТЬ
ПОДПИСКИ! СКОРО ОПЯТЬ „ПОНОВОЙ" БУДЕМ НА ЗОНЕ...

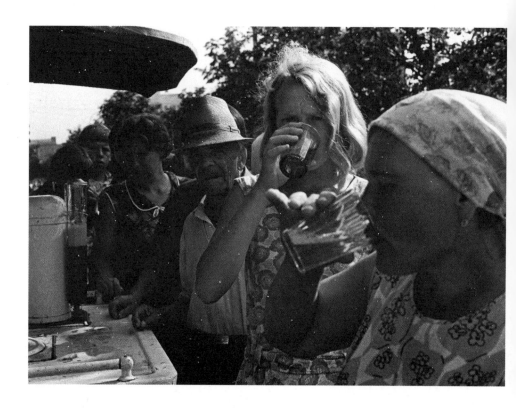

People queue to buy carbonated water sweetened with syrup from a street vendor. Chelyabinsk, 1972.

'Your average homo-sovieticus spent a third to half his nonworking time queuing for something. The *ochered* (line) served as an existential footbridge across an abyss – the one between private desire and a collective availability dictated by the whims of centralised distribution. It was at once a means of ordering socialist reality; an adrenaline-jagged blood sport; and a particular Soviet *fate*, in the words of one sociologist. Or think of the *ochered* as a metaphor for a citizen's life journey – starting on the queue at the birth registry office and ending on a waiting list for a decent funeral plot. [...] Here's what the line wasn't: a gray inert nowhere. Imagine instead an all-Soviet public square, a hurly-burly where comrades traded gossip and insults, caught up with the news left out of the newspapers, got into fist fights, or enacted comradely feats. In the thirties the NKVD had informers in queues to access public moods, hurrying the intelligence straight to Stalin's brooding desk. Lines shaped opinions and bred ad hoc communities: citizens from all walks of life *standing*, united by probably the only truly collective authentic Soviet emotions: yearning and discontent (not to forget the underlying hostility towards war veterans and pregnant women, honoured comrades allowed to get goods without a wait.' Anya von Bremzen, *Mastering the Art of Soviet Cooking*, 2013.

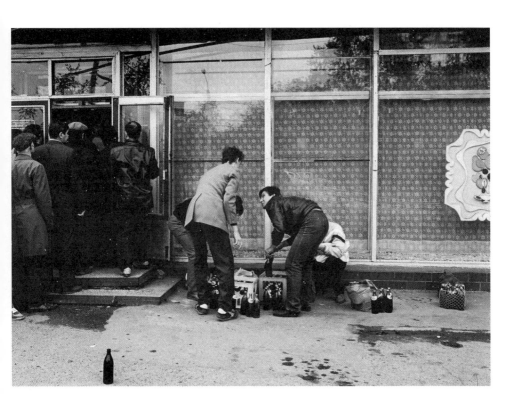

People queue to buy alcohol from an official shop during the period of restricted sales under the Gorbachev administration. Chelyabinsk, 1986.

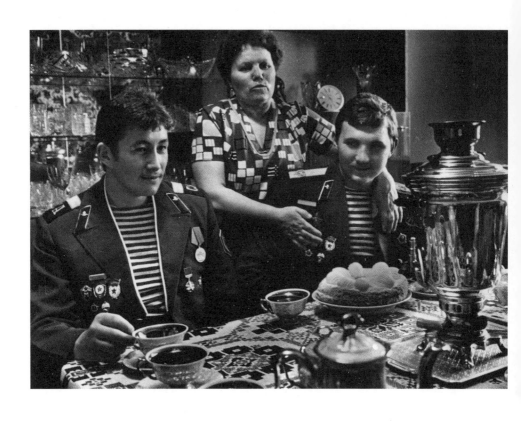

Above Soldiers return home on leave from Afghanistan. Chelyabinsk, 1982.
Right A veteran wearing an Order of Glory medal. Chelyabinsk, 1967.

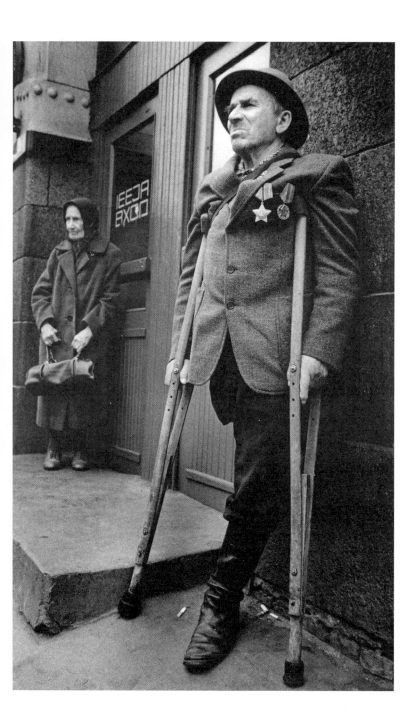

THE SHADY ENTERPRISE

The War in Afghanistan

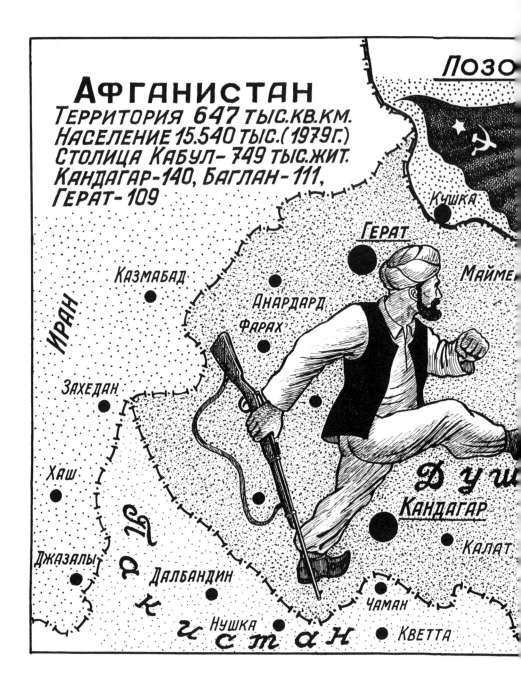

АФГАНИСТАН
ТЕРРИТОРИЯ *647* ТЫС.КВ.КМ.
НАСЕЛЕНИЕ 15.540 ТЫС. (1979г.)
СТОЛИЦА КАБУЛ – 749 ТЫС.ЖИТ.
КАНДАГАР – 140, БАГЛАН – 111,
ГЕРАТ – 109

ПОЗО

ИРАН

КАЗМАБАД

АНАРДАРД
ФАРАХ

ЗАХЕДАН

ХАШ

ДЖАЗАЛЫ

ДАЛБАНДИН

НУШКА

а к и с т а н

КУШКА

ГЕРАТ

МАЙМЕ

Д У Ш

КАНДАГАР

КАЛАТ

ЧАМАН

КВЕТТА

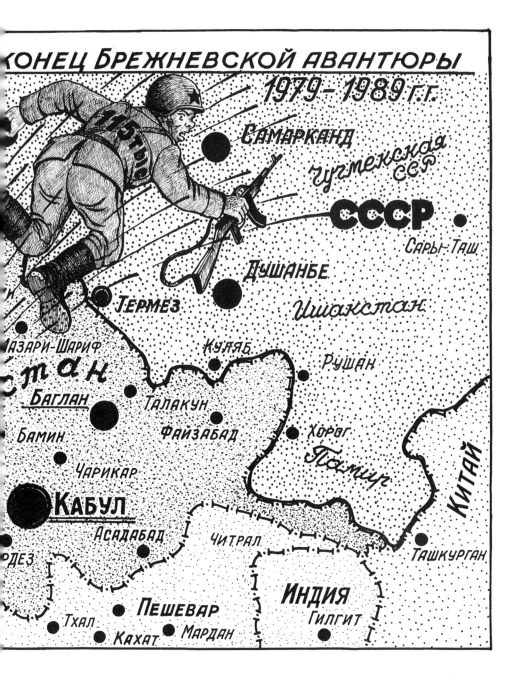

Refers to the previous drawing on pages 134-135.
Text at the top reads: **'The shameful end of Brezhnev's venture of 1979–1989*'**. Text on the left reads: **'Afghanistan. Area: 647,000 sq. km. Population: 15,540,000 (est. 1979). Capital: Kabul, pop. 749,000. Kandahar, pop. 140,000. Baghlan, pop. 111,000. Herat, pop. 109,000'**. Text on the Soviet soldier's back reads: **'115 thousand'**. On the map, some geographical names have been intentionally altered: Afghanistan is rendered as **'Dushmanistan'** (*Dushman* – from Dari *dušman* 'enemy' – was the term used by the Soviet soldiers to refer to the Mujahideen – Afghan guerrilla fighters. Another slang name derived from the same word was *dukhi* meaning 'ghosts'.) **'Chuchmek SSR'** for Uzbekistan (from *chuchmek*, a pejorative blanket term referring to all 'non-white' people from the Southern republics of the USSR). **'Ishakstan'** for Tajikistan (from *ishak*, 'mule, donkey'; both literally and figuratively).

* Refers to the Soviet war in Afghanistan (27 December 1979–15 February 1989)

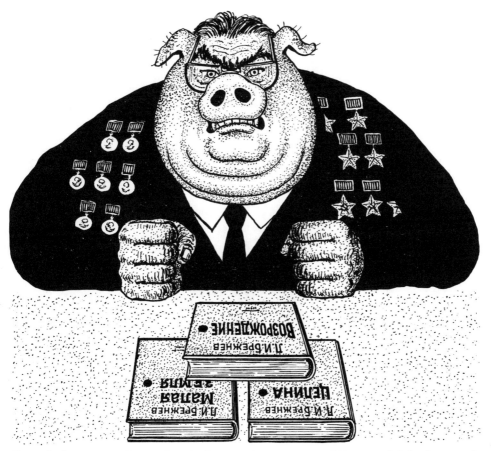

ВЕЛИЧАЙШИЙ ТЕОРЕТИК ВСЕХ ВРЕМЕН И НАРОДОВ – „ВОЗДУШНО- ДЕСАНТНО-ТАНКОВОГО СОЦИАЛИЗМА"... ДАЁШЬ АФГАНИСТАН!...
УБЬЕМ МИЛЛИОН, ДВА И ОН БУДЕТ НАШ!

The books on the desk are: ***The Minor Land***; ***Rebirth*** and ***Virgin Lands****.

The greatest theoretician of 'paratrooper / tank socialism' of all time and all people: 'Bring on Afghanistan! Kill a million or two and it'll be ours![†]'

* The Small (or Minor) Land was the name of a Soviet outpost during WWII, which was recaptured by the Soviet army after a battle lasting 225 days. In the 1970s, Leonid Brezhnev, who had fought in that region, published a memoir consisting of three books: *The Minor Land*, *Rebirth*, *Virgin Lands*.
[†] 'There is no single piece of land in Afghanistan that has not been occupied by a Soviet soldier... no single military problem that has arisen and not been solved, and yet there is still no result.' Sergei Akhromeyev, Soviet General Staff Chief, 1986.

ПЛЕНЁННЫЕ ОККУПАНТЫ-„ИНТЕРНАЦИОНАЛИСТЫ"
„ДИКАРЯМИ-ДУШМАНАМИ"

РЕЗУЛЬТАТ АВАНТЮРЫ БРЕЖНЕВСКОГО ПОЛИТБЮРО КПСС: полностью разрушена экономика Афганистана, 5 млн. беженцев, миллионы вдов, сирот, калек, 30 млн. мин на территории страны... и уничтожено 70% жилого фонда...

Occupant – 'internationalists*' captured by 'Mujahideen savages'

The results of the bluff[†] pulled out by the Brezhnev Politburo: the completely destroyed economy of Afghanistan, five million refugees, millions of widows, orphans, crippled, thirty million land mines on the territory of the country, and the destruction of 70% of residential buildings.

* In 1979 twenty Soviet military advisors were lynched, and their families killed in the Afghan city of Herat. From that point on, the attempt to create an Afghan satellite state was justified in Marxist-Leninist terms of the Soviet Union's 'internationalist duty' towards its friendly neighbours. The 1978 'Treaty of Cooperation and Good-Neighbourliness' between the USSR and Afghanistan served as the official pretext to intervene using military force.

† 'I heard about a guy in Kabul who'd nearly been sent to a mental ward because of abysmal manic depression caused by the war. The thought of suicide was slowly but steadily eating at his mind and quite possibly would have eaten right through had it not been for a lucky accident. After suffering a concussion, he developed total amnesia. The boys who served with him took turns telling him his life story, but he kept asking the same question: "What are we doing in Afghanistan?" No one could give him a definite answer.' Artyom Borovik, *The Hidden War*, 1990.

Our locomotive is flying forward – the next stop is Kabul!*

* An alteration of the first two lines of the chorus of *Nash Parovoz* (Our Locomotive), the song that was written and popularised in 1917, during the Civil War. The original uses the words *the Commune* instead of *Kabul*.

"БАНДА ДУШМАНОВ ПЕРЕД НАПАДЕНИЕМ НА МИРНЫЕ КОЛОНЫ..."

БРАТЬЯ И СЕСТРЫ МУСУЛЬМАНЕ, В НАШУ СТРАНУ ПО ПРИКАЗУ МАРШАЛА БРЕЖНЕВА ВТОРГЛАСЬ САМАЯ СИЛЬНАЯ АРМИЯ МИРА ЗА НАШИМИ ПОДЗЕМНЫМИ БОГАТСТВАМИ. ОНИ СБРАСЫВАЮТ НА НАС БОМБЫ С САМОЛЕТОВ, УТЮЖАТ ТАНКАМИ НАШУ ЗЕМЛЮ, УНИЧТОЖАЮТ ГОРОДА, ГОРНЫЕ КИШЛАКИ, БЕЗНАКАЗАННО УБИВАЮТ И КАЛЕЧАТ АФГАНСКИЙ НАРОД! ЭТО ВАМ НЕ ГДР, ВЕНГРИЯ, ПОЛЬША И ЧЕХОСЛОВАКИЯ! ДАДИМ ЖЕ ИМ ОТПОР!!!

A band of Mujahideen before attacking the peace convoy

'Brother and sister Muslims, following orders by Marshal Brezhnev, the most powerful army in the world has invaded our country, lusting after our underground treasures. Their jets drop bombs from the sky, they bulldoze our lands with tanks, destroy cities, mountain villages, and kill and maul the Afghan people with impunity! This is no East Germany, Hungary, and Czechoslovakia! Let us repulse them!*'

* 'To watch the courageous Afghan freedom fighters battle modern arsenals with simple hand-held weapons is an inspiration to those who love freedom.' Ronald Reagan, President of the United States of America, 1983. To indirectly combat their cold-war foe the Americans supplied the Mujahideen with US-supplied surface-to-air missiles, rockets, mortars, and communication equipment.

Цена жизни мусульман-афганцев для советских воинов-„интернационлистов"

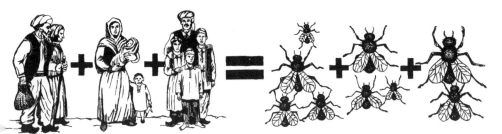

Басмачи, черножопики и духи *Вредные насекомые-мухи*

По келейному решению оккупации Афганистана мракобесов брежневского Политбюро ЦК КПСС в течении 9 лет беспощадно уничтожалисть в кровавой бойне народы страны за отказ одеть ярмо нежизнеспособного марксистского социализма: страна была превращена в полигон испытания всех видов оружия...

Text at the top reads: **'The Value of Life of Muslim Afghans to Soviet "Internationalist" Soldiers'**. Text under the left-hand image reads: **'Basmachi*, black-asses†, and dukhi‡'**. Text under the right-hand image reads: **'Flies, pest insects'**.

Through a secret decision by the obscurants of Brezhnev's Politburo of the Communist Party of the USSR to occupy Afghanistan, over the course of nine years the people of this country were being mercilessly exterminated in a bloody war for their refusal to put on the yoke of the nonviable Marxist socialism: the country was effectively turned into a proving ground for all types of weapons.

* Basmachi was the name of Muslim (largely Turkic) peoples of Central Asia who formed part of the movement against Russian Imperial and Soviet rule. The movement began in 1916 and was defeated in 1923–1924. The remaining indigenous leaders cooperated with Soviet authorities, and many of them gain high positions in the governments of Central Asian Soviet republics.
† A pejorative term used in reference to 'dark-skinned' people.
‡ See page 136.

ПРОЦВЕТАНИЕ ПОРЯДКОВ СТАРО-РУССКОЙ АРМИИ- ИЗБИЕНИЯ И ПРИТЕСНЕНИЯ МОЛОДЫХ СОЛДАТ СО СТОРОНЫ СТАРОСЛУЖАЩИХ...

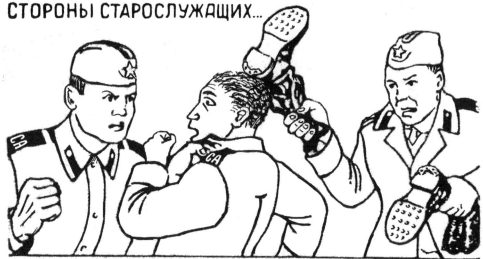

- ТЫ, САЛАГА СЕРЫЙ, ПОЧЕМУ НАМ САПОГИ НЕ ПОЧИСТИЛ, КРОВАТИ НЕ ЗАСТЕЛИЛ, В КАЗАРМЕ И КЛОЗЕТЕ ЗА НАС УБОРКУ НЕ СДЕЛАЛ?!... (В СОВЕТСКОЙ АРМИИ ТАКИЕ "ПОРЯДКИ" НАЧАЛИСЬ С КОНЦА 50-Х ГОДОВ, КОГДА КОМАНДИРЫ БЫЛИ ЛИШЕНЫ ЕДИНОНАЧАЛИЯ И ИХ СТАЛИ ЗАМЕ- НЯТЬ БОЛТУНЫ-ПОЛИТРАБОТНИКИ, А ТАКЖЕ НАЧАЛИ ПРИЗЫВАТЬ СУ- ДИМЫХ, КОТОРЫЕ ПРИНЕСЛИ В ВОИНСКИЕ КАЗАРМЫ ПОРЯДКИ ГУЛАГА.)

The old Russian Army order – beating and humiliation* of new junior conscripts by more seasoned servicemen – is flourishing...

'Hey, you, rookie! Why didn't you polish our boots, make our beds, or clean up in the barracks and the toilets?!' (In the Soviet Army such order of things began in the late 1950s, when commanding officers were deprived of the unity of command. They were replaced by blabbermouth political workers. Moreover, ex-convicts were then drafted, too. They brought the habits and rules of the Gulag with them to military barracks.)

* Ritualised bullying known as *dedovshchina*, the 'grandfather system', emerged in the Soviet army in the late 1960s and is an extreme example of the hazing phenomenon. 'Russian commentators give various reasons for that. By then the conscript army was demoralised. It was too large, and the soldiers were underemployed. The better off and better educated managed to evade service, so that many conscripts fell below the standards needed by a technically sophisticated force. Some were recruited from the prisons, and brought with them the bullying rituals of the criminal world. Under the 'grandfather system' conscript soldiers were divided into four categories, depending on their length of service. In his last six months the soldier was known as a 'grandfather' (*ded*). The new recruits were made to clean the barracks, look after the grandfathers' kit, get them cigarettes from the shop and food from the canteen. Their few personal possessions and their parcels from home were taken from them. They were ritually humiliated, and beaten sometimes to the point of serious injury or death.' Rodric Braithwaite, *Dedovshchina: bullying in the Russian Army*, OpenDemocracy.net, 2010.

„*ВТОРАЯ ВОЛНА* ЗАБЫТЫХ КАЛЕК И ИНВАЛИДОВ АВАНТЮРЫ 1979 Г. ...

– ЭХ! ПОБОЛЬШЕ БЫ ПЕНСИИ И ВНИМАНИЯ К НАМ...

The 'second wave' of the forgotten and neglected disabled veterans of the 1979 shady enterprise*...

'I wish we had better disability pensions and more attention from the government...'

* Meaning the war in Afghanistan.

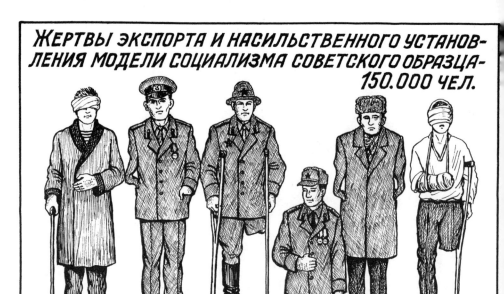

Victims of the export and forceful establishment of the Soviet model of socialism – 150,000 people.

Our callous government shows utter indifference toward the invalids and former Afghan war soldiers.

'As I limped out of the hospital I passed another soldier who'd lost both his legs above the knee... His tear-stained face, which could have pierced the heart of even the most war-hardened officer, had the look of a man who could see ahead into his future.' Artyom Borovik, *The Hidden War*, 1990.

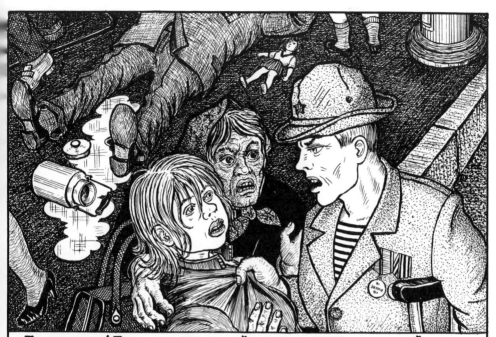

'You swine! You dirty Mujahideen!* Why did you kick the old veteran of WWII in the jaw?'
'I take karate classes in college. I figured I'd test my kick on "live meat".'
'You leave the boy alone or I'm calling the police!'

* The man is an *Afgantsy* (Afghanistan war veteran): he uses the word 'Mujahideen' as a derogatory term and wears an *Afghanka* hat, synonymous with the Soviet troops of the campaign. As the war dragged on they became increasingly visible in Soviet cities, 'Since many *Afgantsy* belonged to the non-Russian nationalities, opposition to the war from citizens in non-Russian Soviet republics increased. Since their presence often was not acknowledged by the authorities, who wished to play down Soviet involvement in Afghanistan, these *Afgantsy* became bitter and openly critical of the Soviet leaders.' R. Reuveny and A. Prakash, *The Afghanistan war and the breakdown of the Soviet Union*, 1999.

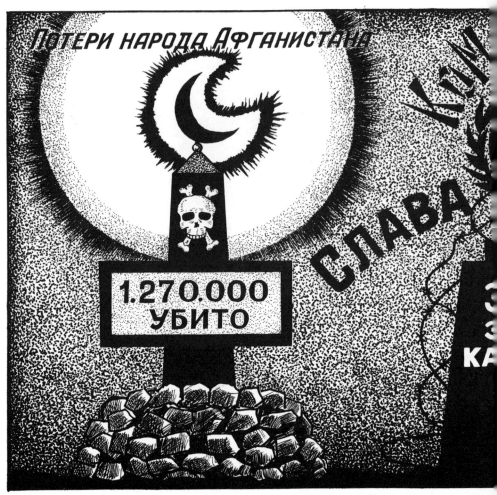

Text top left reads: **'Losses of the people of Afghanistan'**, text on the memorial underneath reads: **'1,270,000 killed'**. Text top right reads: **'Losses of the Soviet Army'**, text on the memorial underneath reads: **'57,000 killed'**. Text over Brezhnev's head reads: **'Communist'**, text to the left and right of Brezhnev's head reads: **'Glory to the Communist Party of the Soviet Union!'**, text on Brezhnev's plinth reads: **'Stagnation*, Bingeing, Embezzlement'**.

'Let us offer our brotherly international help to the people of Afghanistan! Let us free the country from the brutal gangs of occupant Mujahideen and Basmachi† that invaded Afghanistan from Pakistan, equipped with US weaponry!'

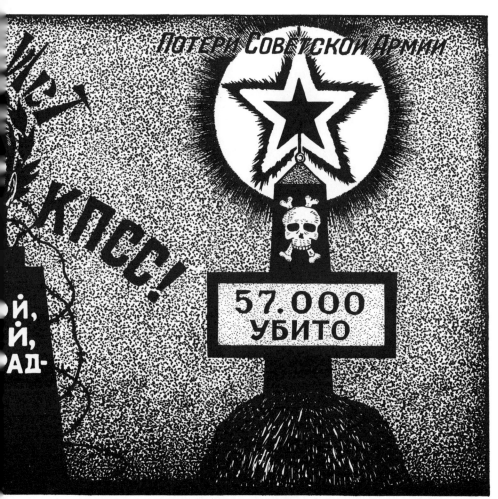

ОККУПАНТОВ-ДУШМАНОВ И БАСМАЧЕЙ, ВТОРГШИХСЯ ИЗ ПАКИСТАНА С АМЕРИКАНСКИМ ОРУЖИЕМ!

* [Borovik interviewing the Deputy Chief of General Headquarters, V. I. Varennikov in 1988] '"Don't you think the Soviet officials in Afghanistan, who had a duty to keep Moscow accurately apprised of the situation here, often sent only information that was likely to be well received, so they wouldn't upset their bosses and provoke their wrath?" Varennikov replied, "... as far as supplying only favourable information to Moscow, this undoubtedly happened. What's more the diplomats weren't the only ones doing it. Unfortunately this was the disease of the stagnation period: to inform central offices only of what would be well received, rather than what was actually taking place. The discrepancies caused Moscow to make decisions that weren't always sound, which harmed the Soviet Union a great deal."' Artyom Borovik, *The Hidden War*, 1990.

† See footnote on page 141.

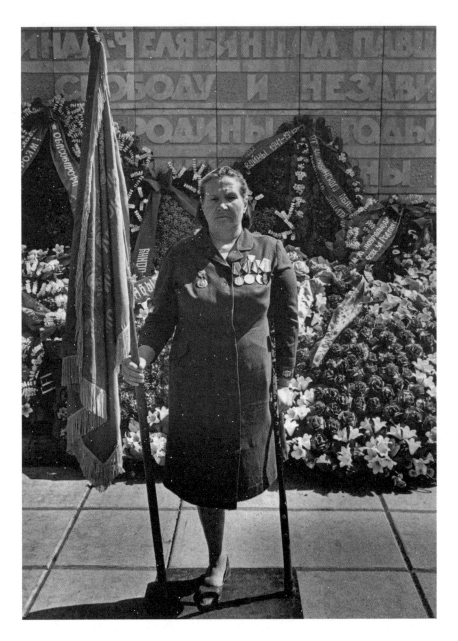

Above On the eve of Victory Day, a veteran stands guard over a monument to the fallen. Chelyabinsk, 1968.
Right Commemorating Victory Day at the Eternal Fire, a woman holds a portrait of a loved one who died during the Great Patriotic War (World War II). Chelyabinsk, 1964.

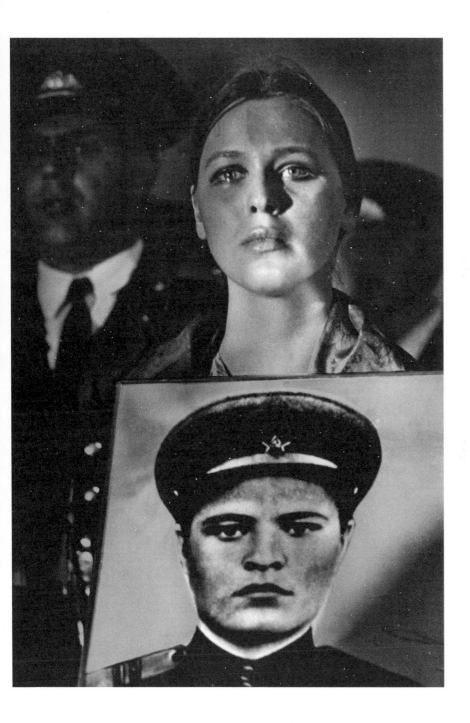

Above and right In the maternity ward. Chelyabinsk, 1978.

LIVING

Life's Thrown Us Overboard

„ЧТО ЖДЕТ МАЛЫША В БУДУЩЕМ ?..."

„ У ЭТОГО МАЛЫША ЕСТЬ НЕБОЛЬШАЯ НАДЕЖДА В БУДУЩЕМ
КОГДА ЕГО ЖИЗНЬ НЕ БУДУТ ОТРАВЛЯТЬ ПАРТИЙНАЯ
МАФИЯ С БАНДОЙ БЮРОКРАТОВ И БОЛТУНОВ..."

'What does the child's future hold for him?'

'There's a slim chance that the Party mob with its band of bureaucrats and windbags won't wreck this toddler's life in the future...*'

* Baldaev is referring to the unlikely possibility of changes to the system of government, which could mean that the rule of the Soviet bureaucrats will cease to exist in the future.

В СРЕДНЕЙ ОБЩЕОБРАЗОВАТЕЛЬНОЙ ШКОЛЕ НА УРОКЕ ХИМИИ...

–ДЕНИС ИВАНОВ, НАПИШИТЕ ХИМИЧЕСКУЮ ФОРМУЛУ ВОДЫ...
–МАРИЯ ИВАНОВНА, Я НАПИСАЛ ЕЁ ДАЖЕ В ДВУХ ВАРИАНТАХ– ВОДЫ И ЛЬДА!
–ИВАНОВ, КОГДА ВЫ БУДИТЕ УЧИТЬ УРОКИ ХИМИИ И ПО ДРУГИМ ПРЕДМЕТАМ? У ВАС
СПЛОШНЫЕ ДВОЙКИ И ВАС МОГУТ ОСТАВИТЬ НА ВТОРОЙ ГОД!
–МЕНЯ, МАРИЯ ИВАНОВНА, НИКТО НЕ ПОЗВОЛИТ ОСТАВИТЬ НА ВТОРОЙ ГОД! ЭТО ПОВЛИЯЕТ НА
УСПЕВАЕМОСТЬ КЛАССА, А ЗАТЕМ ВСЕЙ ШКОЛЫ, РОНО, ГОРОНО, ОблОНО, РСФСР И В ЦЕЛОМ
НА МИНИСТЕРСТВО ПРОСВЕЩЕНИЯ СССР И СОЦЛАГЕРЬ! ВОТ ОТСИЖУ ЕЩЕ ГОД УЖЕ В
ВОСЬМОМ, ПОТОМ В ПТУ И В АРМИЮ...

Text at the top reads: **'A chemistry class in a public school'**. Text on the blackboard reads: **'Aitch OO, Aitch 20'**.

'Denis Ivanov, write down the chemical formula of water.'

'Maria Ivanovna, I did! Even twice: one for water and one for ice.'

'Ivanov, when are you going to do your homework for chemistry and other classes? You get F after F, and you're facing grade retention!'

'But I'm not, Maria Ivanovna. If I repeat a grade, I'll bring down the grade report figures first for the class, then for the school, then for the District Department of Public Education, the Municipal Department of Public Education, then the departments of public education of the Oblast, the Russian Soviet Federative Social Republic, the Ministry of Education of the Soviet Union, and then all the Communist states! I think I'll just stay another year in school, now in the eighth grade, though. Then I'll either go to a vocational school or straight into the military.'*

* Here Baldaev is making a point about the system (of education in this case) only being concerned with results on paper, rather than producing good, knowledgeable students. Having too many students (or, perhaps, even just one student) who had to 'repeat a grade' would amount to a loss of face for the teacher, and then to the teacher's superior, and so on. This is shown as a progressively absurd sequence of 'bringing down grade report figures.' The solution was simple: rather than having him repeat a grade, the teacher would simply 'fix' his grades – if only to up the bare minimum necessary for the student to start a new grade the following year. Baldaev extends the analogy to the entire country. For example, a great deal of mediocre, or plainly unqualified workforce, were receiving their paycheques regularly without the fear of getting fired. The system ensured a perfect environment for lazy malingerers to thrive in.

Бывшие активисты по раскулачиванию крестьян из числа архи–лодырей, бедняков и батраков, которыми двигала только черная зависть к чужому добру...

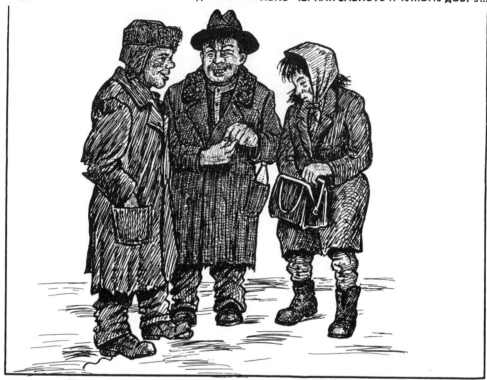

– Помнишь, Вася, как мы втроем в 29-30 годы кулаков в деревнях трясли? Вот житуха была! Водочки, мяска попили и поели досыта, шмуток-то сколько поописывали и девок кулацких сколько потоптали! Они все спастись хотели и не ехать на Соловки, а ты пощады не знал! Где их сейчас косточки... А жизнь нас выбросила за борт, даже на политуру не собрать!...

Former activists of dekulakisation* of peasants: the ultimate idlers, impoverished hired hands, who were driven solely by envy of other people's belongings...

'Remember, Vasily, how the three of us shook down kulaks in villages in 1929–1930? Now that was good life! We had our share of vodka and meat, stole loads of clothing, and had our ways with kulak girls! They tried to run away, because they didn't want to go to Solovki†, and you showed them no mercy. Who knows where their bones are rotting now... Life's thrown us overboard. We don't have enough even to buy a bottle of polish.‡

* Dekulakisation was a 1929–1932 campaign initiated by Stalin of political repressions of better-off peasants and their families. Most were executed or sent to labour camps. See footnote on page 52.
† In the Solovki labour camps the NKVD tested different methods, developing the blueprint for the GULAG system as a whole.
‡ Due to the high content of alcohol in certain furniture polishes, they are often used for making cheap booze, or consumed straight from the bottle.

Антиобщественные элементы: пьяницы, наркоманы, бродяги, тунеядцы, проститутки, хулиганы, мошенники, воры, грабители, спекулянты, расхитители соцсобст-венности, бюрократы первыми используют в своих корыстных целях ослабление законов и демократию

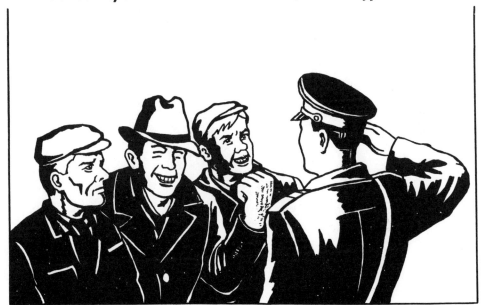

- Гражданин, за учинённую драку в нетрезвом состоянии и нецензурную брань в общественном месте прошу предъявить ваши документы и пройти со мной в отделение милиции...
- Ты, что падла морда ментовская в рожу хочешь? Хрущёв объявил демократию, Берию расстрелял вместе с его корешами, а ты меня в лягавку захотел! Мотай отсюда пока цел! А, то я тебя по прокуратурам затаскаю!...

Antisocial elements – alcoholics, drug addicts, homeless, freeloaders, prostitutes, hooligans, swindlers, thieves, muggers, profiteers, embezzlers, and bureaucrats – are the first to take advantage of relaxed laws and democracy.

'Citizen, for battery under the influence and obscene language in public, you must show me your ID and follow me to the police station.'
'Huh? Do you want me to smash your face, you copper? Khrushchev announced democracy and executed Beria along with his buddies, and you want to book me? Get the hell out of here, or I'll sue the living crap out of you!'

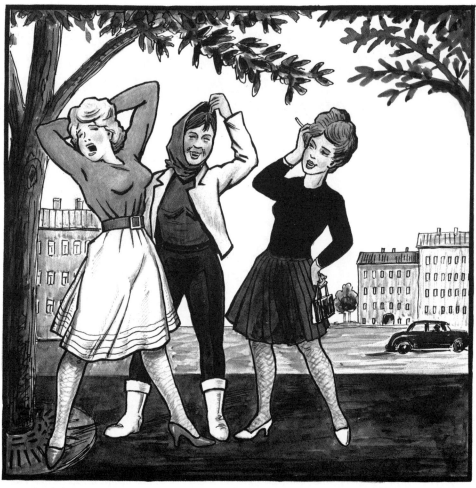

В красном. *Ох! Девки, спать охота! Сегодня всю ночь... Не могу жить только с одним... скучно...*
В жёлтом. *Завидую тебе, Любка!... Эх, кому бы ещё дать...*
В чёрном. *А, вот мой сидит 15 суток...*

Girl in red [left]: Oh, girls, I'm so tired! I've been at it the whole night. I can't live with the same guy all the time. It's too boring.
Girl in yellow [middle]: I envy you so much, Lyuba! I wonder who I should get laid with next?
Girl in black [right]: And my man is doing his 15 days...*

*A form of administrative (civil) imprisonment (as opposed to criminal) for minor offences.

– МАШКА, УБЕРИ СВОЕГО УБЛЮДКА, А ТО Я ЕГО ПРИДУШУ!
– ЖОРА, НЕ ОБРАЩАЙ ВНИМАНИЯ, ОН К ЭТОМУ ПРИВЫК, ДАЙ ЕМУ ВИНА И ОН ЛЯЖЕТ СПАТЬ.....

'Masha, get rid of your bastard or I swear I'll wring his neck!'
'Don't pay any attention to him, Zhora, he's used to this. Give him some wine and he'll go to bed.'

Ты больше ко мне не приходи. Завтра приезжает мой муж...

You should stop seeing me at my place. My husband is coming back tomorrow...

Псковская область. Веселье. На престольном празднике...

Dances in a *kolkhoz**. Rednecks are having fun at a patron saint's day.

* *Kolkhoz* (*kollektivnoe khzyaistvo*) – collective farm.

МЫ ТУТ, БРАТОК, В НОВОМ ДОМЕ КВАРТИРЯ ПОЛУЧИЛИ! ПОКА ПЯТЬ ЛЕТ В ТЮРЯГЕ СИДЕЛИ И ОЧЕРЕДЬ ПОДОШЛА... ЗДЕСЬ ЛАФА, РАЙОН НОВЫЙ ... МИЛИЦИИ МАЛО ...

'You know, mister, they just gave us new apartments in that building over there. Our turn came round* while we were doing time. Great neighbourhood: new block, not too many cops...'

* The Soviet answer to the post-revolutionary housing crisis was the *Kommunalka* or communal apartment: dividing what was formerly a single dwelling into a number of much smaller dwellings, allowing a number of families to live in a single flat. *Kommunalkas* were allotted by a governing body, and as a result the residents had little commitment to either communal living or each other. Whole families were crammed into a single room where they would live, eat and sleep. The bathroom, kitchen, hallway and telephone were shared between all residents, although even these spaces were divided: a family might have its own cooker, table, light switch. Food was kept locked away, and each family would have its own toilet paper. While most people lived in communal apartments, if the number of people exceeded the allotted housing quota they were allowed to improve their living conditions and apply to be included in special waiting lists. As new housing was being built, people at the top of the list were able to move out of their shared rooms in communal apartments and into their own, new apartments. Housing shortages, corruption, and officials' arbitrariness all contributed to people remaining on waiting lists for years, sometimes decades.

Since all the housing (old and new) belonged to the state, even 'the lucky ones' who managed to receive an apartment were considered tenants, rather than owners. The permission to occupy an apartment – *propiska* ('registration') – was essentially the only document securing the tenant's rights to live in it. No rental fees applied; the tenants, however, were required to pay for the utilities (which were also supplied by the state). Sometimes a nominal maintenance fee was also included.

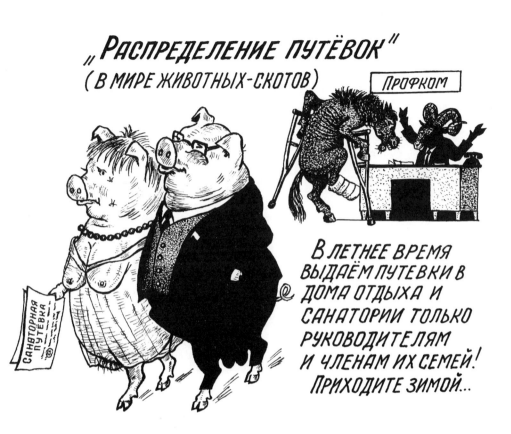

Text at the top reads: **'Distributing Sanatorium Vouchers* (among cattle-beasts)'**. Text over the desk reads: **'Labour Union Committee'**. Text on the paper in the pig's hand reads: **'Sanatorium Vouchers'**.

'In summertime, we only distribute sanatorium vouchers among leader administrators and their families! Come in the winter.'

* In 1960, the Council of Ministers of the USSR decreed that sanatoriums (which were originally clinics, rather than resorts) be accessible to everybody, regardless of an individual's social status or income: essentially, the holiday industry was monopolised by the government. Operations of sanatoriums were subject to licensing schemes similar to the licensing of any medical institution. A sanatorium voucher was a document that entitled the bearer to a set of health-improving procedures. This system appeared quite random (members of the same family might receive vouchers with different dates and for different sanatoriums, leading to a situation where they would holiday separately). However, the apparent arbitrariness of the system was a result of the high levels of corruption. A stay at a sanatorium might be partially, or completely, reimbursed (or free to begin with), but the number of free passes was limited. Some (Party officials, administrators, and their families), who 'happened to be' luckier than others, received vouchers for better sanatoriums or during better seasons (summer, as opposed to winter).

— Мясо, мамаша, без костей не бывает! Понимать надо, слышишь!? Мясо есть в вашем возрасте вредно, отвар другое дело!

'There are always bones in meat, grandma. Hello? Can you hear me? Anyway, it's bad for you to eat meat at your age. Broth would be much healthier!'*

* There were often food shortages in the USSR during the 1980s and 1990s, making everyday life difficult. When the Soviet Union collapsed in 1991 almost all foods were rationed. Non-rationed food (and other goods) had practically disappeared, and long queues were common for everyday items. Even in the non-state shops which began to appear in the mid 1980s, prices were so high they essentially excluded the average citizen.

Text on the left reads: **'With a salesperson'**; text on the right reads: **'Without a salesperson'***†.

* The drawing dates from the 1970s. The first self-service supermarket in the USSR was introduced in September 1970 in Leningrad.

† Baldaev's theme in this drawing is suspicion. When stores without salesmen were first introduced in the Soviet Union – without surveillance cameras or electronic anti-theft systems – there was a special clerk at the exit of each shop who inspected the customers' bags, making sure they didn't take something they hadn't paid for. This is different from the more traditional 'with a salesperson' system, whereby the customer asks a salesperson behind the counter to weigh the goods. The customer would then memorise the amount (or if buying many different items, the salesperson would write them down), and proceed to a cash register. At the register, the customer called out the amount and section number. For example, 'Two fifty-eight for No.2 (e.g. Meat), three seventy and one fifty for No.1 (e.g. Dairy)...' The customer paid and got a receipt (or several, one for each section). Then went back to each respective section, submitted the receipts to the salespersons, and collected the groceries. In the first drawing, the customer is looking at the scales with suspicion, because she anticipates that the salesgirl is cheating by fiddling with the weights (her finger is positioned on top of one) – hence the bulging eyes of the customer. In the second drawing, it's the clerk who's suspecting the customer of shoplifting – hence the bulging eyes of the clerk.

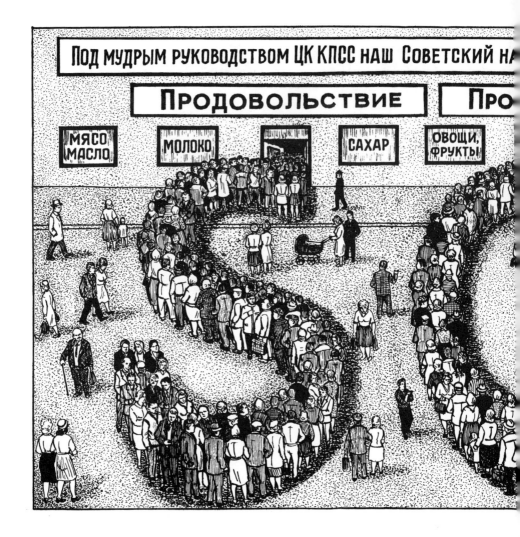

The sign at the top reads: **'Under the wise supervision of the Communist Party of the Soviet Union, our Soviet people marches on toward the bright dawn of the entire humanity – communism!'**. Larger signs read (left to right): **'Groceries'**; **'Wares'**; **'Vodka and Wines'**. Smaller signs read (left to right): **'Meat & Butter'**; **'Milk'**; **'Sugar'**; **'Vegetables & Fruit'**; **'Clothes & Footwear'**; **'Wares'**; **'Cognacs'**; **'Beer'**.

'In 1960 about one out of two families owned a radio, one out of ten a television, and one out of twenty-five a refrigerator. By 1985 there was an average of one of each per family... Shoppers were confronted with a retail distribution system that seemed designed to torment them, rather than cater for their needs. Customers often had to stand in three separate lines to purchase something – one to request the item, a second to pay for it, and a third to pick it up. Availability of goods was never certain, and people had to carry "just in case" bags for the moment when a desired good suddenly appeared in the stores.' David Kotz and Fred Weir, *Revolution from Above: The demise of the Soviet system*, 1997.

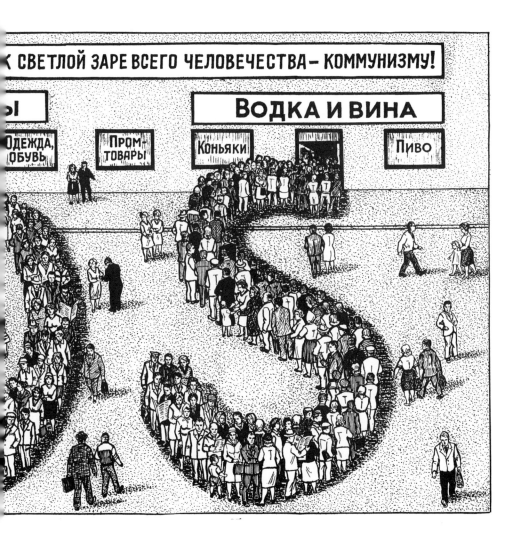

Shortages of the most basic goods were common across the whole of the Soviet Union, so queuing was an everyday occurrence. The presence of goods on the shelves in a state shop often simply meant that these goods were rationed and could not be bought at will. A typical Soviet joke ran: A man walks into a shop and asks, 'Don't you have any fish?' the shopkeeper replies 'No, we don't have any meat: we are butchers. The fishmongers across the road doesn't have any fish.'

Citizens were required to sign up to a waiting list for consumer goods such as televisions, refrigerators and cars. The quality of these goods was poor in comparison to their Western counterparts, and the waiting lists were often long. For a new car (for example) it could be ten or fifteen years. The car factories never met demand and the authorities decided who the lucky recipient of each car would be – as they did with almost every aspect of Soviet life, from holidays to apartments. In theory allocations were made using a system taking into account time on the list and being a good communist, but in reality party connections were more important. Cars were 'sold' first to the party elite (the *nomenklatura*), then to friends of the *nomenklatura*, and – finally – to those few who were able to afford them. Waiting was an endemic in the Soviet system: 'I want to sign onto the waiting list for a car. How long is it?' 'Ten years from today exactly' 'Morning or evening?' 'Why does it matter?' 'I have a plumber coming round in the morning'.

Учуп оперативнику: –
– С самого утра наблюдаю за этой женщиной! Вот уже
31 пару белых чулок продала и все думаю, как ей не стыдно!

A district police officer to an operative:
'I've been watching that woman all morning. She's sold 31 pairs of white stockings already. She has no shame!'*

* Making money in this manner was against the law in the Soviet Union. The job of the police officer was to arrest her, but because of bribes (or he was too lazy to complete all the associated paperwork) he hasn't.

ПОЧТИ „УЗАКОНЕННАЯ" ВЗЯТКА

МОГИЛЬЩИК: „РОБЯ, ГОВОРЯТ, ШТО ЭНТОТ ЖМУРИК БАЛЬШИМ ПАРТЕЙНЫМ БЫЛ, АЖ САМАВО ЛЕНИНА ВЯДАЛ..."

An almost 'legitimate*' bribe

Grave digger: 'Guys, they say that the dead guy was some bigwig in the Party. They say he saw Lenin himself.'

* Funerals were (and still are) commonly acknowledged as being one of the most corrupt parts of the system, with bribes being required to secure plots, monuments and burial services.

A weekend cross-country skiing competition, a popular group sport. Chelyabinsk, 1969.

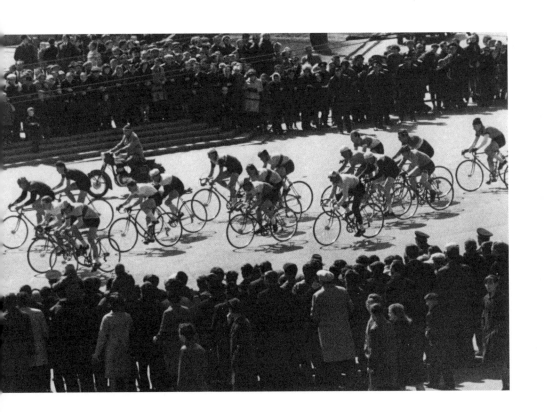

Bicycle race. Chelyabinsk, 1966.

Watching the Victory Day Parade from the tribune of Lenin's Mausoleum. (Facing front, left to right) Admiral S. Gorshkov, Marshalls A. Yeremenko, N. Konev, G. Zhukov, and I. Bagramian, Kirill Meretskov. 9 May 1967, Moscow.

A drive-past parade of mobile weapons. 9 May 1967. Moscow.

'In Red Square, to the accompaniment of military music and the firing of salutes, the *nomenklatura* celebrates another year of power by a military parade that lasts for several hours. Normally you only catch occasional glimpses of them as they flash by in their ZILs and Chaikas [limousines], or (in magazines) in their sumptuous homes or on the platform at important ceremonies. [...] There they are, standing on the light stone steps of the stands, solidly built men with coarse, authoritarian faces, accompanied by their dumpy, aging wives and well-nourished, red cheeked children. They are all warmly dressed. Their overcoats are made of best-quality English material; you are surrounded on all sides by soft furs, Persian lamb coats, fur hats. But an unwritten law is scrupulously observed here: all these luxurious items of clothing must not fit too well or be worn too smartly; on the contrary, they must hang badly, and the women must not be made up. It is a last, modest tribute paid to the mythical proletarian origin of the *nomenklatura*, the democratic idea it pretends to respect. [...] There they are, fascinated by their own power, standing in front of the tombs in the Kremlin wall as in a cemetery, while the November wind tirelessly spreads snow over their world as it slowly declines into autumn.' Michael Voslensky, *Nomenklatura: The Soviet Ruling Class*, 1980.

BUREAUCRATS

Stagnation, Bingeing, Embezzlement and Bribery

В МЕДИЦИНСКОМ ПУНКТЕ ЗАВОДА...

– УВАЖАЕМЫЙ ТОВАРИЩ СЕКРЕТАРЬ ПАРТКОМА, ВАМ НАДО КАК МОЖНО БОЛЬШЕ ДВИГАТЬСЯ! ИЗБАВИТЕСЬ ОТ ОЖИРЕНИЯ, ОДЫШКИ И СОБЛЮДАЙТЕ ДИЕТУ...

A first-aid facility at a factory

'Comrade Secretary of Party Committee*, you need to move more! Go on a diet, and you'll rid yourself of obesity and shortness of breath.'[†]

* The Communist Party maintained its power by use of the *nomenklatura* system, which ensured that every important job in the country was held by a member of the Party. The system worked using two lists: one of key jobs, the other of potential candidates for those jobs. All appointments were made directly by the Party or with Party approval. This meant that an official could not advance his career without the support of a patron to promote him to a position of power. Once there, he was acutely aware that his position was only secure because of the assistance of his patron: any disloyalty would result in his replacement, his allegiance to his patron's policies was ensured. This situation made basic change impossible, as managers and bureaucrats engaged in ceaseless political manoeuvring. Members of the *nomenklatura* (comprising approximately 1.5% of the population) were not only endowed with political power, but also economic privileges – access to special restaurants, Black Sea holiday resorts, apartments and consumer goods – far beyond the reach of the general population. The system had established an elite ruling class, its existence was a symbol of the failure of Communism itself.

[†] Baldaev is making a comment about those in power engaging in embezzlement, bribery and bingeing. 'The corrupt Communist knows that he is a nobody, but he really, really wants to live well. In a situation of free competition, he would most likely lose out to the businessman, the farmer, and the intellectual. Therefore he works out a system of privileges so that access to all the blessings of the world belong only to the chosen. Occasionally he will reward the obedient slave, perhaps with a trip abroad (that is, to the magical kingdom of consumer goods). According to the rules of the game, however, the slave must pay for this upon returning: he must tell those who are not allowed out that everything is quite awful abroad, that people everywhere are out of work, are scavenging in garbage heaps and killing each other on the streets, where they also sleep. [...] These people are naturally bound to each other by a round robin of bribes and base actions. There is a file on each of them, and they all know it.' Tatyana Tolstaya, *Pushkin's Children: Writings on Russia and Russians*, 2003.

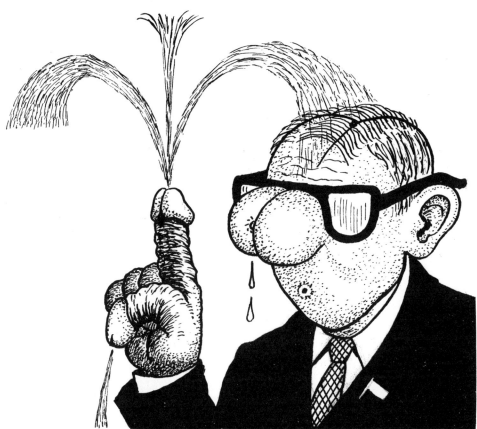

- НАША ВЫСШАЯ ПАРТШКОЛА ПРИ ЦК КПСС, КОТОРУЮ Я КОГДА-ТО ОКОНЧИЛ, ДАЁТ ШИРОЧАЙШИЕ ЗНАНИЯ УЧЕНИЯ МАРКСА - УПРАВЛЯТЬ МАССАМИ И ВЕСТИ ЕЁ В КОММУНИЗМ, УДОВЛЕТВОРЕНИЮ ВСЕХ ПОТРЕБНОСТЕЙ - ИЗОБИЛИЮ. ПАРТШКОЛА ОГРОМНЫЙ ИСТОЧНИК ЭРУДИЦИИ, ГДЕ ДАЖЕ УЧАТ КАК ПОЛЬЗОВАТЬСЯ СТОЛОВЫМИ ПРИБОРАМИ И САЛФЕТКОЙ. УНИВЕРСИТЕТЫ КАПСТРАН КАК ПЕНСИЛЬВАНСКИЙ, КЕМБРИДЖ ИЛИ ФРАНЦУЗСКАЯ СОРБОННА ОТСТАЛИ ОТ НАШЕЙ ВЫСШЕЙ ПАРТШКОЛЫ НА ТРИ ПОРЯДКА, ТАМ ТОЛЬКО И УЧАТ ТОМУ КАК ОБОЛВАНИВАТЬ И ЭКСПЛУАТИРОВАТЬ ТРУДЯЩИХСЯ С БОЛЬШОЙ ВЫГОДОЙ ДЛЯ СЕБЯ ... Я, КАК ПЕРВЫЙ СЕКРЕТАРЬ ОБКОМА, ВСЕМ ДОВОЛЕН. Я ВСЕГДА БУДУ СЫТ, И У МЕНЯ ВСЕГДА БУДЕТ БОЛЬШАЯ ВЛАСТЬ.

'The Communist Party Training Institute that I once graduated from, has given me extensive knowledge of the teachings of Marx: how to control the masses and bring them to communism, satisfaction of all needs, and build an affluent society. The Institute is a source of vast erudition. They even teach you how to use silverware and napkins. Universities of capitalist countries, such as the University of Pennsylvania, Cambridge, or the Sorbonne in France lag well behind our Party Training Institute. They only teach you how to make workers dumber and exploit them for your personal gain. As First Secretary of the Regional Party Committee, I'm very content. I will always have bread on the table and have a lot of power.'

Text across the top reads: **'The highest and strictest and orders* to the People's Judge by the powers that be...'** Text on the left reads: **'This is First Secretary of the District Committee of the Communist Party speaking†. I believe you should drop the charges against Mr. Sidorov‡ for doctoring records, accepting bonuses, and taking bribes, due to lack of evidence. I also believe you'd like to remain for a third term as the People's Judge in my district...'** The text on the right reads: **'As Chairman of the Executive Committee I insist that Mr. Yegorov§ be convicted with all the strictness of Soviet laws for his complaints to the People's Control Committee‖, Oblast Party Committee, and Central Committee of the Communist Party about doctored reports, accepting bonuses, and mismanagement... We must all coexist in peace!'**. Text at the bottom reads: **'For me, a People's Judge, orders of the Party – the leading power – and orders of the Executive Committee have always been law!'**.

* The *telefonnoye pravo* (law of the telephone) – was the name of a system of command where instructions were given by telephone. A higher placed official would telephone through orders to a lower placed official, whose job it was to execute them without question. This system was fundamental to the operation of the Soviet government, it effectively ensured there was no evidence and therefore no responsibility. The system also worked in reverse, where the lower official would telephone his immediate superior for approval before taking any action. The number of calls and the weight of their significance were crucial: they determined the status of the official and the trajectory of their career. No one was immune from *telefonnoye pravo*: 'Few people know what torture it is to sit in the dread silence of an office, in a complete vacuum, subconsciously waiting for something. For this telephone with the state seal to ring. Or not.' Boris Yeltsin, *The Struggle for Russia*, 1994.

† The *vertushka* was the physical manifestation of *telefonnoye pravo*: a dial-less telephone made to receive important calls, but unable to make any. It was a symbol of considerable status, signifying that you didn't need to call anyone – they called you.

‡ A generic last name, like Mr. Smith, Mr. Brown, etc.

§ Another generic name.

‖ A semi-civic, semi-government organisation for scrutinising the activities of the government, local administrations, and enterprises.

178

Высочайшие и бесприкословные указания Народному судье сильных мира сего...

– Говорит Первый секретарь РК КПСС! Есть мнение оправдать за недоказанностью Сидорова по припискам, получении премий и взяток... Полагаю, что вы хотите остаться и на третий срок Народным судьёй в моём районе...

– Как председатель исполкома, я настаиваю Егорова осудить по всей строгости Советского закона за его жалобы в Народный контроль, Обком и ЦК КПСС по припискам, премиям, бесхозяйственности... Мы должны жить в мире!

– Для меня, Народного судьи, указание партии – руководящей и направляющей силы и исполкома всегда были законом!...

ЖЕРТВЫ ВОЙНЫ, ДЕПОРТИРОВАННЫЕ ИЗ ГЕРМАНИИ В 1945 ГОДУ...

– ВАМ ВСЕМ 20 ЛЕТ! ЧЕМ МОЖЕТЕ ДОКАЗАТЬ, КАКИМИ ДО-
КУМЕНТАМИ, ЧТО ВЫ НЕ ДОБРОВОЛЬНО ПЕРЕБЕЖАЛИ К НЕМ-
ЦАМ, СТАВ ПРЕДАТЕЛЯМИ ВО ВРЕМЯ ОККУПАЦИИ, В ЛАГЕРЬ
ДОХАУ, ГДЕ СДАВАЛИ КРОВЬ РАНЕНЫМ ФАШИСТАМ И
ВАС ОСВОБОДИЛИ АМЕРИКАНЦЫ, А ЗА ТЕМ С ЗАДАНИЕМ
ПОСЛАЛИ К НАМ В СОВЕТСКИЙ СОЮЗ? ОТВЕЧАЙТЕ!...

„ЛГУННАЯ ПРАВДА." 1959г.

Victims of the war are deported from Germany in 1945...

'Twenty years of imprisonment to all of you! How can you prove – with what papers – that you didn't volunteer to defect to the Germans and became traitors during occupation? That you didn't flee to Dachau and donate blood to wounded Nazi soldiers? That you weren't rescued by Americans who then sent you on a reconnaissance mission back here to the Soviet Union? Answer now!'
*Lgunnaya Pravda**. 1959.

* *Lgunnaya* (lying, deceiving) *Pravda* (truth); here Baldaev is making a comment on the Soviet propaganda newspaper *Pravda*.

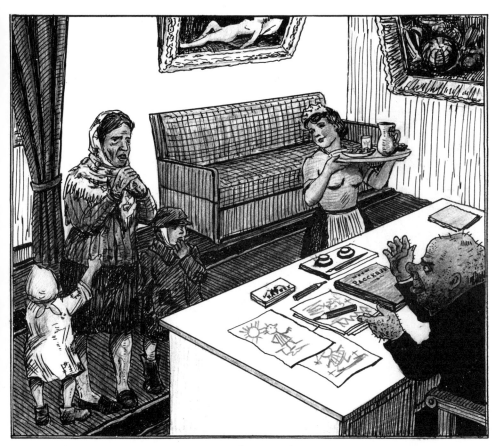

Товарищ, директор, помогите устроить ребятишек у детский садик! Ведь вдова я, муж-то запрошлом годе помер, сами знаете, тяжало жить-то на 60 рублей и дед-то с нами совсем больной и старый из деревни приехал...
- Что у меня богодельня или детский сад! У меня план, а детсад строим. Года через три-четыре будет готов! И раньше подобные, вам, все жаловались на зарплату - 45 рублей, а теперь прибавили и стало 60 рублей! Что думаете мне легко живется?! Вспомните войну, блокаду... Еще хуже жили !.. Ненравится - увольняйтесь!

'Comrade director, please help send the kids to nursery. I'm a widow. My husband died two years ago, you know. It's hard to live on 60 roubles a month. Grandpa is also living with us. He's old and sick. He came to live with us from the village...'

'What do you think I'm running here? A charity? I have a five-year plan to follow. The nursery is being built. It should be finished in three or four years. People like you used to complain about the salary of 45 roubles a month. Now you've got a raise and get 60 roubles! Do you think it's any easier for me? Remember the war, the Siege*. It was even worse! If you don't like it, go ahead and quit!'

* The Siege of Leningrad took place in World War II, when the German army blockaded the city for 872 days. Estimates of civilian death from starvation and bombardment range from 1.1 to 1.3 million.

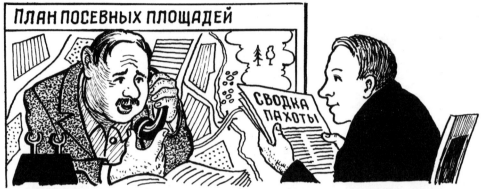

Text at the top reads: **'We eagerly await directives from the local committee of the Communist Party...'** Text on the map reads: **'Overview of the net sown area'**. The newspaper is called ***The Tillage Review***.

'Comrade First Secretary. The Dawn of Communism *kolkhoz** has completed tillage, this is kolkhoz chairman Timofeev speaking. We're waiting for your orders as to what, where, and when to sow, and how much root crops we ought to plant.'[†]

* *Kolkhoz* – see footnote page 161.

[†] It was not only farming that was so strictly controlled by Moscow. Across the USSR every industry was required to follow their orders, even at the expense of the harvest: 'What made him furious was to see the "government nets" – the nets set out along the shore by the state fishing boats – filled with rotting fish, big, glorious salmon going grey and belly up while the captains [of the fishing boats] idled at sea, waiting for Moscow to give them the order to bring the fish on board. [...] Because the local bureaucrats had to wait for orders from the central bureaucrats of the "central command system," a million-dollar catch would soon be little more than rotting guts, bones, and scales. "Can you imagine anything so stupid?" he said.' David Remnick, *Lenin's Tomb: Last Days of the Soviet Empire,* 1994.

„ПЕРВЫЙ СЕКРЕТАРЬ РК КПСС СО СВОИМИ ВНУКАМИ В РАЙОННОМ МУЗЕЕ „ИСТОРИИ СОЗДАНИЯ КОЛХОЗОВ"...

ЧЕСТВЕННУЮ ВОЙНУ

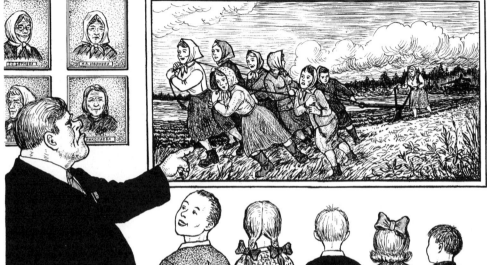

— ВОТ ПОСМОТРИТЕ ВНИМАТЕЛЬНО НА ЭТУ КАРТИНУ! ЕСЛИ ВЫ БУДЕТЕ ПЛО-
ХО УЧИТЬСЯ И НЕ ПОСТУПИТЕ В КОМПАРТИЮ, КОГДА ВЫРАСТИТЕ, ТО НА ВАС БУ-
ДУТ ПАХАТЬ КАК НА ЭТИХ МАЛОГРАМОТНЫХ БАБАХ! ГЛАВНОЕ В НАШЕЙ СТРА-
НЕ ЗАНЯТЬ ВЫСОКУЮ ДОЛЖНОСТЬ, ИМЕТЬ ВЛАСТЬ НАД РАБСИЛОЙ...
И ПОЛУЧИЛИ ЭТИ БЕЗМОЗГЛЫЕ БАБЫ ПО 20-30 РУБЛЕЙ ПЕНСИИ...

„ЛГУННАЯ ПРАВДА." 1963г.

Text at the top reads: **'The First Secretary of the Regional Committee of the Communist Party of the USSR with his grandchildren in the regional Museum of History of the Kolkhoz.'** Text above the portraits on the right reads: **'[ci]vil war'**. Text at the bottom reads: **'Lying Truth*, 1963'**.

'Take a good look at this painting†. If you don't study well and fail to secure a place in the Communist Party when you grow up, they'll put a harness on you and strap you to a plough, like these illiterate women. The key to success in our country is to secure a higher position and exercise power over the workforce... Also, those stupid women got no more than 20–30 roubles a month when they retired.'

* *Lgunnaya* (lying, deceiving) *Pravda* (truth); here Baldaev is making a comment on the Soviet propaganda newspaper *Pravda*.
† An adaptation by Baldaev of the famous painting *Barge Haulers on the Volga* (1870–1873) by Ilya Repin. In the original the haulers were all men, the painting a tribute to their dignity and a statement against the inhumanity of such labour. Here they are all women and the First Secretary is being far from complimentary. This is a reference to the peasant women's significant role in the resistance to the Communist collectivisation programme: because they were perceived by the authorities as the most backward element of the peasantry, women were able to resist far more effectively, and with less severe repercussions, than men.

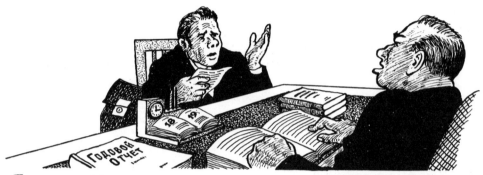

НА ПРИЁМЕ У МИНИСТРА...
(В ПЕРИОД ЗАСТОЯ, ЗАПОЯ, КАЗНОКРАДСТВА И ВЗЯТОЧНИЧЕСТВА)

–ТОВАРИЩ МИНИСТР, НА СКОЛЬКО МИЛЛИОНОВ ДОПУСТИМЫ
ПРИРОСТЫ В МОЕМ ОБЪЕДИНЕНИ К МЕСЯЧНОМУ ПЛАНУ, ЧТОБЫ
НЕ ПОЛУЧИТЬ ОТ ВАС ВЫГОВОР ЗА СВОЮ САМОДЕЯТЕЛЬНОСТЬ?
– НА ВАШУ ПРОДУКЦИЮ, ТОВАРИЩ ГЕНЕРАЛЬНЫЙ ДИРЕКТОР,
ПОКА ОТВЕТ И РАЗРЕШЕНИЕ ДАТЬ НЕ МОГУ. ЭТОТ ВОПРОС НАДО
СОГЛАСОВАТЬ С ТОВАРИЩАМИ ИЗ СОВМИНА ЧТОБЫ НЕ ИДТИ
В РАЗБРОДЕ С ДРУГИМИ МИНИСТЕРСТВАМИ...

Text at the top reads: **'At a reception in a minister's office... (During the period of stagnation*, bingeing, embezzlement, and bribery)'**. The book on the desk reads: ***Annual Report***.

'Comrade minister, by how many millions of units can I go over the monthly quota at my company, so I don't run the risk of getting a reprimand and a warning from you for unauthorised activity?'

'I cannot give you an answer and approve production yet, comrade general director. We must consult and agree upon this issue with the comrades from the Council of Ministers, so as to conform with other Ministries.'

* The 'Era of Stagnation' was a phrase used by Gorbachev to describe the economic situation in the USSR during the Brezhnev years (1964–1982). The suggested causes of the stagnation vary, from over spending on defence and under spending on consumer goods, to a lack of reform, leading to an unproductive workforce. In 1961 Khrushchev had declared that the USSR would achieve 'Communism in twenty years' (meaning that the USSR would move from socialism into 'higher-phase communism,' in accordance with Marxist theory). He was dismissed in 1964, following poor economic growth, and the phrase 'Developed socialism' was introduced to counter his statement. This term inferred that the USSR had reached such an advanced level, that evolution into higher-phase communism would be a natural progression. The timescale for this transformation was unspecified.

„Бесконечный путь к горизонту..."

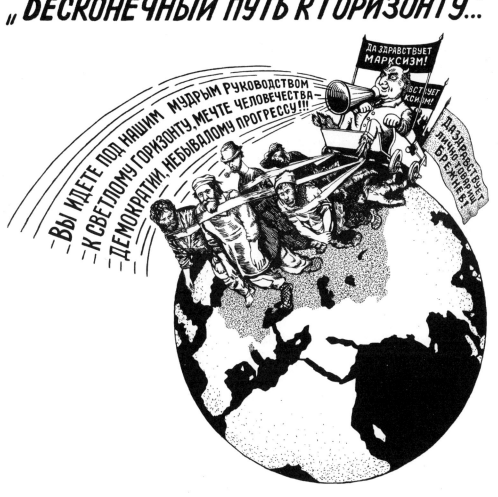

Text at the top reads: **'The endless road to the horizon…'**. Banners on the cart read: **'Long live Marxism!'**, **'Long live Comrade Brezhnev!'** Text from the megaphone reads: **'You are marching under our wise guidance to bright horizons, the dream of humanity – democracy and unheard-of progress!'***

* Here Baldaev makes another adaptation of *Barge Haulers on the Volga* by Ilya Repin (1870–1873; see page 183). In this version the figures are taken directly from the original painting, as is the message: a condemnation of such barbaric labour. In changing the barge of the original for the cart carrying the bureaucrat/devil, he is associating Soviet rule with Tsarist rule, illustrating that both systems allowed such conditions to prevail.

„Бюрократ — каковой он есть!..."

ТОВАРИЩИ! КАК ПОКАЗАЛ ОПЫТ ПРОШЕДШИХ 50-ТИ ЛЕТ НАШ ГЕРОИЧЕСКИЙ НАРОД НЕ МОЖЕТ ЖИТЬ БЕЗ БОРЬБЫ С ТРУДНОСТЯМИ И ЕСЛИ ИХ НЕТ НАДО СОЗДАТЬ ИСКУССТВЕННО ЧТОБЫ ПРЕОДОЛЕВАТЬ ИХ С БЛЕСКОМ!
ЗАПОМНИТЕ, ТОВАРИЩИ, НАША 70-ЛЕТНЯЯ ПАРТИЙНАЯ МУДРОСТЬ ДОКАЗАНА САМОЙ ЖИЗНЬЮ О ТОМ, ЧТО НИ В КОЕМ СЛУЧАЕ НЕЛЬЗЯ ЗАКАРМЛИВАТЬ НАРОД! СЫТЫЕ, ЗАКОРМЛЕННЫЕ, ОПЛЫВШИЕ ЖИРОМ НАРОДНЫЕ МАССЫ ТЕРЯЮТ ПОЛИТИЧЕСКУЮ АКТИВНОСТЬ! НАША ИДЕАЛЬНАЯ КАРТОЧНО-ТАЛОННАЯ СИСТЕМА НА МЯСО, МАСЛО И ДРУГОЕ БЕРЕЖЕТ ЗДОРОВЬЕ И ДУХ НАШИХ ТРУДЯЩИХСЯ ВОТ УЖЕ МНОГИЕ ДЕСЯТИЛЕТИЯ И СОХРАНЯЕТ ИХ ВЫСОКУЮ ПОЛИТИЧЕСКУЮ АКТИВНОСТЬ ПО ВСЕЙ НАШЕЙ СТРАНЕ...

The bureaucrat in all its glory...

'Comrades! The experience of the past fifty years suggests that our heroic people cannot survive without struggling with difficulties. If difficulties are absent, we must create them in order to overcome them with flying colours! Remember comrades: the seventy years of Party wisdom have proved by life itself that you cannot afford to overfeed the people! Complacent, overfed, with fat dripping from every pore of their bodies, the masses lose political activity. Our ideal ration system for distributing meat, butter, and other goods has been preserving the workers' physical health and spirit for many decades, while maintaining their political activity throughout the country...'

СССР- *ОПЫТНАЯ ЛАБОРАТОРИЯ...*

СОЮЗ СОВЕТСКИХ СОЦИАЛИСТИЧЕСКИХ РЕСПУБЛИК

- УВАЖАЕМЫЕ ЗАРУБЕЖНЫЕ КОЛЛЕГИ! Я КАК УЧЕНЫЙ ВООРУЖЕННЫЙ ПЕРЕДОВОЙ МАРКСИСТКОЙ ИДЕОЛОГИЕЙ СКАЖУ ВАМ, ЧТО СССР ДЛЯ НАС УЧЕНЫХ ЛИДОВ ЯВЛЯЕТСЯ ИДЕАЛЬНОЙ НАУЧНОЙ ЛАБОРАТОРИЕЙ С ОГРОМНОЙ ТЕРРИТОРИЕЙ В 22.402.000 КВ.КМ С БОЛЬШИМ ЛЮДСКИМ ПОДОПЫТНЫМ МАТЕРИАЛОМ В 205 МЛН ГОЛОВ, А ТАКЖЕ ЛАБОРАТОРИЯ ОБЛАДАЕТ ТРЕМЯ ПОЯСАМИ КЛИМАТА.МЫ ПРОВЕЛИ РАБОТЫ. НАПРИМЕР:
1.БЫЛИ СДЕЛАНЫ ФУНДАМЕНТАЛЬНЫЕ ИССЛЕДОВАНИЯ НА ВЫЖИВАНИЕ ПУТЕМ МАССОВОГО ГОЛОДА, ХРОНИЧЕСКОЙ НЕХВАТКИ ПРОДУКТОВ ПИТАНИЯ И ЭПИДЕМИЙ.
2.ПРОВЕДЕНЫ ЭКСПЕРИМЕНТЫ ПУТЕМ МАССОВОГО ОТСТРЕЛА НЕКОТОРЫХ ВИДОВ ПОПУЛЯЦИИ НАРОДОВ С ОПЫТНЫМ МАССОВЫМ ПЕРЕСЕЛЕНИЕМ В БОЛЕЕ ХОЛОДНЫЙ КЛИМАТ.
3. ЭТОТ БОЛЬШОЙ ПОДОПЫТНЫЙ ЛЮДСКОЙ МАТЕРИАЛ ХОРОШО ПОНИМАЕТ ВСЮ ВАЖНОСТЬ НАШИХ НАУЧНЫХ ИССЛЕДОВАНИЙ И С ВООДУШЕВЛЕНИЕМ ГОТОВ СЛУЖИТЬ НАУКЕ.
4. В ДАННОЕ ВРЕМЯ РАБОТАЕМ НАД ВЫРАЩИВАНИЕМ БОЛЬШОЙ ГРУППЫ БЮРОКРАТОВ...

Text at the top reads: **'The USSR as an experimental lab'**. Text at the top of the map reads: **'The Union of Soviet Socialist Republics'**.

'Dear foreign colleagues, take this from a scientist armed with the state-of-the-art Marxist ideology: for us learned Hadeses, the USSR is the ideal science lab with an enormous area of 22,402,000 square kilometres. It has plenty of human test material, counting about 205 million heads, and spans three geographical zones. We have carried out the following:

1. Conducted fundamental survival studies by inducing famine, chronic food supply shortages, and endemics.

2. Experimental mass shooting of certain people species and resettled others into the colder climates.

3. The aforementioned human material is well aware of the importance of our scientific studies and is fervently willing to serve in the interests of science.

4. Currently experiments in growing a substantial group of bureaucrats are underway...'

„БОНЗЫ ВСТРЕВОЖЕНЫ НИ НА ШУТКУ"…

СТОЛЬКО ЛЕТ ПРОЖИЛИ В СТРАХЕ И ПОВИНОВЕНИИ, А ТЕПЕРЬ ИМ ДЕМОКРАТИЮ ПОДАВАЙ!… А ВЕДЬ ЗАВТРА ЭТА РАБСИЛА ЗАЯВИТ, ЧТО И МЫ С ВАМИ ИМ НЕ НУЖНЫ…

Text across the top reads: **'The bigwigs* are seriously worried…'**. Text on the banner reads: **'Bring Solzhenitsyn†
back home!'**.

'For years they live in fear and obedience and now they're demanding democracy! What if tomorrow that
workforce declares they don't need us?'
'We are the best friends of Russian people…'

* The Russian word *bonzi* (translated here as 'bigwigs'), is from the Japanese *bonze*, an outmoded term for Buddhist monks. In
Russian, however, the term *bonza* (singular) is often used figuratively to refer to swaggering or conceited bureaucrats or any politician,
oligarch, etc.

† Aleksandr Solzhenitsyn (1918–2008) was a tireless critic of the Soviet system. A former gulag prisoner, his books such as *One Day in
the Life of Ivan Denisovich* (1962), and *The Gulag Archipelago* (1973–1978), brought world-wide attention to the atrocities of the gulag
and forced labour camp systems. Awarded the Nobel Prize in Literature in 1970, he was expelled from the USSR in 1974. In exile he
continued to make his opinions known, which were generally received with diminishing acclaim by other dissidents: 'It turned out, in
short, that everyone should or should not do one thing or another, and that only Solzhenitsyn knew what precisely that thing was. Submit –
or be condemned and excommunicated. Russians learned a good lesson. For the umpteenth time they had raised up an idol, and for the
umpteenth time, having barely settled on his pedestal, the idol began to kick, bite and spit in their faces…' Tatyana Tolstaya, *Pushkin's
Children: Writings on Russia and Russians*, 2003. Solzhenitsyn's Soviet citizenship was restored in 1990, and he eventually returned to
Russia in 1994.

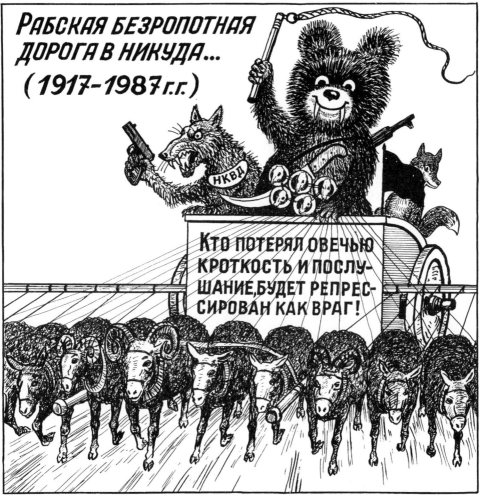

Text at the top reads: **'The submissive, slave road to nowhere... (1917–1987)'**. Text on the wolf's* chest reads: **'NKVD[†]'**. Text on the front of the chariot reads: **'Those who have lost their sheepish meekness and obedience will be persecuted as enemies!'**.

'You've got to keep the plebs in constant fear and submission, make them work, and not overfeed them...'

* The wolf, the bear, and the fox are typical protagonists of many Russian folk tales. In this drawing, the bear is depicted as the 1980 Moscow Olympics mascot named 'Misha'.
[†] NKVD – *Narodnyy Komissariat Vnutrennikh Del* (the People's Commissariat for Internal Affairs).

„РАЗДУТИЕ ШТАТОВ..."

ОТКРЫТИЕМ НОВЫХ ОТДЕЛОВ И ДРУГИХ ВСПОМОГАТЕЛЬНЫХ СЕЛЬХОЗТЕХНИКЕ ПОЛНОСТЬЮ ЛИКВИДИРОВАН РУЧНОЙ ТРУД.

Text on the left reads: **'Inflation of the personnel...'**. Text on the dog's lectern reads: **'Lecturer, propagandist, canvasser, ideologist-liar'***. Text above the cat reads: **'Ministry of Agriculture'**. Text above the rat reads: **'National Agricultural Industry'**[†].

[The dog announces:] Comrades! In the past years, as the managerial staff have got stronger, we have introduced additional units, opened up new departments and other auxiliary subdivisions in the Ministry, National Agricultural Industry, Head Food Industry, and Agricultural Machinery. This has enabled us to completely eradicate manual labour, increase the yield, and generally improve productivity.[‡]

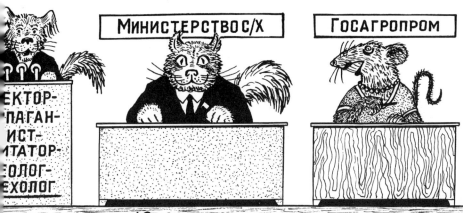

* The last word in the description is *brekholog*, a portmanteau of *brekh* — (from *brekhnya* 'lies') and *-log* '-logist.'

† The illustration caricatures a famous Russian fairy tale *The Giant Turnip*. It is a cumulative or chain tale (like *The House that Jack Built*, *The Gingerbread Man*, etc.), in which the grandfather plants a turnip that grows so big that he cannot pull it up himself. He then successively calls his wife, granddaughter, and then the dog, the cat, and finally the mouse to help him.

‡ True Soviets believed they could create a society populated by a better kind of person: New Soviet man. This ideal faded during the period of stagnation under Brezhnev, and the dissident writer Aleksandr Zinovyev came up with a comparable, derogatory term: *homo-Sovieticus* (the title of his eponymous book, published in 1986). *Homo-Sovieticus'* characteristics included a lack of initiative and responsibility which, coupled with an over-reliance on the state, led to a complete indifference in the results of his labour. Theft from the workplace was also regarded as normal (the line from a popular song 'everything belongs to the *kolkhoz*, everything belongs to me', was taken quite literally). Zinovyev believed himself to belong to the *homo-Sovieticus* species, in that he had been irrevocably tainted by the regime: 'I'm a Communist not in the sense that I believe in Marxist fairy-tales (very few people in the Soviet Union believe in them), but in the sense that I was born, reared and educated in a Communist society and have all the essential characteristics of Soviet man.' (The term *sovok* – from the Russian *sovokopniy*: a cooperative or a collective person – is also used to describe someone who still adheres to a Soviet mentality.)

Cake baking competition. Chelyabinsk, 1981.

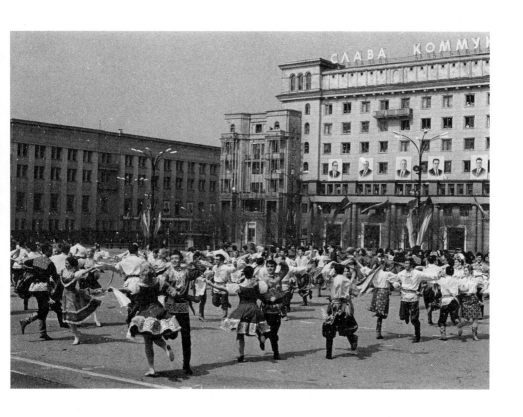

May Day celebrations in Revolution Square. Portraits of the Politburo adorn the surrounding buildings. Chelyabinsk, 1981.

Workers stand on a gantry at the Metallurgical Plant. Chelyabinsk, 1970.

Soldiers march in front of the Kremlin. Moscow, 1981.

CENSORSHIP, PARANOIA AND SUSPICION

Be Hyper-Vigilant!

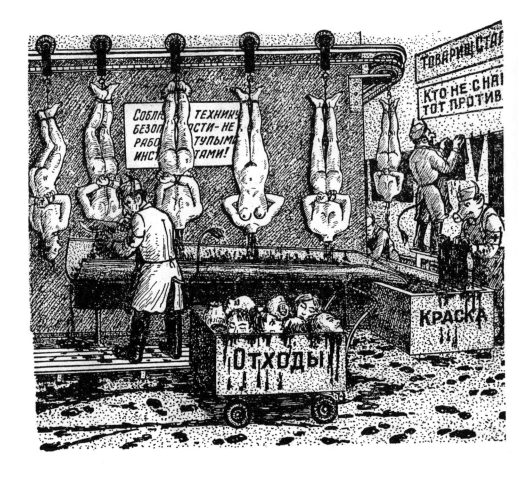

Sign behind the dead bodies reads: **'Follow safety rules – do not work with unsharpened tools!'**. Signs on the right read: **'Comrade Sta[lin . . .]'**, **'He who is not w[ith us] is aga[inst us]'**. Text on the box containing heads reads: **'Waste'**. Text on the other box reads: **'Paint'**.

The routine work of a slaughter and paint shop of the challenge red flags and banners* in the most democratic communist country in the world – Soviet Russia and the USSR.

*A mock title, based on the concept of the Transferable (or Challenge) Red Banner, which was an award given to winners of socialist competitions at various Soviet workplaces. Usually, there was a single physical copy of the award that was transferred to the next winner of the competition.

„ДОКУКАРЕКАЛСЯ О ДЕМОКРАТИИ..."

- Ну, что, гад, докукарекался! Всех больше кричал о демократии, правах человека! Кончилась твоя болтовня, за тобой пришли, я их вызвал! Скоро поедешь в Воркуту на уголёк, на лесоповал... Там будешь кричать комарам долой Сталина и Брежнева!

He blabbered too much about democracy.

'Well, mister, now you've done it! Your yapper was loudest when you were blabbing about democracy and human rights. But now it's over for you. They came to take you away. I called them. Soon you'll be off to Vorkuta* to dig coal and fell trees. You're going to be yelling "Down with Stalin and Brezhnev!" to the mosquitoes now.'

* Vorkuta Gulag was a prison camp system in Siberia, established in 1932 to exploit the coal deposits of the region. The city of Vorkuta was created to support the camp. It was called 'the city of concentration camps' by Vladimir Ilyin in his book *Power and Coal: Miners Movement of Vorkuta, 1989–1998*, 1998. At its height there were 132 separate camps within this system. Officially closed in 1962, still a large number of people living in Vorkuta and the surrounding area are former prisoners and their descendants, who were unable to escape the system.

В ПСИХИАТРИЧЕСКОЙ БОЛЬНИЦЕ

– ОН МИТИНГОВАЛ, КРИЧАЛ О ПРАВАХ ЧЕЛОВЕКА, ХЕЛЬСИНКСКОМ СОГЛАШЕНИИ, ТРЕБОВАЛ ПРОКУРОРА, ОКАЗАЛ СОПРОТИВЛЕНИЕ И ПРИШЛОСЬ ЗАПЕЛЕНАТЬ В СМИРИТЕЛЬНУЮ РУБАШКУ, ЗАТКНУТЬ КЛЯПОМ РОТ!
– Я ВИЖУ ЭТО НАШ! БУДЕМ ЛЕЧИТЬ ОТ БРЕДОВЫХ ИДЕЙ! ПОМЕСТИТЕ БОЛЬНОГО В ПАЛАТУ №6, БУДЕМ ВВОДИТЬ КЛИЗМЫ И БАРБИТУРЫ...

In a psychiatric hospital.

'He was protesting at a rally, shouting about human rights and the Helsinki Declaration*. He demanded to see a prosecutor and resisted the authorities. We had to put him in a straightjacket and gag him.'
'I see he's one of ours. We'll cure him of his nonsensical ideas. Take him to Ward No. 6†. We'll give him enemas and barbiturates‡.'

* A declaration signed in 1975 in Helsinki, Finland, between the Communist bloc and the West in an attempt to improve relations.
† A reference to *Ward No. 6* (1892) a story by Anton Chekov in which the chief doctor becomes a patient in his own asylum. Lenin claimed that *Ward No. 6* was the book that turned him into a revolutionary. However, Baldaev is pointing out the close resemblance between the 'mentally ill' of both pre- and post-revolutionary Russia.
‡ 'Soviet officials began having dissidents diagnosed as insane back in the 1960s, and came to appreciate the value of psychiatric drugs in social control. These chemicals could sedate or torture anyone who refused to obey orders, or who acted differently. ... [Many dissidents endured] regular injections of sulphazin. That was a suspension of sulphur in peach oil, which had no medical use beyond causing pain and inducing fever.' Oliver Bullough, *The Last Man in Russia*, 2013.

Text across the top reads: **'All troubles in the Soviet Union come from the US imperialists and Zionists'**. *Poster on the left reads:* **'The USA has the entire world in the grip of fear!'**. *Poster behind the bureaucrat reads:* **'KKK [Klu Klux Klan]'**.

The enemies of the Soviet Union accuse us communists of causing the complete destruction of the economy, industry, agriculture, science, and morals* of the country. But they neglect to mention the undermining elements that have been sent over here by the United States at the request of the CIA, who are in fact responsible for all the above...

* Many methods were found to smuggle unauthorised material into the country. Once across the border, copies would be made and distributed through underground methods. This often involved tremendous ingenuity '... it was impossible to get records and it was before the era when audio cassettes were easy to find. "We had friends who worked in medical clinics and they would steal used X-rays," Kolya said. "Someone would have a primitive record-making machine and you would copy the music by cutting the grooves in the material of the X-rays. So you'd be listening to a Fats Domino tune that was coming right off of the X-ray of someone's long-forgotten broken hip. They called that 'On the Bones'."' David Remnick, *Lenin's Tomb: Last Days of the Soviet Empire,* 1994.

МОЙ СОСЕД МАРСИАНСКИЙ ШПИОН….ПО НОЧАМ ПЕРЕДАЕТ СВЕДЕНИЯ…..

'My neighbour is a Martian spy. He collects information and sends it off at night...'

'One day the spring I turned eight, I was playing in our courtyard in the sand, building a castle for a rubber hippopotamus. Suddenly an old man and an old woman towered above me. The old woman had fat, swollen legs, and the old man breathed with a slow asthmatic wheeze. "Is this the right way to the Botanical Gardens?" he asked. *There they are*, I thought. *Enemies!* I answered instantly, brave, almost without a tremble in my voice: "No, you're going the wrong way. You need to go back that way." "Thank you so much," replied the old man. The couple turned slowly and headed back. I sat in the sandbox and watched them go, the hippopotamus clutched in my hands. My heart thumped. I had just done something heroic! I had fended off spies! Something was wrong with this picture. I felt an acute surge of shame. Suddenly, in one overwhelming moment – a moment I shall never forget – the truth was revealed to me. [...] I clearly saw the couple as old people who had lived a long, loving life, had survived a terrible war, gone hungry, suffered illness, been crippled; who perhaps – in fact even certainly – lost friends and loved ones in the recently ended massacre of peoples. I saw them decending the steep staircase of their home slowly, step by step, in order to go to the gardens, to sit on a bench, enjoy the young leaves and spring flowers on this warm day, in what might be their last spring. I saw the lies and vileness of my teachers, their paranoia, their ruthlessness, their sadism. I heard the scrape and clank of the cogs in the state propaganda machine, a machine that had forgotten why it was turning. And at that moment, burning with shame, I swore a silent oath: *Never*. But *never* what? I couldn't explain, and no one asked me.' Tatyana Tolstaya, *Pushkin's Children: Writings on Russia and Russians*, 2003.

ВСЕГДА ВЕСЕЛЫЕ, УЛЫБАЮТСЯ...
ЖИВУТ НЕ ПОСРЕДСТВАМ...
По НОЧАМ ВАРЯТ КУРИЦУ...
ТАК ДВЕРЬ ВСЕГДА ЗАКРЫВАЮТ НА ВНУТРЕННИЙ КЛЮЧ...
И РАЗГОВАРИВАЮТ В КОМНАТЕ ТИХО ПОДОЗРИТЕЛЬНО ...

Always smiling and happy... Live beyond their means... Boil chicken at night... Always lock the door to their room from inside... And talk quietly in their room... Very suspicious...' Text on the paper reads: **'Report*'**.

* 'Those who grew up under Brezhnev were slowly crushed by a great invisible weight. "Most conformed out of laziness, hopelessness," the music critic Alex Kahn told me one night. "When I was eighteen and in my first year of college, I was picking apples on a collective farm and I was talking to a friend of mine every day in the field. And I remember how we concluded that we were living in the most sophisticated dictatorship that has ever existed on this planet. The force of the propaganda was so strong that there could never be a revolution from below. I knew all about Sakharov and the other dissidents, but they were on a tiny island off by themselves. The system had permeated society at every level. It was everywhere. No one was being tortured, as in the Middle Ages or under Stalin – or, at least, not many. But the system was unshakable because it penetrated society so thoroughly. You could talk openly only with your closest friends, and even that was not always safe."' David Remnick, *Lenin's Tomb: Last Days of the Soviet Empire*, 1994.

„ИНСТРУКТАЖ ОБЛАДАТЕЛЕЙ ТУРИСТИЧЕСКИХ ПУТЕВОК ДЛЯ ВЫЕЗДА ЗА РУБЕЖ..."

– ТОВАРИЩИ! ВЫ ВСЕ ЕДЕТЕ ЗА РУБЕЖ В СОЦСТРАНЫ И ВЫСОКО НЕСИТЕ ДОСТОИНСТВО СОВЕТСКОГО ГРАЖДАНИНА! БУДЬТЕ БДИТЕЛЬНЫ, ВРАГ НЕ ДРЕМЛЕТ, ТАМ ЕСТЬ ЕЩЕ МНОГО НЕ ДОБИТЫХ НАШИХ ВРАГОВ. В РУМЫНИИ ОТРЕБЬЯ АНТОНЕСКУ, ВЕНГРИИ ХОРТИ, ГДР ГИТЛЕРОВЦЕВ, ПОЛЬШЕ АНДРЕСОНОВЦЕВ, БОЛГАРИИ МИХАЙЦЕВ, ЧЕХОСЛОВАКИИ ИЗ ГРУПП БЕНЕША. НЕ ОТРЫВАЙТЕСЬ ОТ СВОЕЙ ГРУППЫ, СЛЕДИТЕ ДРУГ ЗА ДРУГОМ, НЕ ПОДДАВАЙТЕСЬ НА ПРОВАКАЦИИ, ИЗБЕГАЙТЕ КОНТАКТОВ С ЖИТЕЛЯМИ...

Text at the top reads: **'A briefing for holders of tourist vouchers for travelling abroad...*'**. The top poster reads: **'Vigilance, vigilance, and vigilance again![†]'**. The bottom poster reads: **'Be alert! The enemy is eavesdropping!'**.

'Comrades! You are all travelling abroad to the Eastern Bloc countries. Carry the honour of the Soviet citizen with your head held up high! Be vigilant, the enemy never sleeps. Many of our enemies still lurk out there: Antonescu's scum in Romania*, Horthy in Hungary[†], Hitler's followers in the DDR, Anders's in Poland[‡], Mihov's in Bulgaria[§], and Beneš's groups in Czechoslovakia[II]. Don't fall behind your group, keep an eye on each other, don't fall for provocations, and avoid any contacts with locals...'

* Ion Antonescu (1882–1946), Romanian authoritarian politician and convicted war criminal. Executed after a trial in 1946.
[†] Miklós Horthy (1868–1959), Hungarian Regent and Head of State from 1920 and until his deposition in 1944. Allied with Nazi Germany.
[‡] Władysław Anders (1892–1970), a Polish general. During WWI he served Czar Nicholas II, then joined the Polish army. Later he was imprisoned by the Soviets but was released shortly after Germany attacked the Soviet Union in 1941, with the goal of forming an army that would fight alongside the Red Army. In 1946, he was deprived of Polish citizenship and military rank by the Soviet-installed communist government in Poland. He was exiled to London until his death in 1970.
[§] Nikola Mihov (1891–1945), general, minister, and later Regent of Bulgaria. He sided with Bogdan Filov, a pro-Nazi Bulgarian Prime Minister, and was demoted and arrested by the pro-Soviet government in 1944, then executed in 1945. In 1996 he was posthumously rehabilitated by the Supreme Court of Bulgaria.
[II] Edvard Beneš (1884–1948), Minister of Foreign Affairs and the second President of Czechoslovakia. Not a Communist himself, he was forced to resign his presidency in 1948 after a Communist-dominated government was installed.

Text across the top reads: **'Be hyper vigilant! Imperialists send their spies and saboteurs masquerading as tourists to the Soviet Union all the time!'** Text on the bottle in the boy's right hand reads: **'Plague'**. Text on the bottle hanging at the boy's side reads: **'Taburn*'**. Text on the spray can in the woman's right hand reads: **'Poison'**. Text on the cassette player underneath reads: **'Record'**. Text on her backpack reads: **'Leaflets'**. Text on the tube at her side reads: **'Dynamite sticks'**. Text on her suitcase reads: **'AIDS, Syphilis, Murrain[†]'**. Text on the man's purse reads: **'For bribes'**. Text on his backpack reads: **'Anti-Soviet literature; Bibles'**. Text on his suitcase reads: **'Morphine, Heroin, Hashish'**.

Do not engage in any contact with foreigners (from the Communist states or capitalist countries)! The enemy is cunning, guileful, and merciless!

* A nerve agent. It is an extremely toxic, clear, colourless and tasteless chemical weapon.

[†] Any infectious cattle disease, particularly foot-and-mouth disease.

Птичьи интервью...

- В ТРЁХ СЛОВАХ, КАК ВЫ ВСЕ ХАРАКТЕРИЗУЕТЕ СВОЮ СТРАНУ?
- ЭТО ОГРОМНАЯ КЛЕТКА, ГДЕ У ВСЕХ ПОДРЕЗАНЫ КРЫЛЬЯ, ПРО-
ИЗВЕДЕНО ПОГОЛОВНОЕ ОКОЛЬЦЕВАНИЕ И ВЫБИТЫ МОЗГИ...

Bird interviews...

'How would you characterise your country in a few words?'
'It's a huge cage, where everybody has his wings clipped, and every single person is banded and brainwashed*.'

* '[Andropov stated that] the secret of the Soviet Union's survival was constant vigilance. "We simply do not have the right to permit even the smallest miscalculation here, for in the political sphere any kind of ideological sabotage is directly or indirectly intended to create an opposition which is hostile to our system – to create an underground, to encourage a transition to terrorism and other extreme forms of struggle, and, in the final analysis, to create the conditions of the overthrow of socialism."' Oliver Bullough, *The Last Man in Russia*, 2013.

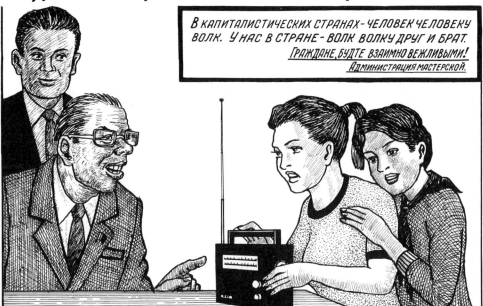

ПРИЧИНЫ РАДИОПОМЕХ ЗАРУБЕЖНЫХ РАДИОСТАНЦИЙ, ТРАНСЛИРУЮЩИХ НА СССР...

В КАПИТАЛИСТИЧЕСКИХ СТРАНАХ- ЧЕЛОВЕК ЧЕЛОВЕКУ ВОЛК. У НАС В СТРАНЕ - ВОЛК ВОЛКУ ДРУГ И БРАТ.
ГРАЖДАНЕ, БУДТЕ ВЗАИМНО ВЕЖЛИВЫМИ!
Администрация мастерской.

- У ВАС В МАСТЕРСКОЙ РЕМОНТИРУЮТ РИЖСКИЕ РАДИОПРИЁМНИКИ?
- МЫ РЕМОНТИРУЕМ ВСЕ, КРОМЕ ЯПОНСКИХ! ЧТО С НИМ СЛУЧИЛОСЬ?
- Я ХОТЕЛА СЛУШАТЬ „БИ-БИ-СИ", „ГОЛОС АМЕРИКИ", КОТОРЫХ НЕ ГЛУШАТ, НО ВСЕ ВРЕМЯ СЛЫШАТСЯ ЗАВЫВАНИЯ, ТРЕСК И ШУМ...
- КАК СПЕЦИАЛИСТ Я ЗНАЮ, ЧТО В АНГЛИИ, США И В ФРГ СЛАБЫЕ И УСТАРЕВШИЕ РАДИОСТАНЦИИ И ИХ РАДИОВОЛНЫ ЧАСТО ВЕТЕР ОТНОСИТ В СТОРОНУ ОТ СССР И ВИНОВАТЫ В ЭТОМ АТЛАНТИКА, ДОЖДЬ, СНЕГ И Т.Д.

Text across the top reads: **'The causes for radio interference of international radio stations broadcasting in the Soviet Union'**. The sign below reads: **'In capitalist countries, a man is a wolf to his fellow man. In this country a wolf is a friend and brother to his fellow wolf. Citizens, be polite to each other. – The administration of the repair shop'**.

'Can your shop repair this Riga-made radio?'

'We can repair any radios, except Japanese-made ones. What happened to it?'

'Well, I wanted to tune in to the BBC and the Voice of America, because they are not being jammed, but I could still hear noises, and static, and some crackling...*'

'As an expert I know the UK, USA, and FRG all have weak and outmoded broadcasting equipment. Their radio waves are often blown away from the USSR by the wind. You can blame the Atlantic, the rain, the snow, etc.'

* The jamming of the Voice of America and BBC was stopped in September 1986 (while some other radio stations where still being jammed). On 30 November 1988 all radio jamming was stopped.

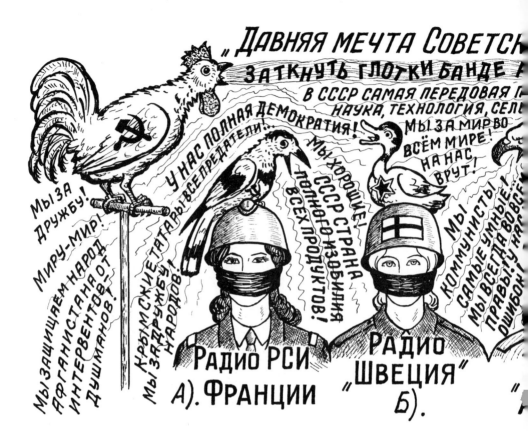

Text across the top reads: **'The long-coveted dream of the Soviet Golden Radio Cockerel…'**, text directly underneath reads: **'To shut up the band of radio-saboteurs* and hooligans!'**. Text to the left of the cockerel's post reads: **'We are for friendship! World peace! We protect the people of Afghanistan from Mujahideen invaders!'**. Text under woman on far left reads: **'A) RSI Radio, France'**, the magpie on her head proclaims: **'We are nice!'**, **'The USSR is the country of abundance of all types of goods and services!'**. Text under woman on far left reads: **'B) Radio Sweden'**, the duck on her head proclaims: **'We have complete and utter democracy!'**, **'Crimea Tatars are all traitors!'**, **'We are for friendship between the peoples!'**. Text under woman in the centre reads: **'V[†]) Voice of America radio'**, the parrot on her head proclaims: **'We Communists are the smartest people…'**, **'We are always right about everything!'**, **'We are infallible!'**.

* 'By far the most effective Cold War "weapon" was Radio Free Europe, a broadcasting service based in Munich, funded by the US government but staffed by émigrés and exiles, broadcasting in their own languages. Radio Free Europe ultimately proved defective not because it offered counter-propaganda, but because it reliably reported the news of the day.' Anne Applebaum, *Iron Curtain: The Crushing of Eastern Europe 1944–1956*, 2012.
[†] The Russian alphabet runs: A, B, V, G, D, E etc.

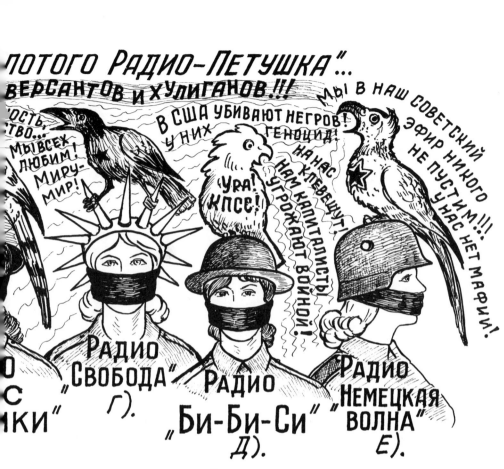

[‡] See footnote on page 68.

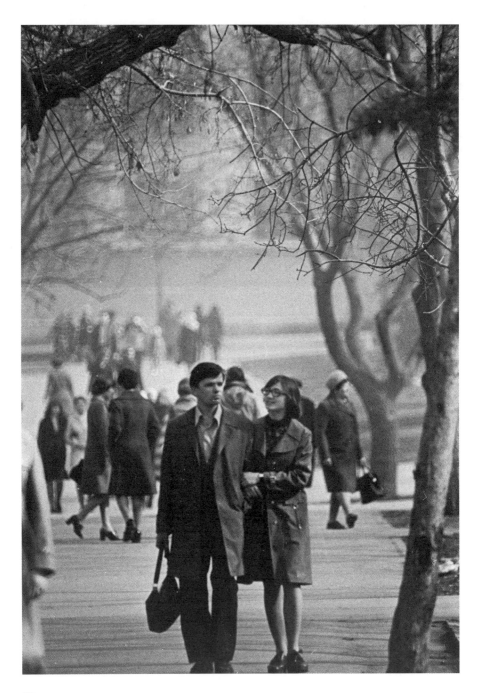

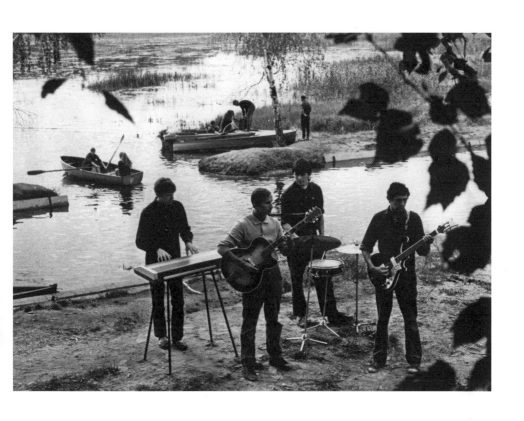

Above A band plays on the shore of the boating lake. Chelyabinsk, 1979.
Left A couple stroll along Lenin Avenue. Chelyabinsk, 1978.

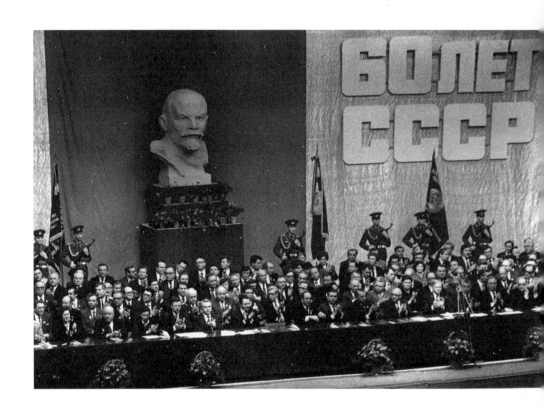

The Politburo (the governing body of the Soviet Union) celebrates sixty years of the USSR. Moscow, 1977.

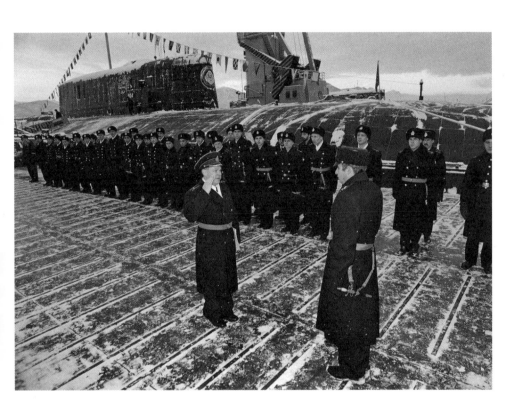

The nuclear submarine 'Chelyabinsk'. Krasheninnikov Harbour, Kamchatka Peninsula, 1990.

THE TRANSITION

May Everything Continue To Be The Way It Has Always Been!

ПЕРЕСТРОИЛИСЬ

АКТУАЛЬНАЯ БАСНЯ

ЮРИЙ БОГДАНОВ

МЕДВЕДЬ ДО МЕДА НЕ ДОБРАЛСЯ,
ХОТЬ БЫЛ У САМОГО ДУПЛА.
С БОЛЬШОГО ДЕРЕВА СОРВАЛСЯ,
КОГДА УЖАЛИЛА ПЧЕЛА.
КЛЯНЕТ МЕДВЕДЬ СВОЕ ПАДЕНЬЕ,
ОТ БОЛИ СЪЕЖИЛСЯ В КОМОК.
ОН ПОНЯЛ СУЩНОСТЬ УСКОРЕНЬЯ,
А ПЕРЕСТРОИТЬСЯ – НЕ СМОГ.
КАБЫ НЕ ВОЗРАСТ ПЕНСИОННЫЙ,
ЗА МУРАВЕЙНИК И ЗА ПЧЕЛ
ПОНЕС БЫ НАКАЗАНЬЕ ОНЫЙ,

А ТАК... НА ПЕНСИЮ УШЕЛ.
СОЛИДНЫЙ ПОСТ БЫЛ, ЛИХО ПРАВИЛ,
ДОВЕЛ ХОЗЯЙСТВО ДО БЕДЫ
И В ЖИЗНИ ЛЕСА ОН ОСТАВИЛ –
ЛИШЬ КОСОЛАПЫЕ СЛЕДЫ...
В БЕРЛОГЕ – НЕ НУЖНА СМЕКАЛКА,
СОСИ ЛИШЬ ЛАПУ – ВОТ МОРАЛЬ:
ТАКИХ МЕДВЕДЕЙ НАМ НЕ ЖАЛКО!
ЗАГУБЛЕННОЕ ДЕЛО ЖАЛЬ!..

Text at the top reads: **'They have reformed*'**. Text on the turnip reads: **'The 1986 Plan†'**. Text underneath reads: **'Relevant Fable, Yuri Bogdanov'**. Fable reads: **'The bear missed the honey, / Although he was just by the hollow of a tree. / He fell from the tree, / Stung by a bee. / The bear is cursing at his fall, / Curled up in a ball from the pain. / He learned the essence of acceleration, / But failed to reform. / If he hadn't been close to retirement age, / He would have had to answer, / For disturbing the anthill and the bees. / Instead, he simply retired. / He used to have a cushy job, / And managed to destroy the economy. / Alas, the only tracks he left behind in the woods, / Were of his clumsy feet. / There is no need for wit in the lair, / No wit to suck on your paw, and here's the moral of the tale: / We don't feel sorry for such bears, / We're sorry for the work they've botched.'**

* The order of characters in 'The Giant Turnip' is in reverse; hence the 'they have reformed'. In Russian the caption reads *perestroilis*, from *perestraivatsya* 'to reform'. The term perestroika comes from the same root and prefix.

† The final (twelfth) complete Soviet Five-Year Plan ran from 1986–1990.

М.С. ГОРБАЧЕВ В ПЛОТНОМ КОЛЬЦЕ ОППОЗИЦИИ БЮРОКРАТОВ. 1986 г.

— ЧТО ОН ТАМ ВЫДУМЫВАЕТ СО СВОИМИ ДРУЖКАМИ КАКУЮ-ТО ПЕРЕСТ-
РОЙКУ, ГЛАСНОСТЬ И ЕЩЕ ЧТО-ТО? НАМ НИЧЕГО НЕ НАДО! ВОТ УЖЕ 30
ЛЕТ МЫ ЖИВЁМ ПРИ ПОЛНОМ КОММУНИЗМЕ, ДЕТЕЙ, ВНУКОВ И РОД-
НЮ УСТРОИЛИ, ВСЕМ ОБЕСПЕЧИЛИ И ИМ ЭТОГО НА 5-ТЬ ЖИЗНЕЙ ХВА-
ТИТ И ДАЖЕ ПРА-ПРА ВНУКАМ! ЭТОТ ГОРБАЧЕВ ОЧЕНЬ ОПАСЕН НАМ...

Mikhail Gorbachev surrounded by the opposition of bureaucrats. 1986.

'What kind of nonsense are he and his pals concocting? Some sort of perestroika, glasnost, or whatnot? We don't want any of it. We've been living in total communism for thirty years now. We've arranged lives and careers for our children, grandchildren, and the rest of our relations. We've provided them with so much it'll last five generations or more! That Gorbachev spells danger to all of us...'

Text across the top reads: **'First Secretary of the Raion* Committee of the Communist Party calls up Head of the Raion Department of Internal Affairs, Public Prosecutor, and chairs of People's Court and People's Control Committee**[†] **into his office for a reprimand'**. Text on the books in the people's hands reads (left to right): **'Public Prosecutor'**; **'Laws of the USSR'**; **'People's Control'**. Text on the book on the First Secretary's desk reads: **'Criminal Case No. 46008'** [under this is the name of the accused, and numbers of articles of the Criminal Code of the RSFSR]. Text on the books on the adjacent desk reads: **'Raion Marketing'**; **'Vegetable...'**.

РУВД, ПРОКУРОРА РАЙОНА, ПРЕДСЕДАТЕЛЕЙ
НЕТ ПЕРВОГО СЕКРЕТАРЯ РК КПСС...

'УЧШИХ РУКОВОДИТЕЛЕЙ ОРГАНИЗАЦИЙ И ПРЕДПРИЯТИЙ
'ОВАЛИСЬ ОБЪЯВЛЕННОЙ ГЛАСНОСТИ И ПЕРЕСТРОЙКЕ, ЗА-
'ОЛЯ ПАРТИИ! ОТНЫНЕ НИ ОДНОГО ЧЛЕНА КПСС БЕЗ МОЕЙ
'И ОТБЕРУ ПАРТБИЛЕТЫ, ПОНЯТНО! ВОН ОТСЮДА!...

'These bureaucrats dared raise their hands against the best heads of organisations and enterprises of the raion –
accusing them of embezzlement and doctoring records – without permission! They seem to have jumped on
the bandwagon of glasnost and perestroika too early. Forgetting who the boss of the raion was, they tried to escape
the control of the Party. From now on not a single member of the Communist Party should be bothered without
my personal permission, or else I'll fire you all and take away your Party membership. Is that clear? Now scram!'

* *Raion* – an administrative division in the USSR and Russia.
† A semi-civic, semi-government organisation for scrutinising the activities of the government, local administrations, and enterprises.
See also page 77.

НИКАКОЙ ГЛАСНОСТИ О ПРЕСТУПНОСТИ В СССР! ЭТОГО ХОТЯТ НАШИ ИДЕОЛОГИЧЕСКИЕ ВРАГИ!...

–КЕЛЬЗЯ РАЗГЛАШАТЬ ГОСУДАРСТВЕННУЮ ТАЙНУ О ПАРТИЙНО-ХОЗЯЙСТВЕННЫХ МАФИЯХ, КОРРУПЦИИ, ВЗЯТОЧНИЧЕСТВЕ, ХИЩЕНИЯХ, ШИРОКОЙ СПЕКУЛЯЦИИ, УБИЙСТВАХ, РАЗБОЯХ, ГРАБЕЖАХ, МАССОВОМ ВОРОВСТВЕ, НАРКОМАНИИ, ПРОСТИТУЦИИ И НАЦИОНАЛИЗМЕ! ЭТО ВСЁ НЕ ХАРАКТЕРНО ДЛЯ СОЦИАЛИЗМА! ВСЁ ПРОИСХОДИТ ОТ ТЛЕТВОРНОГО ВЛИЯНИЯ ЗАПАДА И ПРОНИКНОВЕНИЯ ИДЕОЛОГИИ ИМПЕРИАЛИЗМА, НАДО ЗАКРЫТЬ ВСЕ КАНАЛЫ!

There will be no glasnost about crime levels* in the USSR! That's exactly what our ideological enemies want us to do!

'We cannot divulge national secrets about the Party and economic mafia, corruption, grafting, embezzlement, widespread speculation, murders, robberies, theft, mass stealing, drug abuse, prostitution, and nationalism! All these traits are uncharacteristic of socialism! They all stem from pernicious Western influences and the penetration of imperialist ideologies! We must cut off all channels of information!'

* 'Although the Soviet Press and radio give extensive coverage to crime in the West, the persistence of crime in the Soviet Union remains an ideological embarrassment to which relatively little attention is drawn. Detailed crime statistics for the USSR are never published, and a Soviet journalist, L. Vladimirov, who defected to Britain in 1966, has confirmed that: "It is forbidden to mention … the number of crimes in any category for the country as a whole or for regions, districts, provinces or cities." The basic Marxist premise is that crime is a socio-economic phenomenon: "the elimination of private property in the means of production, the eradication of the exploitation of one person by another, and the resolution of social antagonisms led to the disappearance of basic social roots of crime [in the USSR.]".' Open Society Archives, *Crime In The Soviet Union*, 1973.

ПЕРЕСТРОЙКУ БЮРОКРАТЫ ТОП-ЯТ В ПУСТОПОРОЖНЕЙ БОЛТОВНЕ...

— ВОТ ВЫ РАБОЧИЕ ЗАВОДА, ВЕРИТЕ В ПЕРЕСТРОЙКУ, ГЛАСНОСТЬ?
— ИЗВИНИТЕ, ТОВАРИЩ КОРРЕСПОНДЕНТ, ЗА ОТКРОВЕННОСТЬ. В ПЕРВОЕ ВРЕМЯ
БЫЛИ ПРОБЛЕСКИ КАКОЙ-ТО НАДЕЖДЫ НА УЛУЧШЕНИЕ, А ТЕПЕРЬ ОНИ УЛЕ-
ТУЧИЛИСЬ. ЭТИ ГОДЫ ПУСТОЙ БОЛТОВНИ ВСЕМ НАДОЕЛИ! КАК БЫЛИ ШТУР-
МОВЩИНА, ВЫПУСК БРАКА, ПРИПИСКИ, ПЬЯНСТВО, ВОРОВСТВО, КОМАНДН-
ЫЕ МЕТОДЫ ТАК И ПРОДОЛЖАЮТСЯ. БЮРОКРАТЫ И БЕЗДЕЛЬНИКИ ВСЕ
СИДЯТ НА МЕСТАХ. В ПЕРЕСТРОЙКУ И ГЛАСНОСТЬ ВЕРЯТ ТОЛЬКО ДЕТИ В
ДЕТСКОМ САДИКЕ ПО СВОЕЙ НАИВНОСТИ И ГЛУПОСТИ...

Bureaucrats drown perestroika in idle, empty blabber...

'Tell me, do you plant workers believe in perestroika and glasnost?'
'I'm going to be brutally honest with you. In the beginning there were glimpses of hope for the better here and there. Now there's no hope left. People have become sick and tired of these past years of empty blabber. Just as we had last-minute rushes, defective goods, falsified production records, alcoholism, theft, and directive methods before – we still have all of them now. Bureaucrats and loafers still have their jobs. Only kindergarten children believe in perestroika and glasnost, because they're young and naïve...'

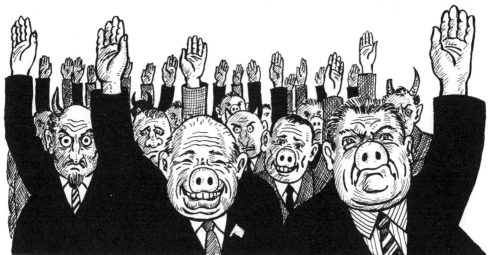

„ЯРЫЕ ВРАГИ РЕВОЛЮЦИОННОЙ ПЕРЕСТРОЙКИ И ГЛАСНОСТИ-ПАРТИЙНЫЕ БОНЗЫ, БЮРОКРАТЫ И СИОНИСТЫ..."

МЫ ВСЕ ПРОТИВ! ТАК МОЖНО ДОКАТИТЬСЯ ДО ЛЕНИНСКОГО ПАРТМАКСИ-МУМА И ЛИШИТЬСЯ ВСЕХ ПРИВЕЛЕГИЙ, СПЕЦРАСПРЕДА, СПЕЦЛЕЧЕНИЯ, КРЕМЛЕВКИ И НАШИ ЖЕНЫ, ДЕТИ И РОДНЯ БУДУТ БЕГАТЬ ПО МАГАЗИНАМ, ГДЕ НЕТ ХОРОШИХ ПРОДУКТОВ ПИТАНИЯ И ПРОМТОВАРОВ, КАК РАБОТЯГИ?..

Avid opponents of revolutionary perestroika and glasnost – party bigwigs, bureaucrats, and Zionists...

'We all vote against it! It smells like Lenin's party quota* and we'll lose all our privileges, preferential treatment, and special health care in the Kremlin. Will our wives, children, and relatives have to rush from one store to the next where there are no good groceries†, like simple working-class people?'

* A maximum monthly wage for party members occupying top positions in governmental organisations, which was abolished in 1934.
† Poor quality was endemic in the Soviet Union, a fact of everyday life for the average citizen. 'The decreptitude of ordinary life irritated the soul and skin. Towels scratched after one washing, milk soured in a day, cars collapsed upon purchase. the leading cause of house fires in the Soviet Union was television sets that exploded spontaneously. [...] The Exhibition of Economic Achievements, a kind of vast Stalinist Epcot Centre near the Moscow television tower, had for years put on displays of Soviet triumphs in the sciences, engineering, and space in huge neo-Hellenic halls. Vera Mukhina's gigantic statue *Worker and the Collective Farm Girl* (jutting breasts and biceps, bulging eyes) presided at the entrance, providing citizens with the sense that they were now part of a socially and genetically engineered breed of muscular proletarians. But with glasnost, the directors grew humble and put up an astonishingly frank display: "The Exhibit of Poor-Quality Goods." At the exhibit a long line of Soviets solemnly shuffled past a dazzling display of stunning underachievement: putrid lettuce, ruptured shoes, rusted samovars, chipped stew pots, unraveled shuttlecocks, crushed cans of fish, and, the showstopper, a bottle of mineral water with a tiny dead mouse floating inside. All the items had been purchased in neighbourhood stores. [...] The exhibit was unsparing, a vicious redefinition of socialist realism. In the clothing section red arrows pointed to uneven sleeves, faded colours, cracked soles. One piece of jewellery was labelled simply, "hideous", and no one argued.' David Remnick, *Lenin's Tomb: Last Days of the Soviet Empire,* 1994.

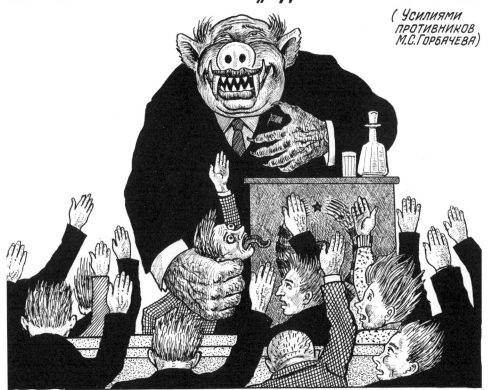

ВОТ ТАК ОБЪЯВЛЕНИЕ ГЛАСНОСТИ СКОРО ОПЯТЬ ПРЕВРАТИТСЯ В „ЕДИНОГЛАСНОСТЬ"...

(УСИЛИЯМИ
ПРОТИВНИКОВ
М.С.ГОРБАЧЕВА)

– ГЛАСНОСТЬ ДОЛЖНА БЫТЬ ГЛАСНОСТЬЮ В ДОЗВОЛЕННЫХ РАМКАХ ПАРТИЙНЫМ АППАРАТОМ, КАК ЭКОНОМИКА ДОЛЖНА БЫТЬ ЭКОНОМНОЙ! ВОТ К ПРИМЕРУ ДАННЫЙ ТОВАРИЩ ПЕРЕШАГНУЛ РАМКИ ДОЗВОЛЕННОЙ ГЛАСНОСТИ И ПОЛНОСТЬЮ ИЗОБЛИЧИЛ СЕБЯ ПЕРЕД НАМИ КАК ЗЛОБНЫЙ ВРАГ НАШЕЙ ПАРТИИ И НАРОДА... ВЫ ПОДУМАЙТЕ, ЧТО О НАС ГОВОРЯТ ИМПЕРИАЛИСТЫ ЗАПАДА ПОСЛЕ ТАКИХ ОГОЛТЕЛЫХ ВЫСТУПЛЕНИЙ С КРИТИКОЙ КПСС!...

This is how the announcement of the glasnost will soon become 'yedinoglasnost*'... (Thanks to the efforts of M. Gorbachev's opponents.)

'Glasnost must remain glasnost only within the limits set by the party apparat, just like the economy must be economical[†]. This comrade, for example, have stepped over the boundaries of approved glasnost and exposed himself as enemy of our party and our people. Think of what western imperialists will say about us after such blatant critiques of the Communist Party!'

* *Glasnost* or 'the fact of being public' comes from *glasny* 'public, open', which stems from *glas* 'voice, vote'. *Yedinoglasnost* from *yediny* 'single, one' and *glas* 'vote', that is, 'unanimity'.
[†] The phrase 'the economy must be economical' was used by Brezhnev in the speech he delivered at the 26th Congress of the Communist Party of the Soviet Union in 1981. The phrase has since become a popular way of mocking the Soviet regime. See pages 93 and 94.

УЧАСТНИК XIX ПАРТКОНФЕРЕНЦИИ СИЛЬНО ОБЕСПОКОЕН СПИСКОМ...

– НЕУЖЕЛИ ИЗ ЧЕТВЕРЫХ В СПИСКЕ У КОРОТИЧА, ПЕРЕДАННОГО ГОРБАЧЁВУ, И МОЯ ФАМИЛИЯ ЗНАЧИТСЯ? ГДЕ МОГ БЫТЬ ПРОКОЛ?! ЧТО Ж Я ОДИН БЕРУ ВЗЯТКИ! ВСЕ БЕРУТ!...

A delegate of the 19th Party Conference* is concerned about the list...

'Could *my* name be among the four people on the list made by Korotich[†], who's so faithful to Gorbachev? Where did I screw up? I'm not the only grafter! Everyone I know takes bribes!'

* The 19th All-Union Party Conference took place from 28 June to 1 July 1988. It was here that Mikhail Gorbachev launched radical reforms intended to reduce party control of the government apparatus. He also proposed a new executive in the form of a presidential system, as well as a new legislative element, the Congress of People's Deputies.
[†] At the Conference, Vitaly Korotich, chief editor of *Ogonyok* magazine – one of the first publications that actively supported perestroika and glasnost – submitted a list to Gorbachev. It contained the names of four top party officials that Korotich accused of grafting, alongside supporting evidence of his allegations. The named were among delegates at the Conference.

ДУБЫ-СТАЛИНИСТЫ ЖДУТ КОГДА КОНЧИТСЯ „ИГРА КПСС В ГЛАСНОСТЬ И ДЕМОКРАТИЮ"...

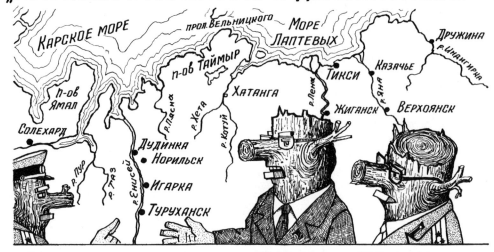

—СКОРО БУДЕМ СТРОИТЬ ГИГАНТСКУЮ ТУРУХАНСКУЮ ГЭС, ГДЕ КОГДА-ТО БЫЛ В ССЫЛКЕ НАШ ДОРОГОЙ ИОСИФ ВИССАРИОНОВИЧ СТАЛИН, И ПОТРЕБУЮТСЯ СОТНИ ТЫСЯЧ ЗАКЛЮЧЁННЫХ, КОТОРЫХ ВЫЯВИЛА „ГЛАСНОСТЬ" И ОНИ УЖЕ СОЗРЕЛИ ДЛЯ ЭТИХ РАБОТ В ЭСТОНИИ, ЛАТВИИ, ЛИТВЕ, АРМЕНИИ, А ТАКЖЕ КРЫМСКИЕ ТАТАРЫ, ЕВРЕИ, ТУРКИ КАВКАЗА И ДРУГИЕ. ЗАКЛЮЧЕННЫЕ БУДУТ ДОСТАВЛЯТЬСЯ ПО ЕНИСЕЮ НА БАРЖАХ КАК И ПРЕЖДЕ В ДУДИНКУ И НОРИЛЬСК. ЭТАПЫ БУДУТ ФОРМИРОВАТЬСЯ В КРАСЛАГЕ... ХОРОШЕЕ ВРЕМЯ ДЛЯ НАС НАСТАНЕТ, ВСЕ ПРИДЁТ „НА КРУГИ СВОЯ"...

Text across the top reads: **'Stalinist blockheads* are waiting out for the Communist Party to "get bored playing 'glasnost and democracy'"...'**. Seas on the map read (left to right): **'Kara Sea'**; **'Vilkitsky Strait'**; **'Laptev Sea'**. Text on the outcrops of land on the left read: **'Yamal Peninsula'**; **'Taymyr Peninsula'**. Names of the villages read: **'Salekhard'**; **'Khatanga'**; **'Tiksi'**; **'Kazaghie'**; **'Druzhina'**; **'Dudinka'**; **'Norilsk'**; **'Igraka'**; **'Turukhansk'**; **'Zhigansk'**; **'Verkhoyansk'**. River names read: **'Pur'**; **'Taz'**; **'Yenisei'**; **'Pyasna'**; **'Kheeta'**; **'Katui'**; **'Lena'**; **'Yana'**; **'Indigirka'**.

'Soon we'll begin constructing the gigantic Turukhan Hydropower Plant, around the place where our beloved Joseph Stalin once was in exile. We'll need hundreds of thousands of convicts that "glasnost" has exposed and who have already ripened for hard labour in Estonia, Latvia, Lithuania, and Armenia. We'll also need Crimean Tartars, Jews, Turks from the Caucasus, and others. The convicts will be shipped down the Yenisei on barges, just like they used to be shipped off before to Dudinka and Norilsk. The batches will be formed in Kraslag. Those will be good times. Everything will return to its normal course...'

* The first word Baldaev uses is *dub* meaning 'oak tree', characterising the stolid, retrograde attitude of the Stalinists – immovable like the stumps they are depicted as.

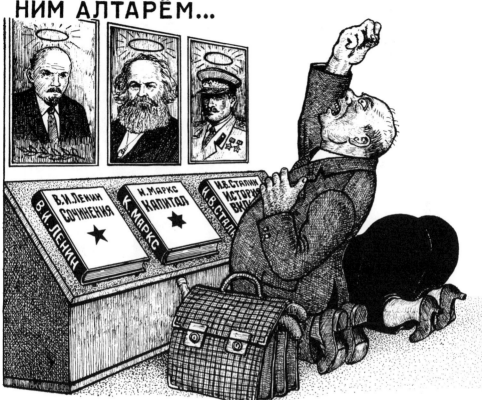

МОЛЬБА БЮРОКРАТА ПЕРЕД ДОМАШ-НИМ АЛТАРЁМ...

Books (left to right):
В.И.ЛЕНИН СОЧИНЕНИЯ / **В.И.ЛЕНИН**
Н.МАРКС КАПИТАЛ / **К.МАРКС**
И.В.Сталин ИСТОРИЯ / К.В.Стал ВКП

—ГОСПОДИ-ТОВАРИЩИ, СПАСИТЕ ОТ АНТИМАРКСИСТОВ-ПЕРЕСТРОЙ-ЩИКОВ НАШЕ МИНИСТЕРСТВО, ГЛАВКИ, НИИ, УПРАВЛЕНИЯ, ОБЪЕДИ-НЕНИЯ, ФИЛИАЛЫ ОТ СОКРАЩЕНИЯ! ПУСТЬ ВСЁ БУДЕТ ПОСТАРОМУ!

Text at the top reads: **'A bureaucrat is praying in front of an altar at home...'** The books are (left to right): **'Works, V. Lenin'**, **'Das Kapital, K. Marx'**, **'The History of the Communist Party, J. Stalin*'**.

'Lords, our Comrades, protect our chief directorates, research institutions, and managerial offices from perestroika-inclined anti-Marxists, and our branches from downsizing! May everything continue to be the way it has always been!'

* *The Concise History of the Communist Party* (*Kratky kurs istorii VKP(b)*), a course book first published in 1938. Although a collective work, its authorship is usually attributed to Stalin.

ЖЕНСКАЯ „ЖЕЛЕЗНАЯ"ЛОГИКА...

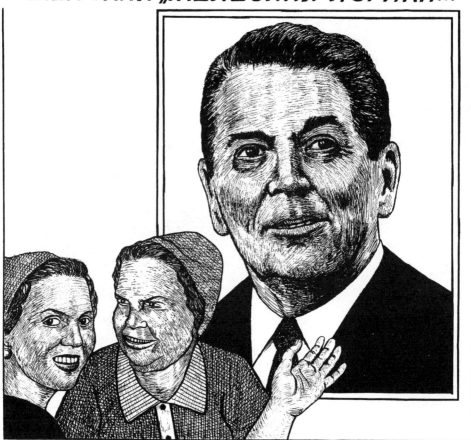

– ТОВАРИЩИ, КОГДА У НАС БУДЕТ ТАКОЙ ТАЛАНТЛИВЫЙ, ДАЛЬНОВИДНЫЙ, ДОБРЫЙ, ЧЕЛОВЕЧНЫЙ И ОЧЕНЬ КРАСИВЫЙ ПРЕЗИДЕНТ ?! У КОТОРОГО НАРОД НЕ ЗНАЕТ, ЧТО ТАКОЕ ТАЛОНЫ НА МЯСО, МАСЛО, САХАР, А ГРАЖДАНЕ ЕГО СТРАНЫ ЗАПРОСТО ЕЗДЯТ В ОТПУСК В ЛЮБУЮ СТРАНУ МИРА И ИХ НИКТО НЕ ПАСЁТ И НЕ ЗАОРГАНИЗОВЫВАЕТ ДО АБСУРДА, ДО ИДИОТИЗМА. ПРИ БРЕЖНЕВЕ НАШИ БЮРОКРАТЫ ТВЕРДИЛИ, ЧТО ОН НАШ ВРАГ №1 И ГОТОВИТСЯ НА НАС НАПАСТЬ ВМЕСТЕ С СОЮЗНИКАМИ ПО НАТО, ГДЕ ЖЕ ПРАВДА ?...

Female 'iron' logic

'When are we going to have such a talented, farsighted, kind, humane, and pretty President? The kind whose people don't know what meat, oil, and sugar ration cards are. Where the citizens of his country can easily go on vacation abroad, with nobody watching over their shoulder or driving them insane with planning and organising to the point of absurdity and idiocy. In Brezhnev's time our bureaucrats kept telling us that *he* was our number one enemy and that he was preparing to attack us along with his NATO allies. Where's the truth in all that?'

„ВЕСЕЛЬЕ В САУНЕ СЧИТАЮЩИХ СЕБЯ ЭЛИТОЙ..."

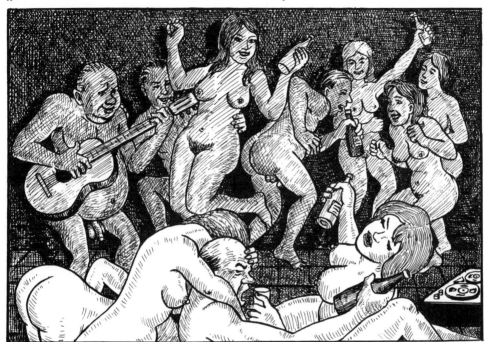

- ПЕЙ ЗА НАШУ ОБЩУЮ РАДОСТЬ - ЕЛЬЦИНА ВЫКИНУЛИ, АБОРТИ-
РОВАЛИ ИЗ КРЕМЛЯ, НАМ НЕ НУЖНЫ ЕГО СТРОГИЕ МОНАСТЫРСК-
ИЕ ПОРЯДКИ! ПУСТЬ ЕДЕТ В СВОЙ СВЕРДЛОВСК - НА УРАЛ, В СИ-
БИРЬ, ПОДАЛЬШЕ ОТ МОСКВЫ! КАК НАМ ХОРОШО БЫЛО РАНЬШЕ
ПРИ ГРИШИНЕ...

The so-called elite having fun in a sauna...

Drink and rejoice with us – they kicked Yeltsin out of the Kremlin, aborted him! We don't need his strict cloister-like regime. Let him go back to Sverdlovsk*, to the Ural Mountains, to Siberia... As far away from Moscow as possible! Boy was life great under Grishin.[†]

* Boris Yeltsin was born near Sverdlovsk.
[†] Viktor Grishin was First Secretary of the Moscow Communist Party in 1985–1987 until he was replaced by Yeltsin.

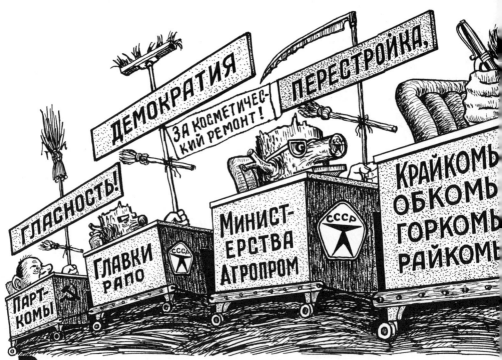

Text across the top reads: '**Bureaucrats refuse to let go of their privileges!***'. Text on the desks reads (left to right): '**Party Committees**'; '**Chief Directorates, Regional Agricultural Organisations**'; '**Ministries, Agricultural Industry**'; '**Kray, Oblast, Municipal, Raion Party Committees**'. Text on the signs above each desk reads (left to right): '**Glasnost**'; '**Democracy**'; '**For cosmetic repairs!**'; '**Perestroika**'; '**Long live...**'. Text on the coffin reads: '**Perestroika. Glasnost. Democracy**'. Text at the bottom reads: '**That's what impedes and suffocates us...**'

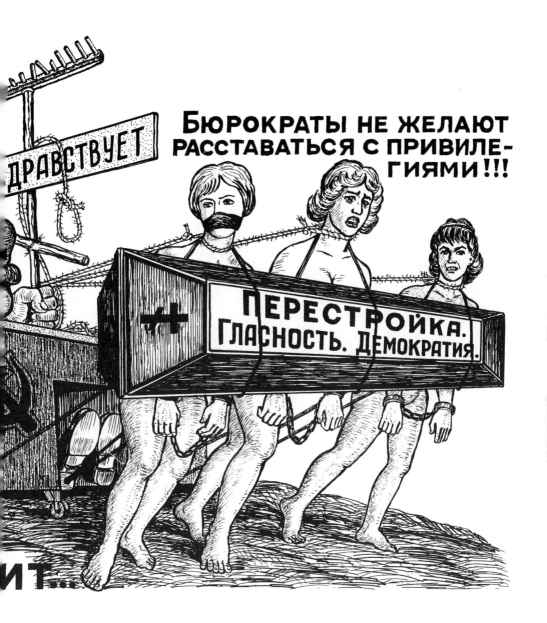

* 'The corrupt ruling class – the millions of men in the party-state *nomenklatura* – is not capable of voluntarily renouncing any of the privileges they have seized. They have lived shamelessly for decades at the people's expense – and would like to continue doing so.' Aleksandr Solzhenitsyn, *Rebuilding Russia: Reflections and Tentative Proposals*, 1991.

Above A woman holds up a sign reading 'YES to Yeltsin! NO to the junta! Putschists – out! Hands off our country!' A photograph taken during the August Putsch, where hard-line members of the Communist Party attempted to wrestle control of the government from the reformist Soviet President Mikhail Gorbachev. Moscow, 1991.
Right A woman carries all her belongings on her back. Moscow, 1991.

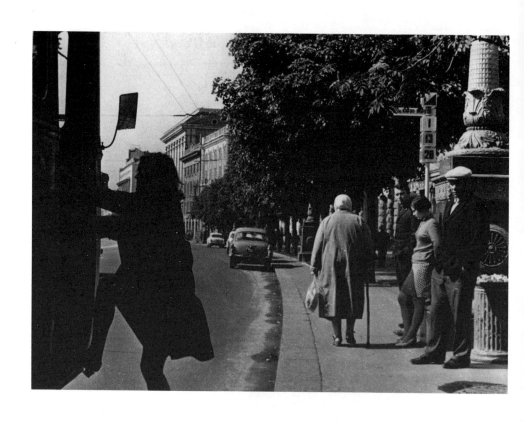

Above Street scene. Chelyabinsk, 1971.
Right New apartment blocks under construction in the north of Chelyabinsk, 1969.

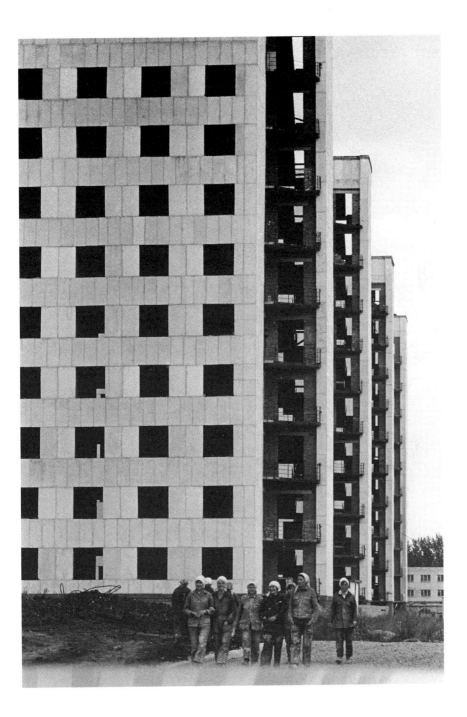

Mikhail Gorbachev's reforms led to a greater freedom of speech, which in turn resulted in open criticism of the Communist regime. The real levels of crime, alcohol abuse, pollution, and corruption were revealed and the public discovered what their consecutive leaders had concealed and denied. The media, now free from government control, exposed Stalin's 1939 treaty with Hitler, the horror of the gulags and the mishandling (by Gorbachev) of the Chernobyl disaster.

As part of the 'democratisation' process, in the spring of 1989 voting took place for a new legislature named the Congress of People's Deputies. This was the first openly contested election since the revolution. An astonished Russian public watched on television as, for the first time, their leaders were questioned and cross-examined by journalists. A number of prominent Party officials were defeated and critics of the leadership elected. A boundary had been crossed and it was impossible to turn back.

Democracy triumphed over the Communist government in Poland, an event that was quickly followed by uprisings in the remaining Warsaw Pact countries (Bulgaria, Czechoslovakia, East Germany, Hungary and Romania). These newly claimed independent states had a destabilising effect on the Soviet Union: Gorbachev had lost control. For the first time he realised that the people did not want to live under a modernised version of Communism: they wanted rid of it altogether.

In 1990 a further six republics were lost (Lithuania, Moldova, Estonia, Latvia, Armenia and Georgia). With this independence came a rejection of Moscow-issued laws and taxes. This led to a breakdown of existing economic chains, accelerating the decline of the Soviet economy. The economy itself was suffering from a lack of direction, occupying an uncertain position somewhere between the Soviet (command) and the Western (capitalist) systems. Although several reforms had been passed in an attempt to ease in a market-driven economy, these tentative steps had only served to undermine the existing structure, and failed to replace it with a viable alternative.

A power struggle developed between Boris Yeltsin (newly elected chairman of the Presidium of the Supreme Soviet of the Russian Soviet Federative Socialist Republic: RSFSR), and General Secretary Gorbachev (Communist Party of the Soviet Union). Yeltsin demanded that Russia itself should become a separate state, independent from the Soviet Union. Frustrated at the failure of the Party to evolve into a legitimate parliamentary structure, he

dramatically resigned. Then in 1991, he became the first democratically elected President of the Russian SFSR, convincingly defeating Gorbachev's proposed candidate, by winning fifty-seven per cent of the vote.

With increasing independence of former Soviet states Gorbachev was forced to restructure the dynamics of the government into a less centralised system. The new Union Treaty was drawn up with the intention of allowing the Soviet Union to become a group of individual states functioning under a common president, foreign policy, and military. But this meant that the Party would still control economic and social life – something that the more radical reformists were against. They wanted a swifter transition to a market economy, even at the cost of the disintegration of the USSR into independent nation-states. Yeltsin supported this more radical approach: alongside regional and local authorities, he wanted to seize power from Moscow. Against them were the conservative Communists and Russian nationalists of the USSR, who were opposed to any action that might weaken the country as a whole and its centralised power base. For them the proposed Union Treaty was the breaking point: they resorted to direct action.

A coup was organised by the General Committee on the State Emergency (formed by Gorbachev's vice president and other senior officials), and on 18th August Gorbachev was placed under house arrest in his holiday home in the Crimea. Assisted by the military and the KGB, they immediately attempted to halt perestroika: reintroducing political censorship, and banning newspapers. But the organisers of the coup lacked the conviction to make their action succeed. The majority of support in large cities and republics was against them. Faced with a defiant Boris Yeltsin, (who from a surrounded White House – the Russian Federations parliament – had rallied strong opposition against the coup), they buckled and were swiftly arrested.

Gorbachev's position had been considerably weakened by the actions against him of those he'd appointed. On the 29th August he ordered all Communist Party units in the government to be dissolved and all Party activity on Soviet territory suspended. Yeltsin understood that without the Soviet Union, Gorbachev would be out of government. Recognising this opportunity, he quickly proceeded to wind up the USSR, holding secret meetings with the leaders of Belarus and Ukraine to agree the dissolution of the Union and the establishment of the Commonwealth of Independent States (CIS). In the early hours of 25th December 1991, a destroyed Gorbachev resigned, ceding all powers to Yeltsin. The red flag was lowered from the Kremlin and the Russian tricolor raised in its place, marking the end of the Soviet Union.

Bibliography

Martin Amis, *Koba the Dread*, 2002
Anne Applebaum, *Iron Curtain: The Crushing of Eastern Europe 1944-56*, 2012
Yuri Borev, *The Staliniad*, 1990
Artyom Borovik, *The Hidden War*, 1990
Rodric Braithwaite, *Dedovshchina: bullying in the Russian Army*,
OpenDemocracy.net, 2010
Anya von Bremzen, *Mastering the Art of Soviet Cooking*, 2013
Zbigniew Brzezinski (editor), *Dilemmas of Change in Soviet Politics*, 1972
Oliver Bullough, *The Last Man in Russia: And The Struggle To Save A Dying Nation,* 2013
Frédéric Chaubin, *Cosmic Communist Constructions Photographed*, 2011
Robert Conquest, *The Harvest of Sorrow: Soviet collectivization and the
Terror-famine*, 1986
Robert V. Daniels, *The End of Communist Revolution*, 1993
R. W. Davis, M. Harrison, S. G. Wheatcroft (editors), *The Economic Transformation of
the Soviet Union, 1913-1945*, 1993
Vladimir Ilyin, *Power and Coal: Miners Movement of Vorkuta, 1989-1998*, 1998
Ryszard Kapuściński, *Imperium*, 1993
Aron J. Katsenelinboigen, *The Soviet Union: empire, nation, and system*, 1991
David Kotz and Fred Weir, *Revolution from Above: The demise of the Soviet system*, 1997
Sergei Maksudov (et al), *Hunger by Design: The Great Ukrainian Famine and its Soviet
Context*, 2009
Martin McKee, *Alcohol in Russia*, 1999
Roy Medvedev, *Let History Judge: The Origins and Consequences of Stalinism*, 1988
John Nicolson, *The Other St Petersburg*, 1994
Open Society Archives, *Crime In The Soviet Union*, 1973
David Remnick, *Lenin's Tomb: Last Days of the Soviet Empire,* 1994
R. Reuveny and A. Prakash, *The Afghanistan war and the breakdown of the Soviet
Union*, 1999
Victor Sebestyen, *Revolution 1989: The Fall of the Soviet Empire*, 2009
Aleksandr Solzhenitsyn, *Rebuilding Russia: Reflections and Tentative Proposals*, 1991
Tatyana Tolstaya, *Pushkin's Children: Writings on Russia and Russians*, 2003
Michael Voslensky, *Nomenklatura: The Soviet Ruling Class*, 1980
Stephen White, *Russia Goes Dry: Alcohol, State and Society*, 1996
Boris Yeltsin, *The Struggle for Russia*, 1994
Aleksandr Zinovyev, *Homo-Sovieticus*, 1986

Other books in this series:

Russian Criminal Tattoo Encyclopaedia Volume I, Danzig Baldaev and Sergei Vasiliev
ISBN: 978-0-9558620-7-6

Russian Criminal Tattoo Encyclopaedia Volume II, Danzig Baldaev and Sergei Vasiliev
ISBN: 978-0-9550061-2-8

Russian Criminal Tattoo Encyclopaedia Volume III, Danzig Baldaev and Sergei Vasiliev
ISBN: 978-0-9550061-9-7

Drawings from the Gulag, Danzig Baldaev
ISBN: 978-0-9563562-4-6

Home-Made: Contemporary Russian Folk Artifacts, Vladimir Arkhipov
ISBN: 978-0-9550061-3-5

Home-Made Europe: Contemporary Folk Artifacts, Vladimir Arkhipov
ISBN: 978-0-9568962-3-0

Notes from Russia, Alexei Plutser-Sarno
ISBN: 978-0-9550061-7-3

First published in 2014

FUEL Design & Publishing
33 Fournier Street
London E1 6QE

fuel-design.com

Drawings and text © Danzig Baldaev/FUEL
Photographs © Sergei Vasiliev
For this edition © FUEL

Special thanks to: Valentina Baldaeva

The publishers would especially like to thank the following people for generously giving their time and expertise:
Clementine Cecil, Polly Gannon, Julia Goumen, Ast A. Moore, Fergal Stapleton, Rebecca Warren.

Translation: http://GnMTranslations.com

Distribution by Thames & Hudson / D. A. P.
ISBN 978-0-9568962-7-8
Printed in China